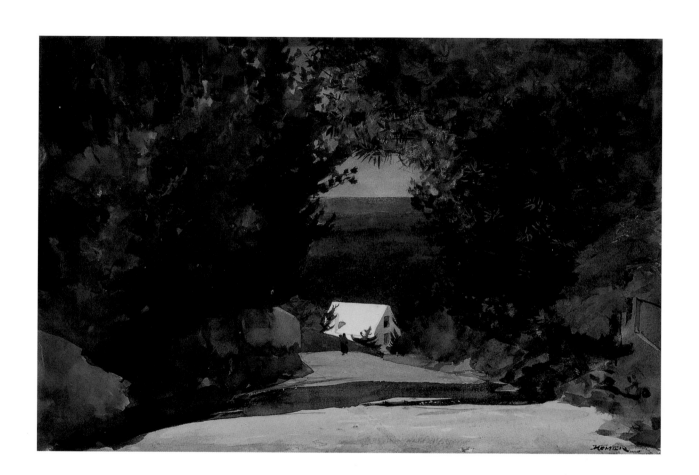

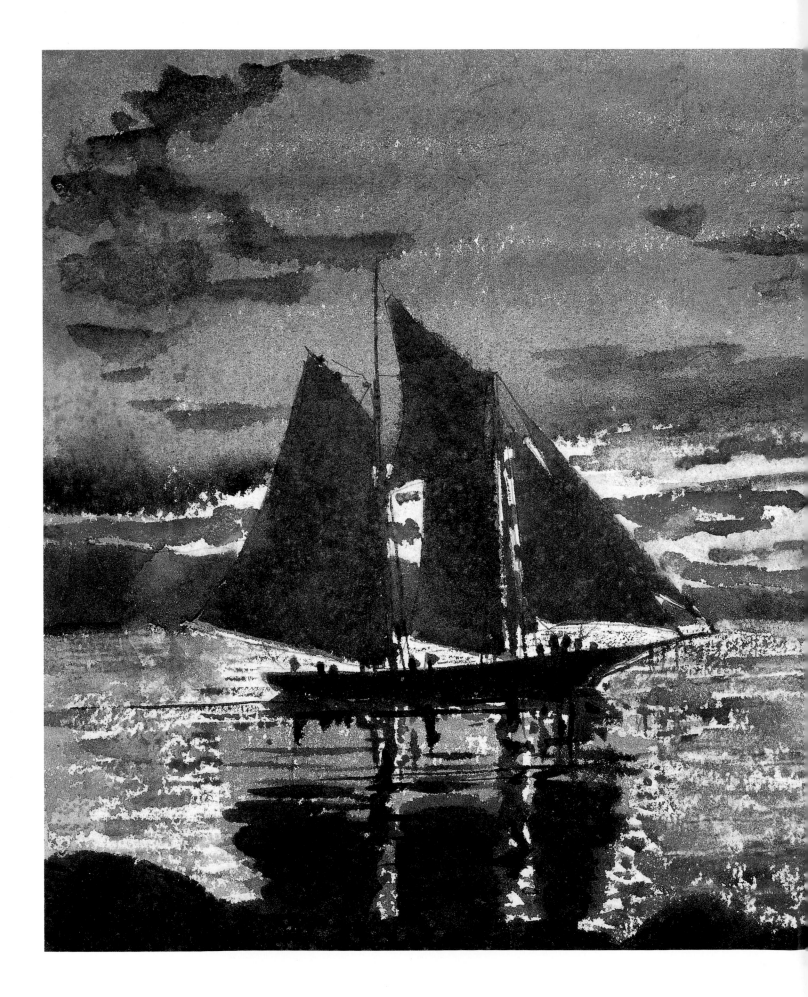

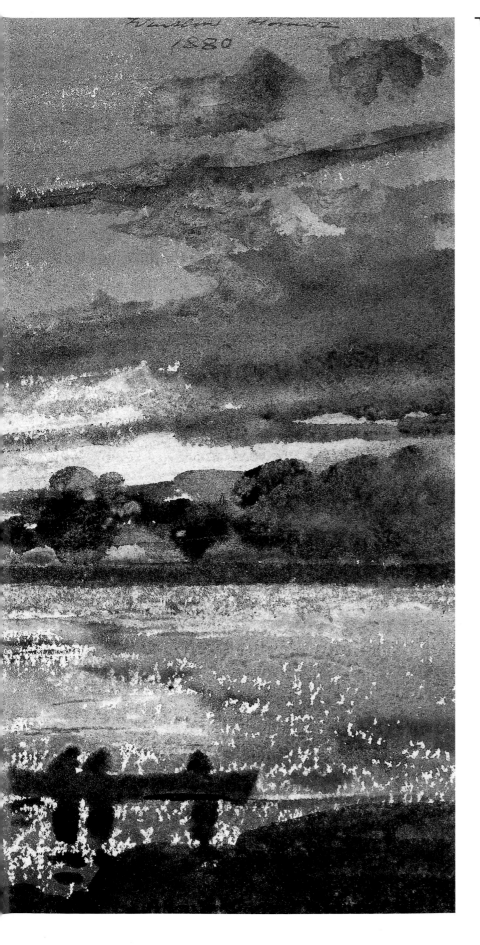

WINSLOW HOMER

HIS ART,
HIS LIGHT,
HIS LANDSCAPES

TEXT
Carl Little

PICTURE EDITOR
Arnold Skolnick

FIRST GLANCE BOOKS

COBB, CALIFORNIA

Published in the United States of America
by First Glance Books

Distributed by First Glance Books
P.O. Box 960, Cobb, CA 95426
Phone: (707) 928-1994
Fax: (707) 928-1995

This edition was produced by
Chameleon Books, Inc.
31 Smith Road
Chesterfield, MA 01012

ISBN 1-885440-04-9

Printed in Hong Kong

President: Neil Panico
Vice President: Rodney Grisso
Designer, Picture Editor: Arnold Skolnick
Editorial Assistant: Laura J. MacKay
Copy Editor: Jamie Nan Thaman

(half-title)
Road in Bermuda, c. 1899-1901
Watercolor over pencil, 14 x 21 1/16 inches
The Brooklyn Museum of Art
Bequest of Helen B. Sanders; 78.151.3

(title page)
Sunset Fires, 1880
Watercolor on paper, 9 3/4 x 13 5/8 inches
Westmoreland Museum of Art
Greensburg, Pennsylvania
William A. Coulter Fund; 64.36

Acknowledgments

Anyone attempting to write about Winslow Homer in this day and age owes a debt of gratitude to the many art historians who have sought to illuminate his work. Lloyd Goodrich, John Wilmerding, Philip Beam—these are just a handful of the scholars whose careful and insightful accounts have been consulted in the course of writing this book.

The author wishes to thank Arnold Skolnick for providing the opportunity to revisit the work of Winslow Homer. Parts of the text originally appeared in an article in *Portland Magazine,* Colin Sargent, editor.

As always, Peggy, Emily and James deserve a lot of the credit. There is simply no way this writer could get by without their love and understanding.

—Carl Little

Chameleon Books wishes to thank all the public institutions who supplied the wonderful images in this book. For their uncommon cooperation and courtesy, we especially thank Courtney DeAngelis, Amon Carter Museum; Mary Sluskonis, Museum of Fine Arts, Boston; Maddy Kelly, Bowdoin College Museum of Art; Lisa Hintzpeter, The Brooklyn Museum of Art; Samantha Kimpel, Butler Institute of American Art; James Crawford, Canojaharie Library and Art Gallery; Chantel Y. Cummings, Cummer Gallery of Art & Gardens; Liz Dickinson, Delaware Art Museum; Beth Garfield, The Detroit Institute of Arts; Edith Murphy, The Farnsworth Art Museum; Elizabeth Gombosi, Fogg Art Museum, Harvard University Art Museums; Recinda Jeannine and Carol Norcross, Los Angeles County Museum of Art; Barbara Chabrowe, The National Gallery of Art; Mel Ellis, New Britain Museum of American Art; Susan Anable, Portland Museum of Art; Melody Ennis, Museum of Art, Rhode Island School of Design; Michael Goodison, Smith College Museum of Art; Barbara Plante, Springfield Museum of Fine Arts; Martha Asher, Sterling and Francine Clark Art Institute; Patricia J. Whitesides and Lee Mooney, Toledo Museum of Art; Amber Woods, Wadsworth Atheneum; Judith O'Toole, Westmoreland Museum of Art; and Jill J. Burns, Worcester Art Museum.

We are also grateful to the galleries for their assistance, including Vicki Gilmer, Curtis Galleries; and Nina K. Barker, Jordan-Volpe Gallery.

Thanks also to the private collectors who contributed: Jo Ann and Julian Ganz, Jr., Erving and Joyce Wolf, Mr. and Mrs. Paul Mellon—and those who prefer to remain anonymous.

—Arnold Skolnick

Contents

Foreword 6

Introduction 7

The Civil War and Early Oils 16

Gloucester and the Coast of Massachusetts 28

The Adirondacks 48

Houghton Farm and Rural New York State 68

Canada 94

England 106

The Tropics: Florida, Bermuda, the Bahamas 118

Prout's Neck, Maine 140

List of paintings 176

Selected bibliography 176

Foreword

Winslow Homer's art and life have been the focus of a wide range of disciplines; his outlook on the world was, in a manner of speaking, human ecological. Social historians turn to him for the detailed records he made of his time, while natural historians appreciate his renderings of flora and fauna. Of course, writers of art history have subjected his work to the closest of scrutiny, analyzing his library, his letters, his liaisons, his light, in order to come to terms with his genius. In a paradoxical sense, the further away we move from Homer's time, the closer we seem to draw to the truth of his art. For example, in recent years museums have retitled many of the pieces he made during his stay in England, changing "Tynemouth" to "Cullercoats" to reflect more accurate knowledge of his whereabouts while abroad in 1881-1883.

A more significant example of our ever-expanding comprehension of the artist derives from the grand retrospective of his work organized by the National Gallery of Art in 1995-1996. In the voluminous exhibition catalogue, the context of many of Homer's greatest pictures was revealed through near-exhaustive scholarly analysis. The why and the wherefore of his artistic impulses were illuminated as perhaps never before.

Certainly, we already knew a great deal about this most American of artists, whose aesthetics have been the subject of numerous studies since his death in 1910. Yet here, in this massive tome, one was transported via newspaper and historical accounts to the year and sometimes the month and the day in which Homer painted a particular image.

Such an act of scholarship is impressive, but also somewhat daunting. Intense scrutiny can draw the lifeblood out of an artist's work. After all, if we figure out his every move, if we know what he was thinking, the very spirit of the work may be weakened.

Homer and his paintings and watercolors have, I am happy to say, withstood this barrage. In a manner of speaking, the artist resembles the central figure in his painting *Defiance: Inviting a Shot Before Petersburg*, 1864. In this Civil War canvas, a soldier stands on a wall on the front line, doing a dance of death in order to draw fire from the enemy.

Homer successfully danced that dance during his lifetime, and his reputation has remained near invincible in the nearly ninety years since his death. Bullets of the critical kind have grazed him here and there, but his art remains supreme. Indeed, his genius has led to a rare occurrence in the art world: a consensus on the greatness of a body of work.

Portrait of Winslow Homer, 1880
Silver print
Courtesy Bowdoin College Museum of Art,
Brunswick, Maine
Gift of the Homer Family

Introduction

Winslow Homer was born in Boston, Massachusetts, in 1836. He would remain a New Englander all his life, despite significant sojourns to England, Canada, the Adirondacks, and the Tropics. New York City served as his base of operations for many years, but he never considered it his home.

Although he was elected to the National Academy of Design in 1866, at the youthful age of 26, Homer didn't achieve artistic proficiency overnight. Not especially interested in schooling, at age 18 he apprenticed to a lithography firm where, among other things, he rendered genre scenes for the covers of sheet music.

Homer was known to have dreaded this work, but he was prepared, as it were, to pay his dues in order to achieve artistic freedom. One imagines him at his drafting table, faced with the task of illustrating such tunes as *O Whistle and I'll Come to You My Lad* (1854) or *The Ratcatcher's Daughter* (1855) or *The Wheelbarrow Polka* (1856)—grinning but scarcely bearing it.

Often described as self-taught, Homer in fact had significant training. During his two-year apprenticeship in the J.H. Bufford lithography shop in Boston, he learned the art of design for wood engravings from Charles Domereau. He also studied M.E. Chevreul's famous treatise *Laws of the Contrast of Colour*, 1859, which his brother gave him in 1860 and which he referred to as his "Bible."

Granted, this was not the kind of formal study that an artist of the age would have received at the academy or in one of the *écoles* in Paris, yet perhaps Homer benefited more from learning technique in a real-life work situation than in the sometimes stuffy studios of the art schools, where one's artistic identity might be subsumed by the trends of the day.

Homer gained further artistic skills as a newspaper illustrator. From 1857 to well into the 1870s, he drew for a number of the popular journals of the day, among them *Harper's Weekly* and *Frank Leslie's Illustrated Newspaper*. He made on-site drawings and oil sketches that were translated into wood engravings for mass consumption. While there were photographers like Matthew Brady record-

*Winter at Sea—Taking In Sail
Off the Coast,
Harper's Weekly,* January 16, 1860

journals, testify to Homer's knowledge of the Victorian age and his role as social historian. It would make an interesting study to review his work from the perspective of the history of fashion, for he had a keen eye for costume.

> May we at times turn from the ordinary pursuits of life to the pure enjoyment of rural nature; which is in the soul like a fountain of cool waters to the way-worn traveler. —THOMAS COLE, *Essay on American Scenery, 1836*

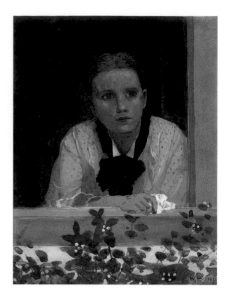

Young Girl at Window, 1875
Watercolor on paper mounted
On masonite, 6 1/4 x 4 3/4 inches
Collection of the New Britain Museum
of American Art, Connecticut
Harriet Russell Stanley Fund
Photography by E. Irving Blomstrann

If the goings-on of the wealthy provided Homer with subject matter, so did the life of country folk. One even suspects that he preferred their company: throughout his life, Homer continually sought out rural milieus, be it a farm in upstate New York, a hunting camp in the Adirondacks, a fishing village on the North Sea, or an isolated promontory on the coast of Maine. He also did an important series of paintings of blacks in the rural south during reconstruction.

Homer never embraced the urban experience as the artists of the Ashcan School would after him; his presence in the city, it would seem, was related to career motives, not to any love of crowded streets and sooty rooftops. Indeed, the extent of Homer's tributes to country people may be regarded as a response to the sordid existence of city inhabitants. A painting like *Fresh Air* stands in stark contrast to the industrial world of New York City.

It might even be said that the farther Homer distanced himself from that world, the greater were his powers as a painter. In 1880, for instance, he sought isolation on Ten Pound Island in Gloucester Harbor, and this semi-exiled setting led to some of his most fiery watercolors. Art historian Helen Cooper called one of his sunset pieces from that time "an image of almost barbaric beauty."

Homer had been visiting Gloucester off and on for many years. This center of the New England fishing industry served as his introduction to seafaring folk. Most significantly, the coastal elements enticed him to take up watercolor in a serious manner: he first practiced the medium in 1873, at age 37. His prowess would lead to the marvelous studies of Fisherfolk in Cullercoats, England, and to the ultimate genius of his work in the Tropics.

As an avid outdoorsman, Homer also found solitude and marvelous painting opportunities in hunting and fishing camps in the Adirondacks and in Canada. Bearing his watercolor kit into the woods with him, he caught the cast of

Boy in a Boatyard, 1873
Watercolor, tempera and graphite
On wove paper mounted on board,
7 7/16 x 13 5/8 inches
Portland Museum of Art, Maine
Bequest of Charles Shipman Payson;
1988.55.5
Photography by Melville McLean

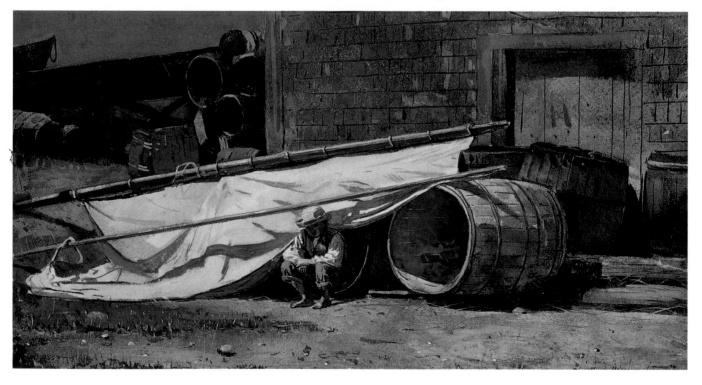

the fly, the leap of the trout, the contours of a canoe with an accuracy based upon firsthand knowledge and extraordinary brushwork.

Homer had a great appreciation for nature; the wild sustained him. For much of his life, he might have been taking to heart something Grover Cleveland wrote in his *Fishing and Shooting Sketches*, 1901: "All but the absolutely indifferent can be made to realize that...intimacy with nature and acquaintanceship with birds and animals and fish, are essential to physical and mental strength."

Homer gained new heights of artistic power, especially in watercolor, during a two-year stay in England. American artists by tradition have sought exposure to the old world, learning from its art or working against it—welcoming, reproving, advancing. Homer was no exception, and yet he was not in England to study art, although it has been shown that he embraced certain techniques of English watercolor painting; he was seeking new subject matter and he wanted to paint.

One suspects that this extended trip abroad also offered Homer a respite from the American art scene. He was at a point in his life where he could afford to turn his back on the academy, on newspaper work and the like, and strike out on his own.

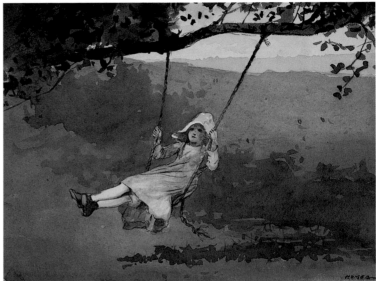

The Swing, c. 1879
Watercolor over graphite on medium,
Smooth cream wove paper,
7 3/16 x 9 5/8 inches
Worcester Art Museum,
Worcester, Massachusetts
Gift of Mrs. Howard W. Preston
In memory of Dr. and Mrs. Loring
Holmes Dodd

Why should not the American landscape painter, in accordance with the principle of self-government, boldly originate a high and independent style, based on his native resources? —ASHER B. DURAND, *1855.*

It was during Homer's years at Prout's Neck, near Scarboro, Maine, that he became the master marine artist. Fed up with New York, where he had maintained a studio off and on since 1859, and annoyed by serving on art juries and by other time-consuming activities, Homer moved to Maine for good in 1884, not long after his return from England. After living in a small fishing village on the North Sea, the transition to the coast of Maine proved a smooth one.

In going to both places, England and Prout's Neck, Homer was, to a certain extent, simply looking for a place to paint with minimal distractions (artists continue to move to Maine for this very same reason). "Get ye all gone, old friends, and let me listen to the murmur of the sea," wrote Hawthorne in a 1838 sketch, "Foot-prints on the Sea-shore," sentiments Homer might have shared.

Yet the painter was never the total recluse he has often been depicted as being, practicing diabolical subterfuges in the name of privacy. Every year he made trips to Boston, New York, Atlantic City, and other places and joined in the company that the artistic society of the day offered. And while we know from his letters that he anticipated with pleasure the departure of summerfolk from Prout's Neck in September, at which point he'd settle down to paint, Homer readily partook of the company of family and friends while they were in residence.

Homer's was a kind of journalistic aloofness; he trained an objective eye on the world around him, maintaining his distance, recording scenes and events as a reporter might. Every once in a while, in the privacy of his studio, he would slip into more dramatic/romantic modes—one thinks of the Hemingway-esque *The Gulf Stream,* 1899, or some of the sublime Prout's Neck marines—but otherwise he sought to render reality as he found it.

Homer was not one of your dime-a-dozen seasonal painters; he often stayed

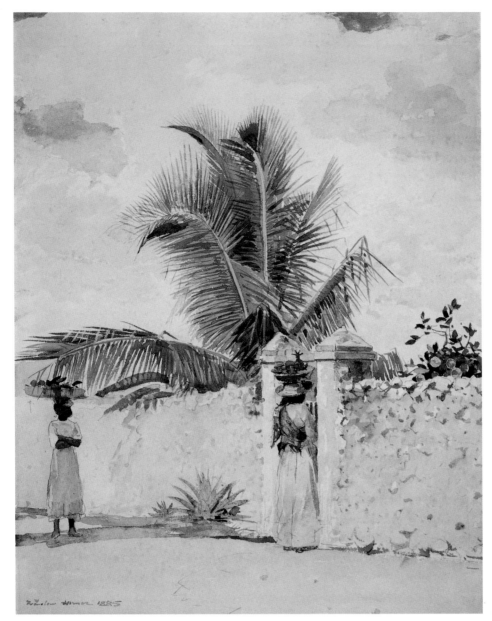

The Garden Gate, Bahamas, 1885
Watercolor over graphite on medium,
Smooth off-white wove paper,
18 1/2 x 14 1/2 inches
Worcester Art Museum,
Worcester, Massachusetts
Bequest of Miss Miriam Shaw

the other artists in the exhibition. For example, you can feel the umbrage—and the pleasure in expressing it—in Albert Van Eyck Gardner's rebuttal in his *Winslow Homer*, 1961: "What Mr. James seems to want [in art] are all the fashionable things that tastes trained on European paintings seemed to think were virtues"—touché!

It's true that some of James's critical arrows flew wide of the mark: his selections for best in show were Miss Fidelia Bridges and Mrs. Spantili Stillman, not exactly household names today. Yet when he set aside his aesthete's mask, James made some cogent points, including the following: "Mr. Homer has the great great merit...that he naturally sees everything at one with its envelope of light and air."

Homer was never directly connected to a writer as, say, Childe Hassam was to Celia Thaxter, or John La Farge to Henry Adams. He illustrated many of the reigning poets of the day, among them Lowell, Bryant, Longfellow, and Whittier (who chose Garrison Rock, near Prout's Neck, as the setting for his famous poem "Mogg Magone"). No doubt some of their verse caught his ear and some of the New England coastal poems set in his subconscious. Yet skim through Stedman's voluminous *An American Anthology*, published in 1900, and you'll find nary a single verse that truly matches up with a Homer painting.

In tying Homer's oeuvre to literature, it is most often to twentieth-century

writers that we turn. In the course of his art he moved, in a manner of speaking, from Longfellow's "My Lost Youth," with its romanticized image—"Often I think of the beautiful town / That is seated by the sea"—to T.S. Eliot's "The Dry Salvages," with its distinctly modern vision—"The sea has many voices, / Many gods and many voices."

Even more recent poets come to mind when viewing Homer's canvases. Some lines from a poem by Amy Clampitt, late of Corea, Maine, work well with a number of Homer's atmospheric canvases from the Prout's Neck period:

> A vagueness comes over everything,
> as though proving color and contour
> alike dispensable: the lighthouse
> extinct, the islands' spruce-tips
> drunk up like milk in the
> universal emulsion; houses
> reverting into the lost
> and forgotten; granite
> subsumed, a rumor
> in a mumble of ocean.
> ("Fog")

Homer loved his home in Maine, even in the dead of winter. Writing on January 14, 1897, to his brother Charles, he notes that his rooms "are very very sunny this time of year. The sun swung low shines under my top piazza into my house and with my new stove makes the place perfect." On January 21, 1907, he wrote to his other brother Arthur, "I keep my food that would freeze in my library. I find this life much pleasanter than having nothing to do but kill time."

And yet in his advancing age Homer recognized his fate. Writing to a nephew from the Hotel Rudolf in Atlantic City in December 1905, he refers to the resort as "the best place for an old man that I have seen." He encloses a sketch of elderly people being wheeled about in bath chairs, noting that such an existence "would be very slow for a man who cares to be doing anything but loaf and be waited on." He closes his letter by telling his young nephew, "You have until you are 70 years old before you would think of this kind of thing." Homer would turn that age a few months later.

The last painting Homer worked on was *Driftwood*, 1909, a Prout's Neck piece that shows a fisherman in the act of salvaging a timber from the ocean. According to Beam, the artist was aware that this was to be his last canvas. "[Homer] took his palette, deliberately messed it up, and hung it with his maulstick on the wall of his studio"—his way, writes Beam, "of saying 'Finis.' "

A final portrait of the artist is provided by William Macbeth, his dealer of many years, who visited the artist in August 1910. "What proved to be his last illness had already laid its grip upon him," writes Macbeth, "but in spite of pain he insisted on giving himself to me, and together we roamed over his Prout's Neck possessions, with their many wonderful views far and near." Macbeth notes that the artist knew his time had come:

> [Homer] was sufficiently discerning to realize that he could not keep up
> to his highest watermark reached a few years ago, and he was deter-
> mined that no inferior work should survive him. So there will be no
> sketch or failure to be dragged out to hurt his memory.

Homer died in his studio, with brothers Charles and Arthur by his side. Nearly a century after his death, we continue to celebrate his genius.

Last Official Portrait of Winslow Homer
(Winslow Homer at Prout's Neck, 1908)
Photograph by Peter Jully ?
Courtesy Bowdoin College Museum of
Art, Brunswick, Maine
Gift of the Homer Family

The Civil War and Early Oils

The men of the new regiment watched and listened eagerly, while their tongues ran on in gossip of the battle. They mouthed rumors that had flown like birds out of the unknown. —STEPHEN CRANE, *The Red Badge of Courage*

Sent by *Harper's Weekly* to cover Lincoln's inauguration in 1861, Homer later served the same publication as a reporter in the Union army camps. He drew numerous sketches of soldiers, some of which he later incorporated into oil paintings. He was drawn to some of the more colorful figures—such as the Zouaves with their Arabic costume, pitching horseshoes to pass the time while awaiting battle. He also recorded warfare: his portrait of a sharpshooter on picket duty is considered to be his first oil.

Practicing the detached approach of a reporter, Homer recorded various scenes and details of the war. He worked from sketches made on the battlefield or in the Union camps, completing his canvases back in his New York studio. In the transferring of sketch to oil, some liberties were taken, but for the most part Homer remained true to the subject.

From early in his career, Homer was widely admired for the authenticity of his images. A painting like *Skirmish in the Wilderness*, 1864, draws the viewer into the depths of a dark woods where a battle is taking place. The entire rendering is technically and aesthetically impressive: the play of light and dark, the sense of the milieu, and the action. Literary historian Van Wyck Brooks once noted that the novelist Stephen Crane, in preparation for writing *The Red Badge of Courage*, "pored over the [Civil War] drawings of Winslow Homer."

It is a known fact that the artist was profoundly affected by what he witnessed on the front lines. As his mother, Henrietta Benson Homer, wrote in a letter, "He suffered much, was without food 3 days at a time & all in camp either died or were carried away with typhoid fever....He came home so changed that his best friends did not know him."

In the years following the war, Homer developed his technique in oils. For one without any substantial prior training, he mastered this difficult medium with remarkable swiftness. Indeed, a number of his earliest pictures won him critical notice and a diploma from the National Academy of Design.

A year in Paris in 1867 may have influenced Homer's aesthetic. The painting *Long Branch, New Jersey*, 1869, his first seascape in oils, displays a kinship to certain of Monet's canvases. Yet critics recognized something distinctly American about Homer's art, and his technique set him apart from his brethren. His White Mountain canvases, in particular, owed little alliance to any school of the day.

Certain modern critics, like Clement Greenberg, find Homer's oil paintings from these formative years to be the best of his career. "In his early oils," Greenberg wrote in 1944, "[Homer] developed, independently, certain revolutionary tendencies that converged with those of the first phase of Impressionism in France." Goodrich had a similar view: he once wrote, "[Homer] was an independent American pioneer of impressionism."

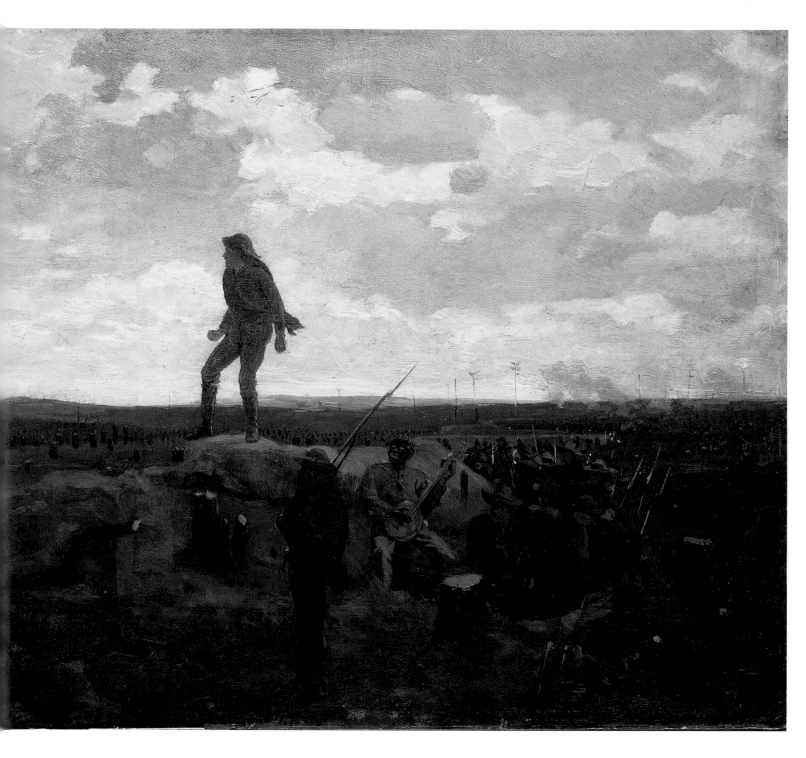

Defiance: Inviting a Shot Before Petersburg, 1864
Oil on panel, 12 x 18 inches
The Detroit Institute of Arts
Founders Society purchase with
Funds from Dexter M. Ferry, Jr.

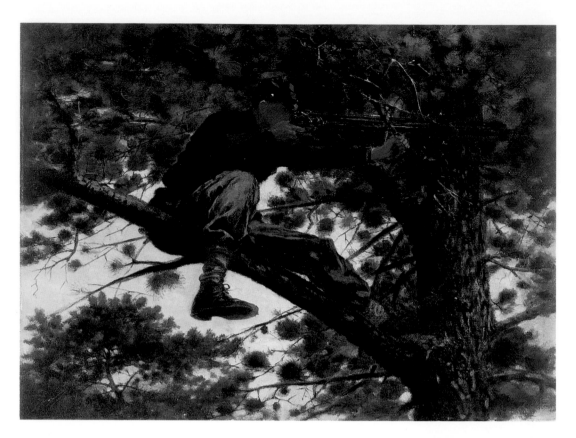

Sharpshooter, 1862-3

Oil on canvas, 12 1/4 x 16 1/2 inches

Portland Museum of Art, Maine

Gift of Barbro and Bernard Osher; 3.1993.3

Photography by Melville McLean

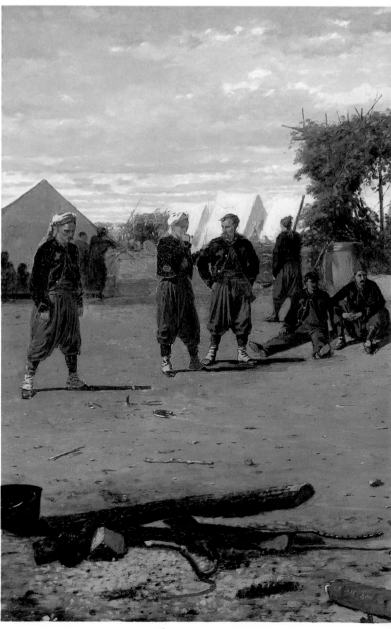

Pitching Quoits, 1865
Oil on canvas, 26 3/4 x 53 3/4 inches
Courtesy of the Fogg Art Museum
Harvard University Art Museums
Gift of Mr. and Mrs. Frederic Haines Curtiss

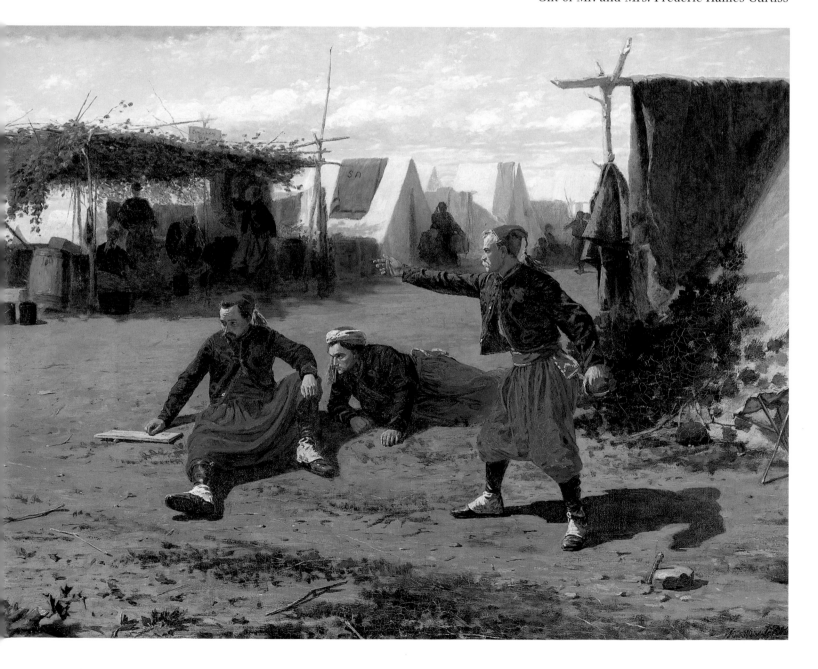

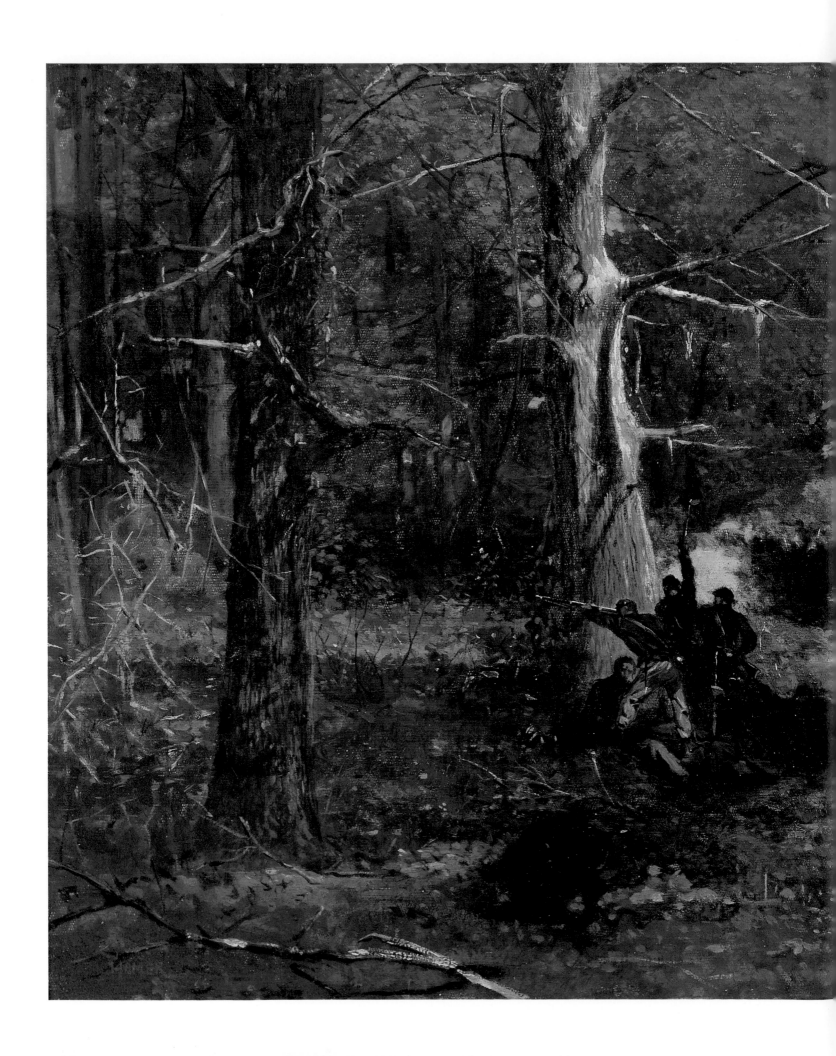

Skirmish in the Wilderness, 1864
Oil on canvas, 18 x 26 inches
Collection of the New Britain Museum
of American Art, Connecticut
Harriet Russell Stanley Fund
Photography by E. Irving Blomstrann

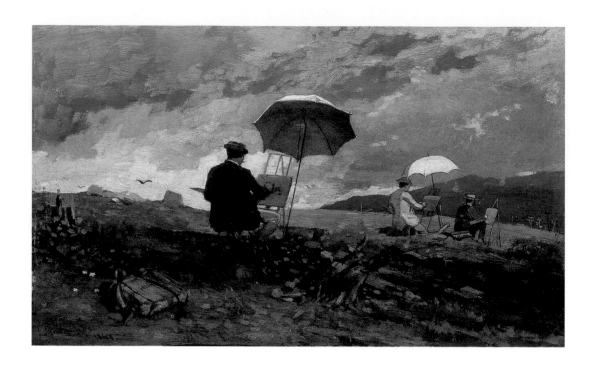

Artists Sketching in the White Mountains, 1868
Oil on panel, 9 7/16 x 15 13/16 inches
Portland Museum of Art, Maine
Bequest of Charles Shipman Payson; 1988.55.4
Photo by Melville McLean

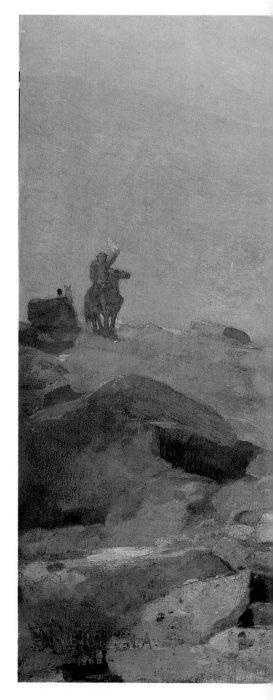

Bridle Path, White Mountains, 1868
Oil on canvas, 24 1/8 x 38 inches
Sterling and Francine Clark Art Institute,
Williamstown, Massachusetts

(overleaf)

Long Branch, New Jersey, 1869
Oil on canvas, 16 x 21 3/4 inches
Courtesy Museum of Fine Arts, Boston
The Hayden Collection

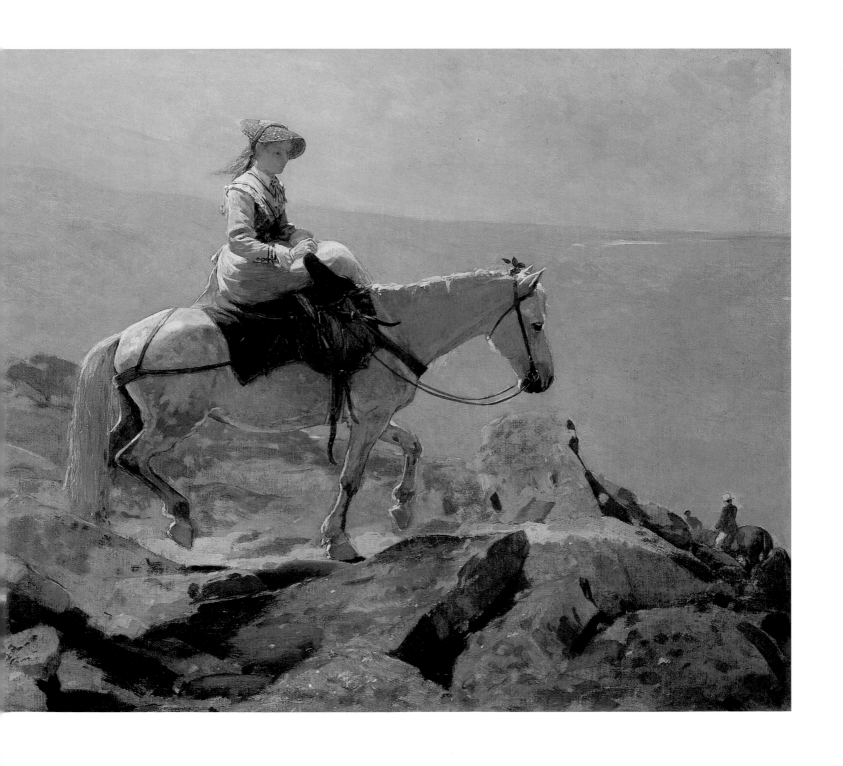

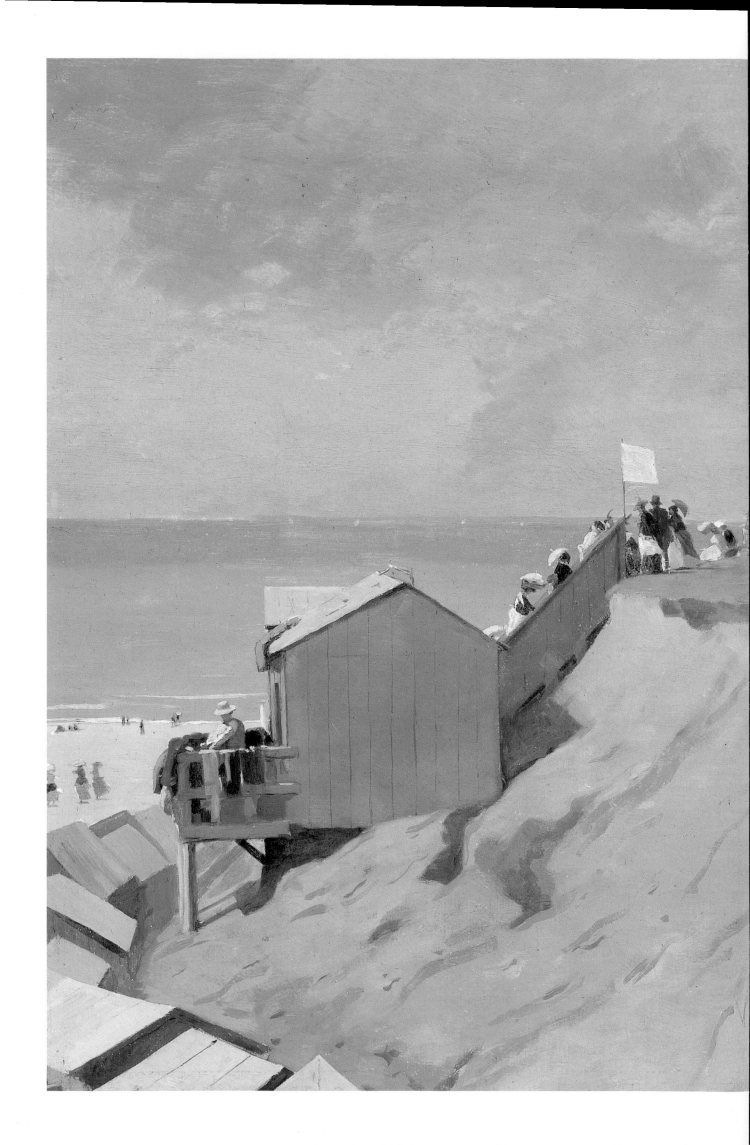

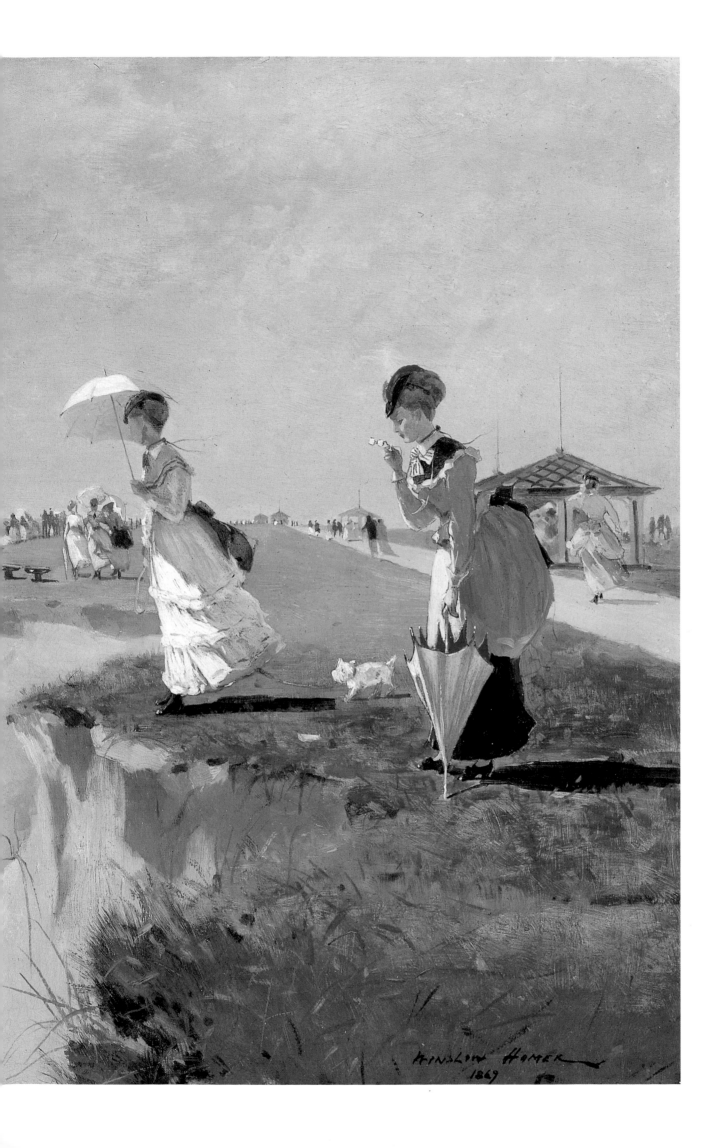

Croquet Scene, 1866
Oil on canvas, 15 7/8 x 26 1/16 inches
The Art Institute of Chicago
Friends of American Art Collection; 1942.35
Photograph © 1996, The Art Institute of Chicago,
All Rights Reserved.

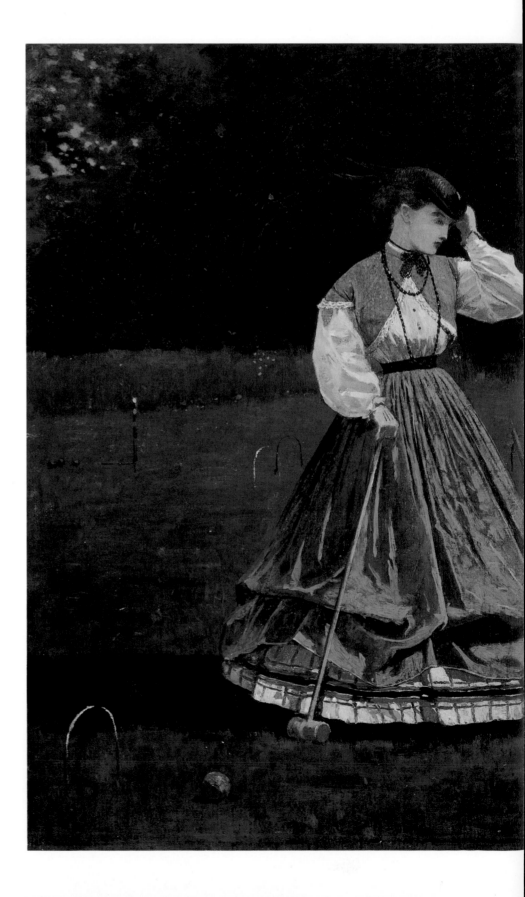

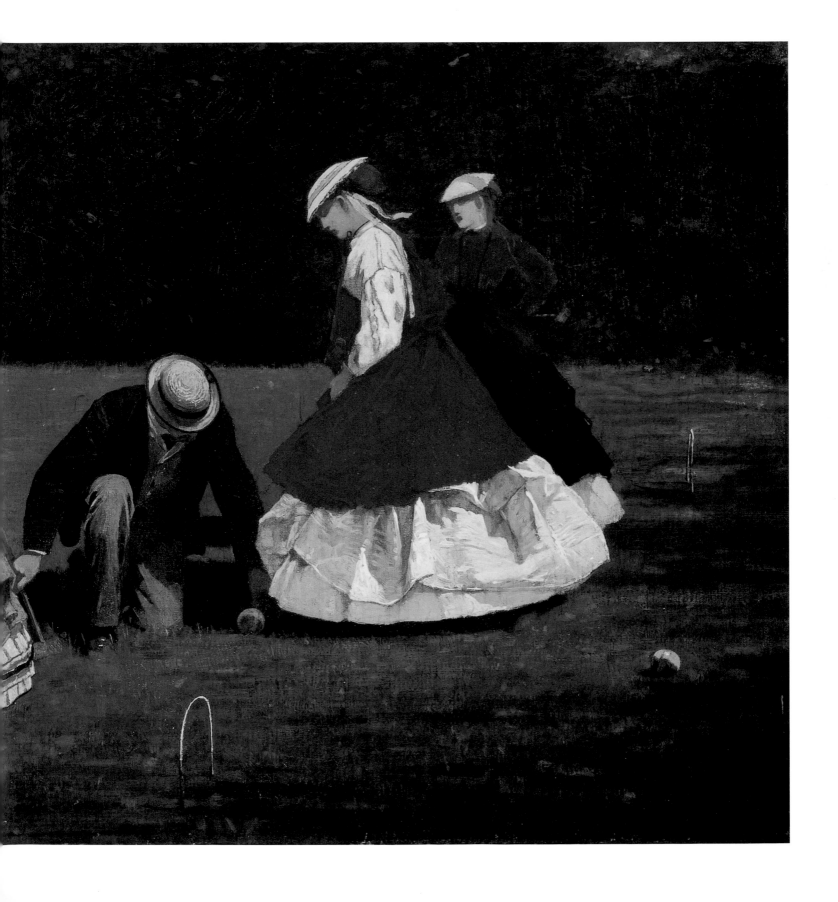

Gloucester and the Coast of Massachusetts

There is no beauty in New England like the boats. —George Oppen

As a native of Boston, from early in his life Homer frequented the coast of Massachusetts. At seaside settings like Manchester and Marshfield, he took pleasure in the rituals of bathing, of women wringing out their swimsuits, which in those more modest days consisted of knee-length dresses.

It is rather amazing to consider that a painting like *Eagle Head, Manchester, Massachusetts,* 1870, was considered "of questionable taste" by the critics. Homer's straightforward brand of realism went against the academic protocol of the day. For starters, his figures were unposed, his landscapes unexaggerated. His situation was not unlike that of the French novelist Zola, who upset the romantic apple cart with his vivid scenes of everyday life.

Homer made especially significant progress as an artist during his stays in Gloucester. He took up watercolor and made it a medium central to his artistic production and vision. His first watercolors were, in Goodrich's estimation, "different from any watercolors done before in this country, fresher in vision, showing direct observation of outdoor light, free from traditional formulas."

Homer let his graphite lines show, and this act alone was revolutionary. As Judith C. Walsh wrote in *American Traditions in Watercolor,* the artist "never ascribed to the idea that watercolors should look effortless."

On the other hand, some of these important early watercolors belong to what Hereward Lester Cooke terms the "illustrator phase" of Homer's career. Cooke notes that in a picture like *The Berry Pickers,* 1873, Homer was still following "the demands of the engraver," using outlines and clearly delineated areas of wash to aid the artisan who would cut this image into wood for *Harper's Weekly,* where it appeared on July 11, 1874.

As significant to his evolution as an artist was the subject matter Homer found in Gloucester. Boats made a great impression on him. Catboats, dories, schooners, winging before the wind, drawn up on the beach, under construction—Homer loved their lines, their tilting shapes, the distinct sails catching sunlight or forming shadows on the horizon. He also portrayed the fisherfolk and the children who entertained themselves around the harbor—picking berries, arranging a makeshift seesaw, doting on a kitten.

A painting like *Dad's Coming,* 1873, anticipates the subject that will be the main focus of Homer's work in England: the anxiety-fraught lives of families who make their living from the sea. Historian John Wilmerding has noted that this work is one of "certain key paintings" from Homer's mid-career that "appear equally to look back in nostalgia and forward in serious thoughtfulness."

Homer was frequently asked by viewers to explain certain of his pictures. In response to a collector's query about the meaning of *Promenade on the Beach,* 1880, he wrote a wonderfully exasperated reply:

> My picture represents the Eastern shore at sunset. The long line from
> the Girls is a shadow from the sun. The Girls are "somebody in particu-
> lar" and I can vouch for their good moral character. They are looking at
> anything you wish to have them look at, but it must be something at sea
> & a very proper object for Girls to be interested in. The schooner is a
> Gloucester fisherman.
>
> Hoping this will make everything clear. Homer.

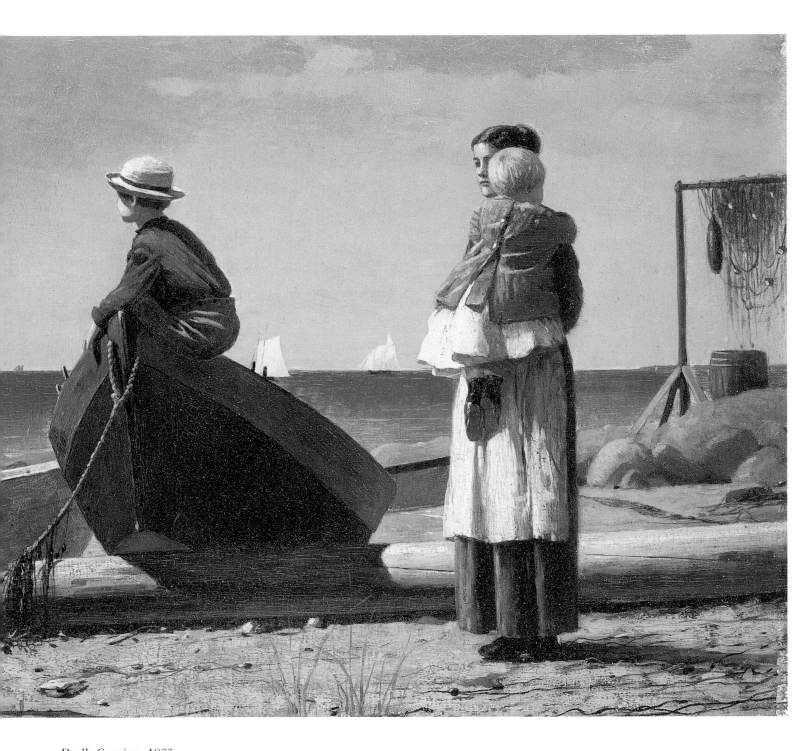

Dad's Coming, 1873
Oil on panel, 9 x 13 3/4 inches
Collection of Mr. and Mrs. Paul Mellon,
Upperville, Virginia

Eagle Head, Manchester, Massachusetts, 1870
Oil on canvas, 26 x 38 inches
The Metropolitan Museum of Art
Gift of Mrs. William F. Milton; 1923

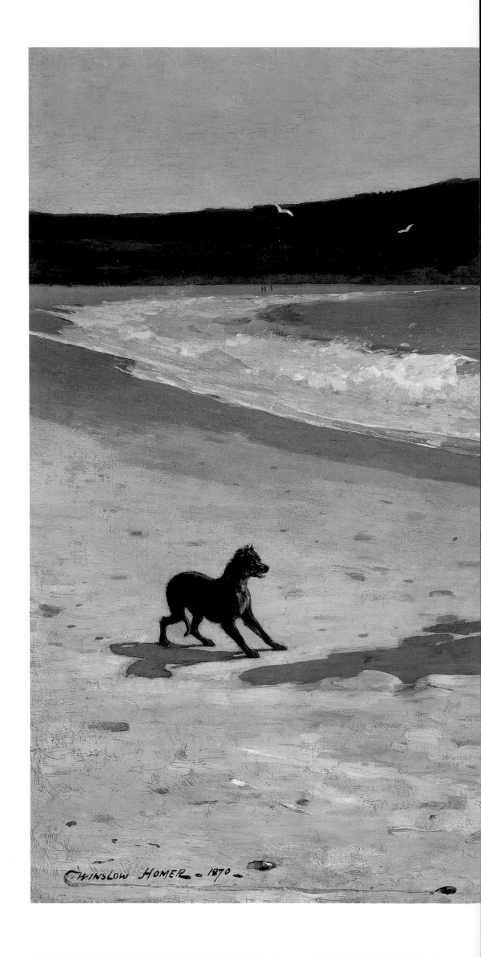

(overleaf)

Promenade on the Beach, 1880
Oil on canvas, 20 1/4 x 30 1/8 inches
Museum of Fine Arts, Springfield, Massachusetts
Gift of the Misses Emily and Elizabeth Mills, in
Memory of their parents, Mr. and Mrs. Isaac Mills

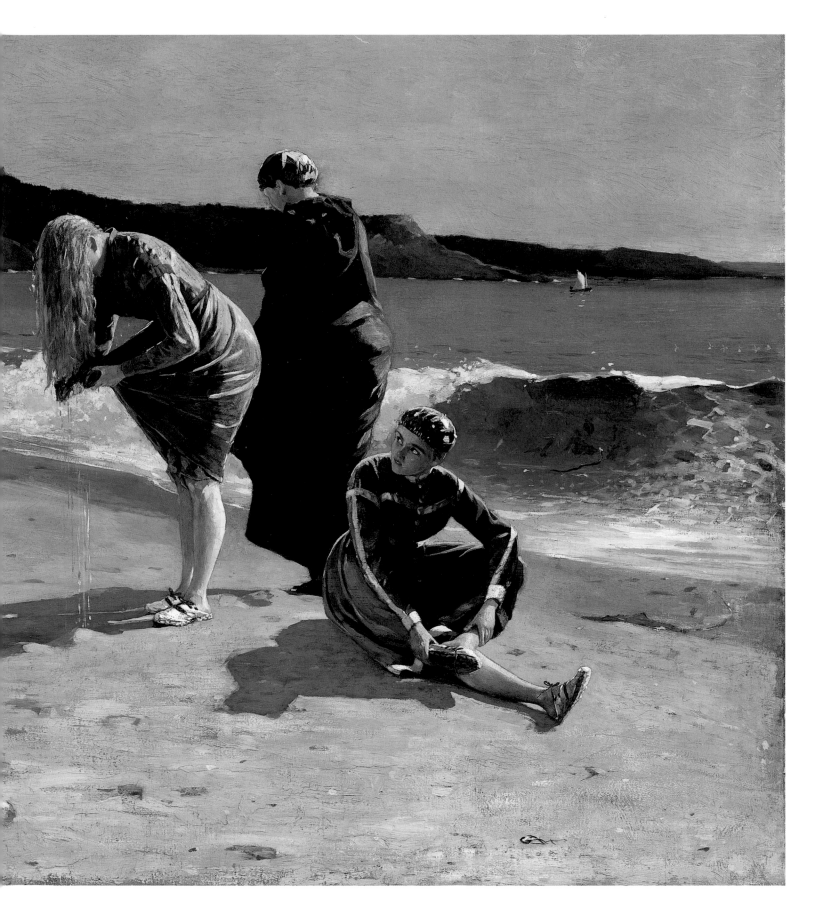

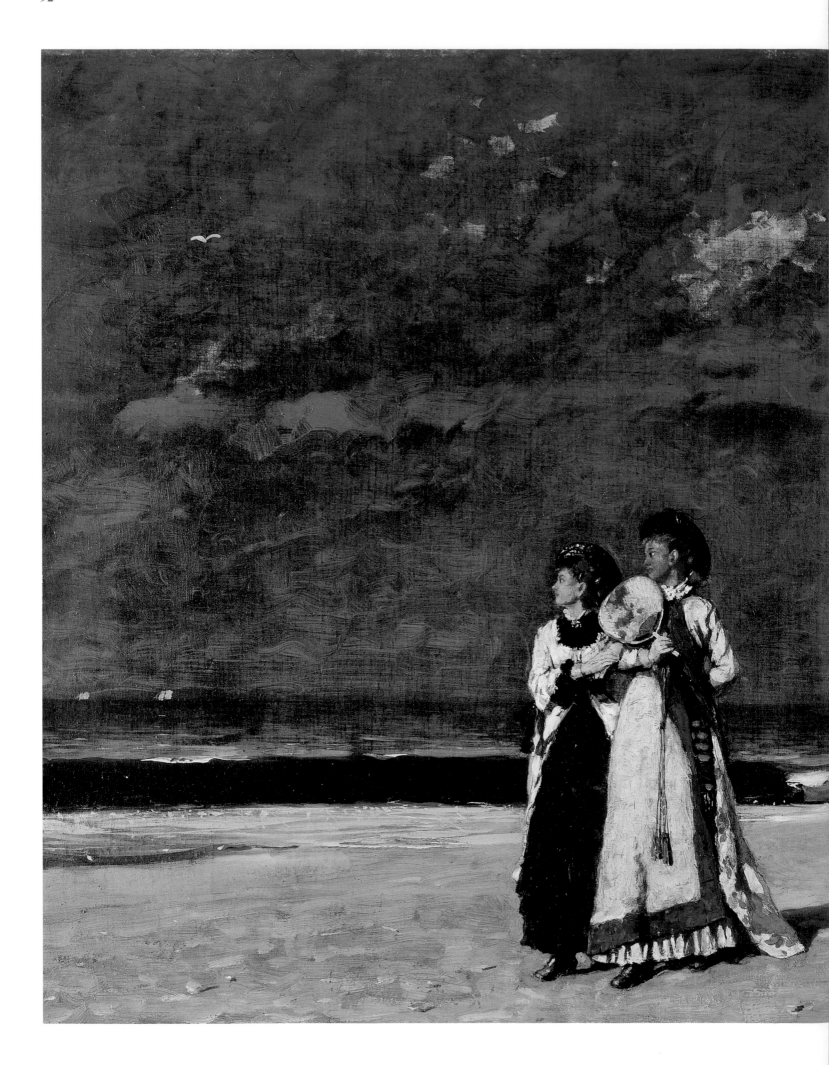

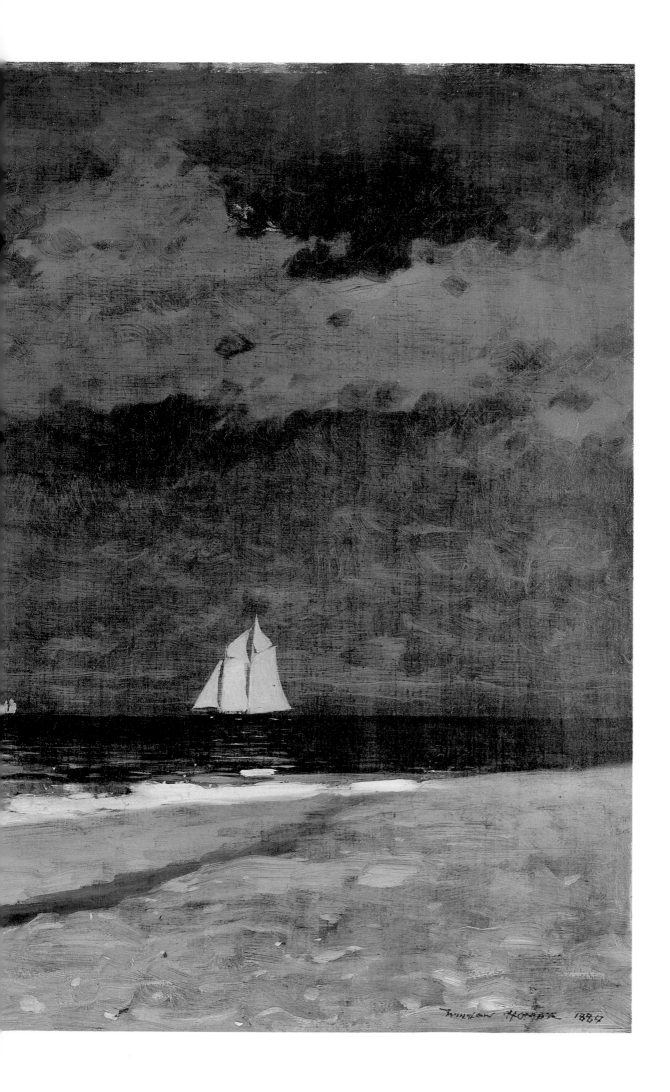

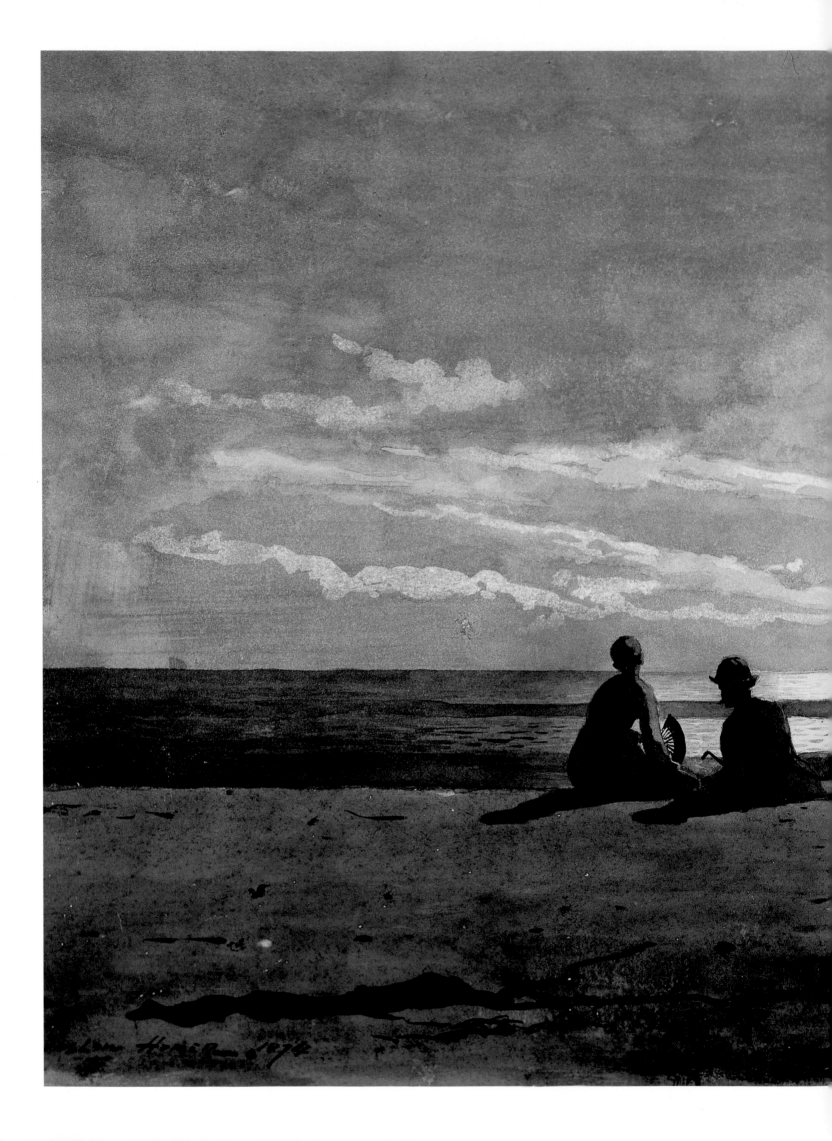

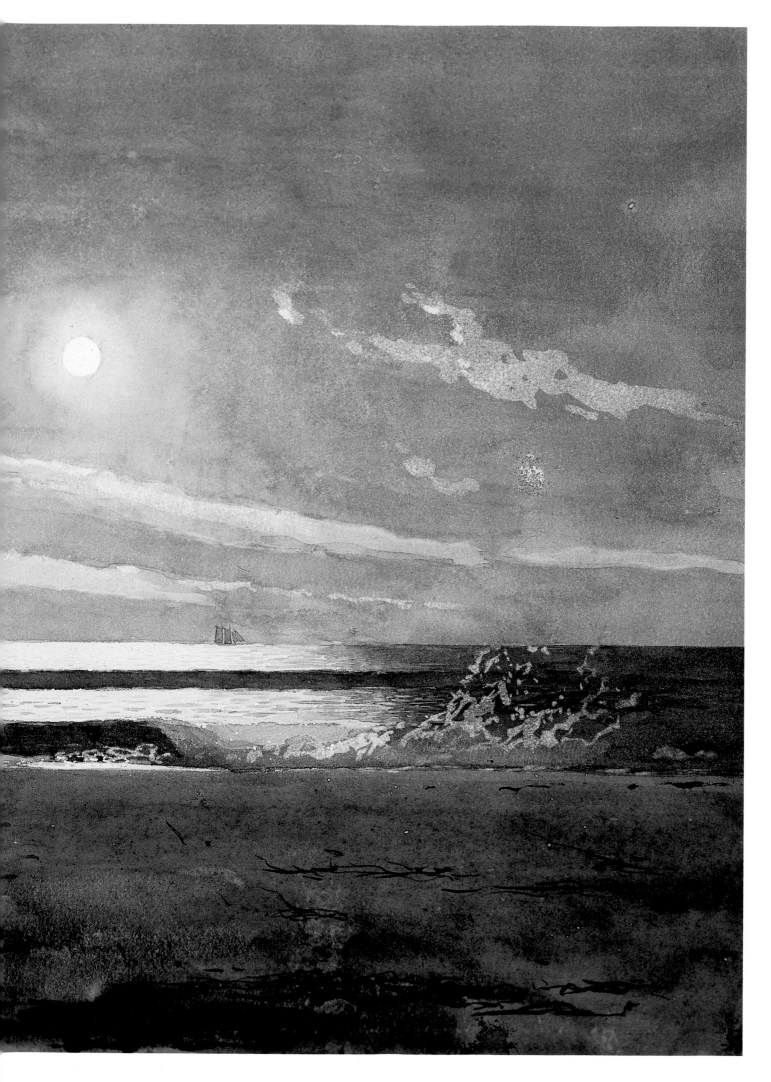

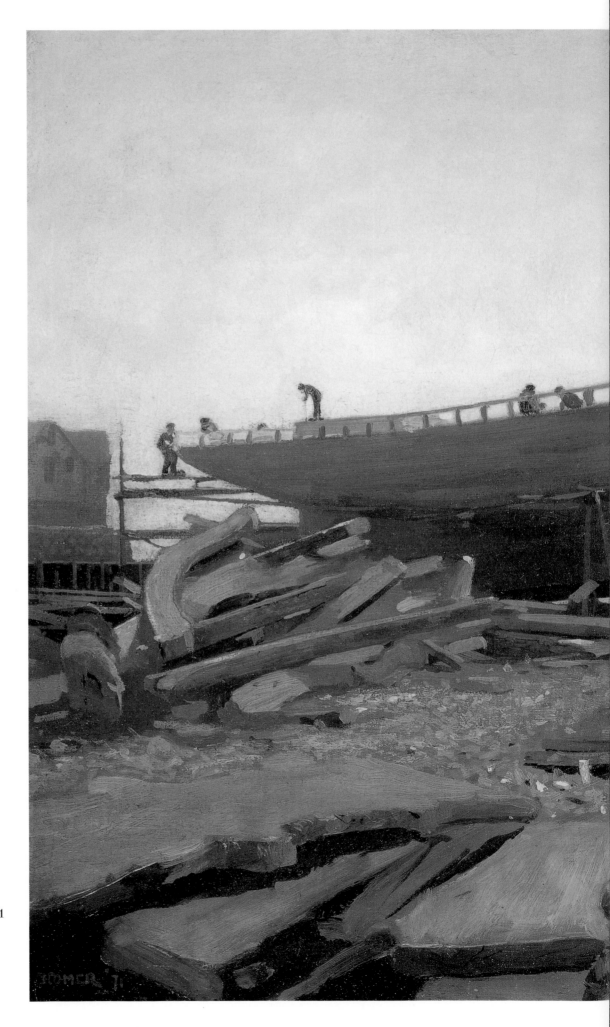

(preceding spread)

Moonlight, 1874
Watercolor and gouache,
14 x 20 inches
Courtesy of the Canajoharie
Library and Art Gallery

Shipbuilding at Gloucester, 1871
Oil on canvas,
13 1/2 x 19 3/4 inches
Smith College Museum of Art,
Northampton, Massachusetts

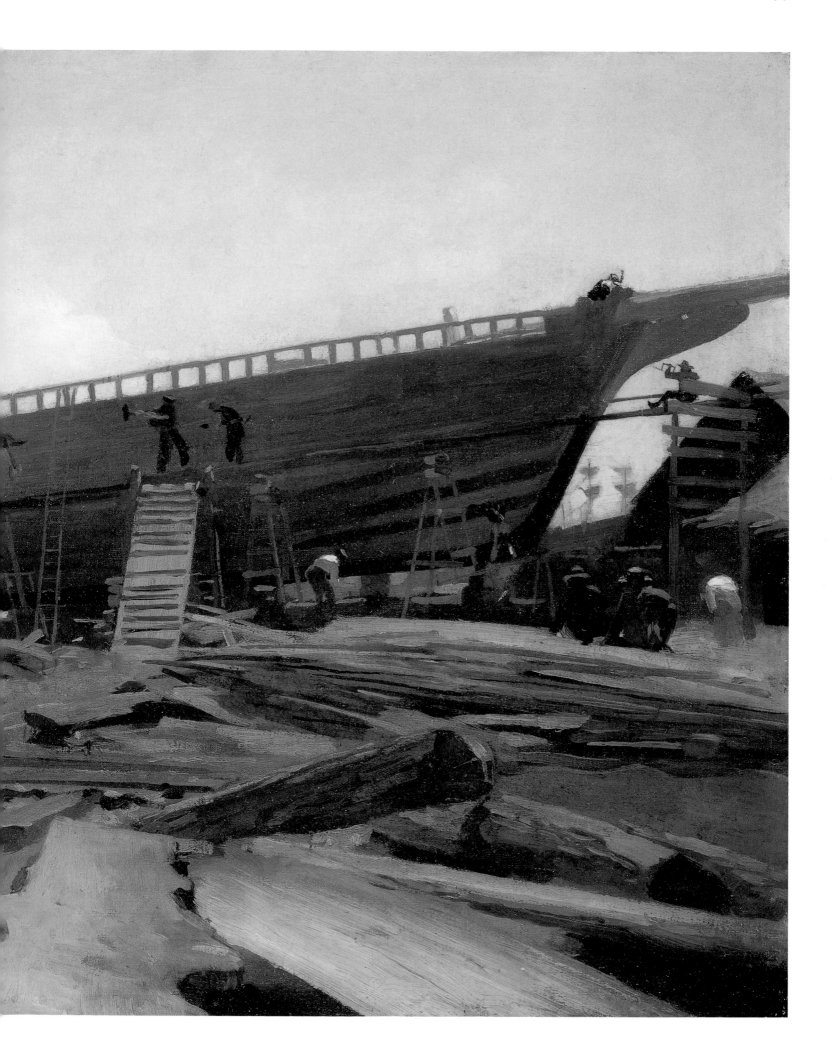

The Flirt, 1873
Oil on panel, 8 1/2 x 12 inches
Collection of Mr. and Mrs. Paul Mellon,
Upperville, Virginia

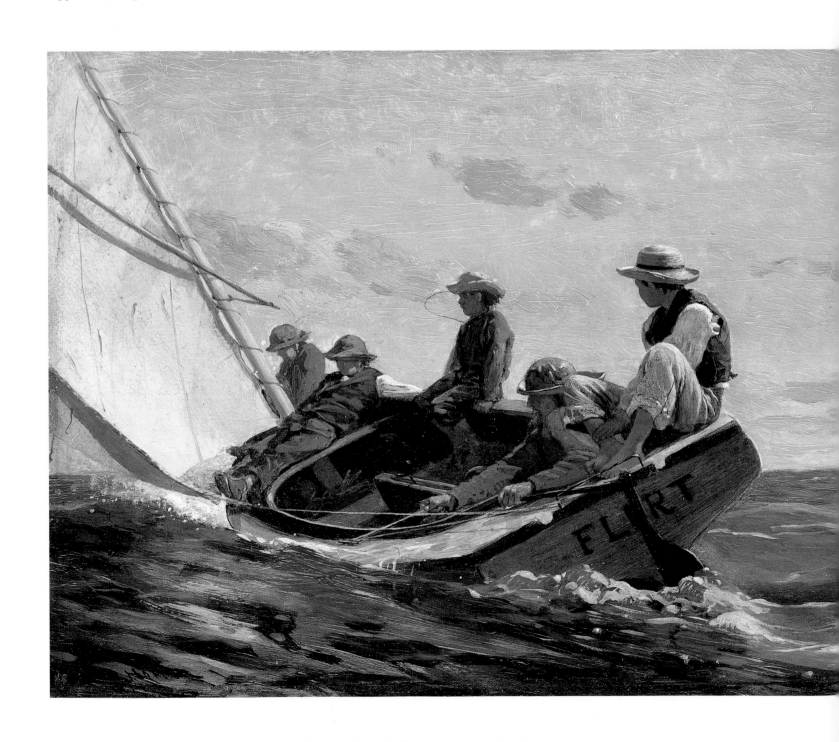

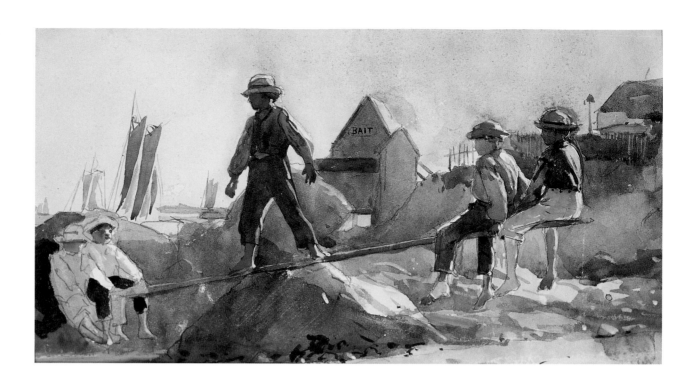

The See Saw, 1873
Watercolor, 7 x 13 inches
Courtesy of the Canajoharie
Library and Art Gallery

Boys and Kitten, 1873
Watercolor and gouache over graphite on medium,
Textured cream wove paper, 9 5/8 x 13 5/8 inches
Worcester Art Museum, Worcester, Massachusetts

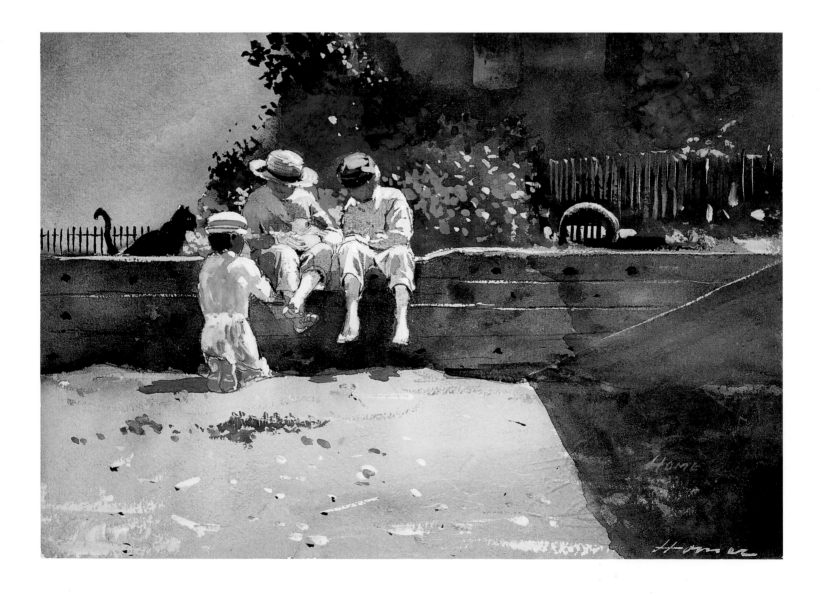

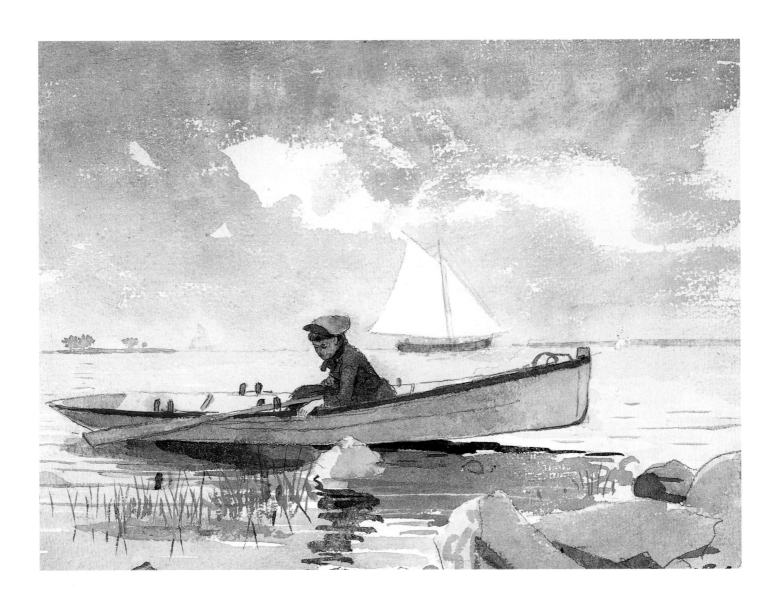

A Girl in a Punt, c. 1880
Watercolor on paper, 8 5/8 x 11 7/16 inches
Farnsworth Art Museum
Museum purchase, 1945
Photography by Melville D. McLean

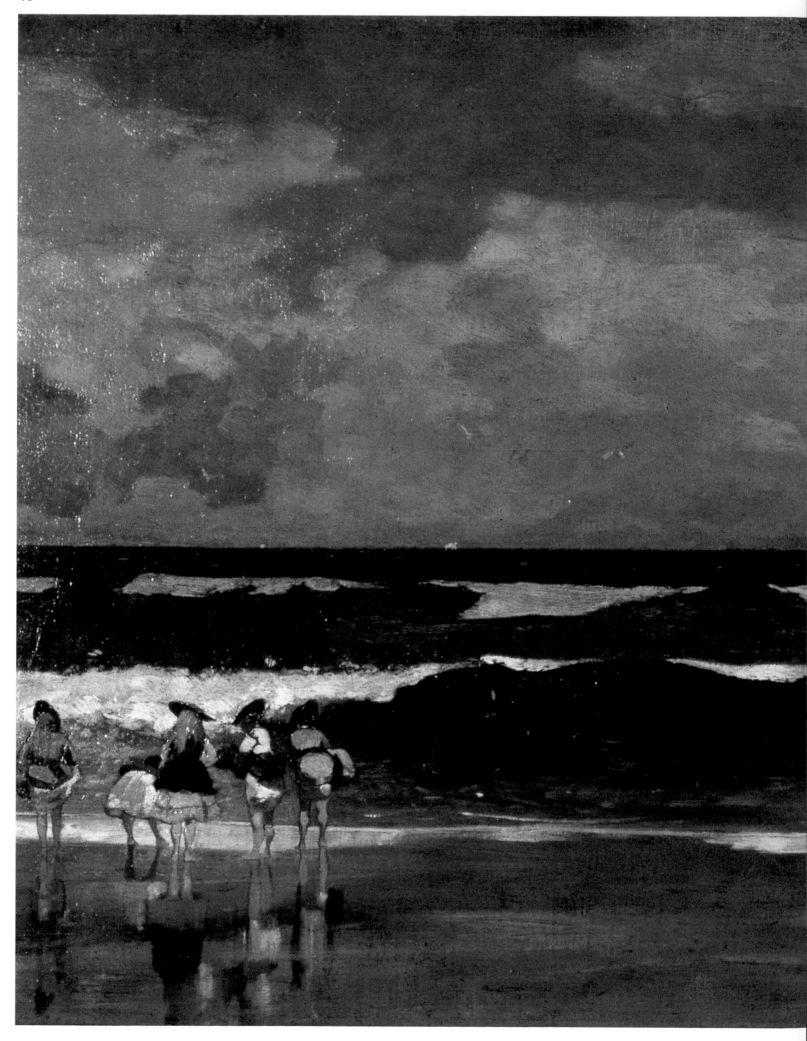

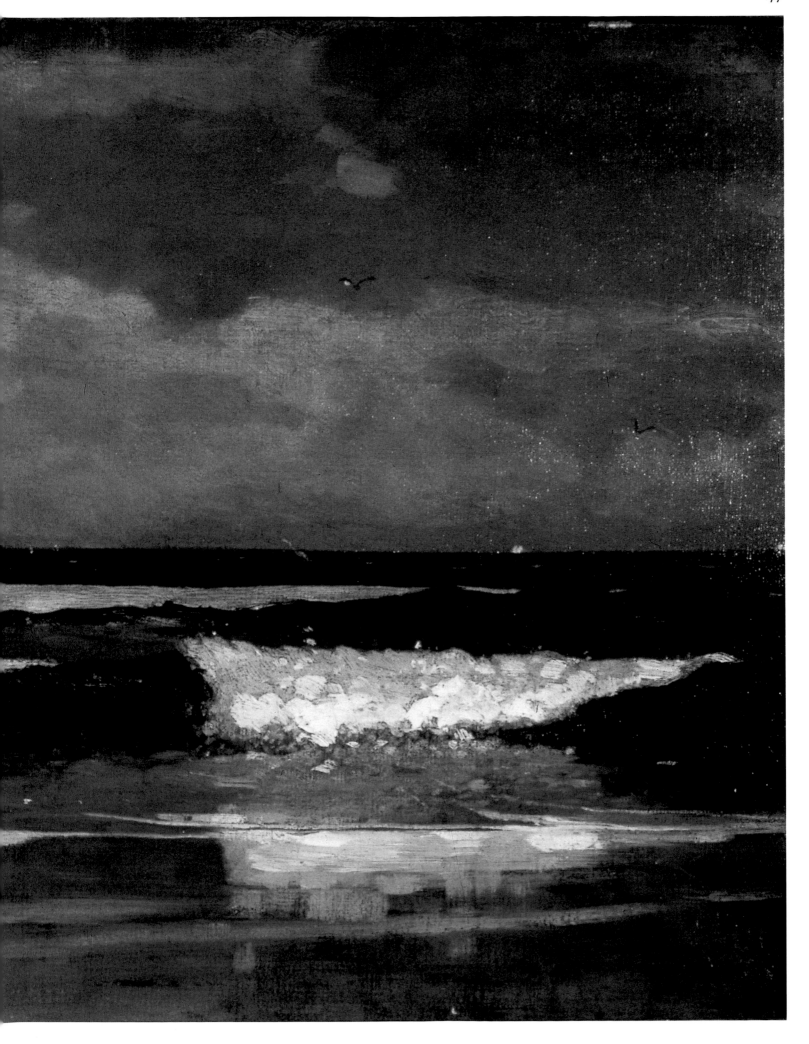

The Adirondacks

[Homer] saw nature less like a poet than a woodsman. He did not try to
express his own emotions about her, but to create a living image of her.
—LLOYD GOODRICH

Goodrich's characterization of the artist's approach to nature has special bear-
ing on the work Homer produced in the Adirondacks. Among the mountains and
lakes of this picturesque region of New York State, he quite literally became a
woodsman, accompanying loggers and fishing and hunting guides into the
wilderness.

The oils and watercolors based upon these experiences serve as a record
of a bygone era—motors have replaced paddles; Army camouflage outfits, the
simple garb of the old-time woodsman. Homer often portrayed actual figures
from the area, such as Orson Phelps, a famous Adirondack guide. He was
equally painstaking in attention to detail, as in the shape of oars or the bend of
a fly rod.

In *The Life and Work of Winslow Homer,* 1979, Gordon Hendricks wrote,
"There is so much beauty in reflections that it is generally well worth while to
try to get them right." Part of Homer's genius lies in his ability to render the
reflective surfaces of water. A lake takes on the gray of overcast skies or provides
the reverse image of a deer's head as it swims through a brilliant display of
fall colors.

In these pictures, man and nature have a special kinship. While it is true
that Homer depicted the activities of logging operations on the Hudson, and
thereby recorded the gradual destruction of woodland habitat, most of his images
represent the close connections of individuals and their natural surroundings.
A guide appears to caress the bark of a huge tree in *Old Friends,* 1894, while a
trapper taking a break from a portage appears to be absorbed by the forest, only
his white sleeve setting him apart from the thick woods.

The Adirondacks pictures provide ample testimony to the truth of Homer's
oft-cited credo, namely that the artist must work outside in order to truly capture
the scene. In an article published in the *Art Journal* in 1880, Homer made his
famous statement:

> I prefer every time a picture composed and painted out-doors. The
> thing is done without your knowing it....Out-doors you have the sky
> overhead giving one light; then the reflected light from whatever
> reflects; then the direct light of the sun: so that, in the blending and
> suffusing of these several illuminations, there is no such thing as a
> line to be seen anywhere.

"The blending and suffusing of these several illuminations"—that was the
effect Homer sought and achieved in so many of his pictures. In a manner of
speaking, this was also the goal of his subjects, be they hikers seeking the tonic
of mountain heights, a young boy focused upon the line of his fishing rod, or the
boatman, paddle in hand, looking out over a serene Adirondack lake.

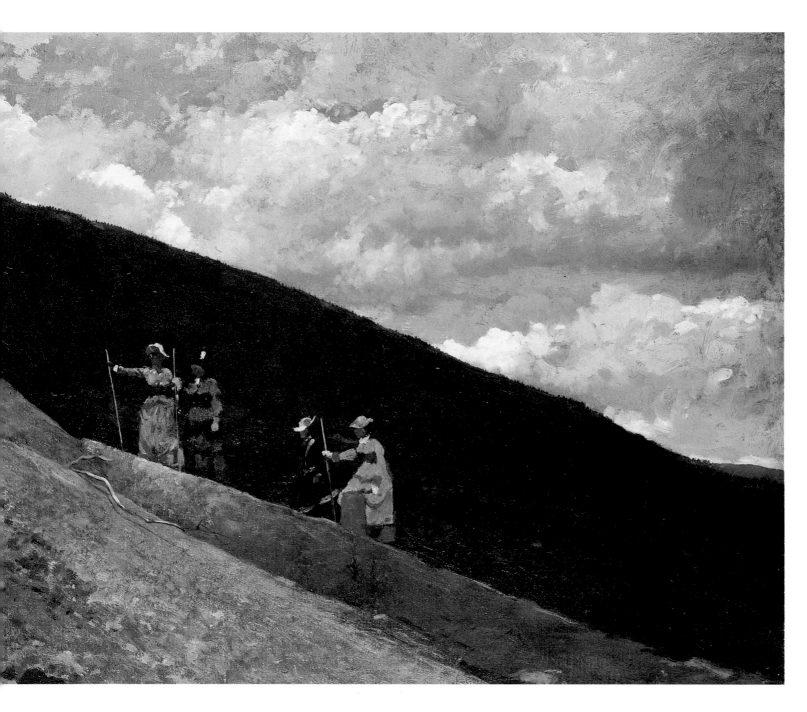

In the Mountains, 1877
Oil on canvas, 24 x 38 inches
The Brooklyn Museum of Art
Dick S. Ramsay Fund; 32.1648

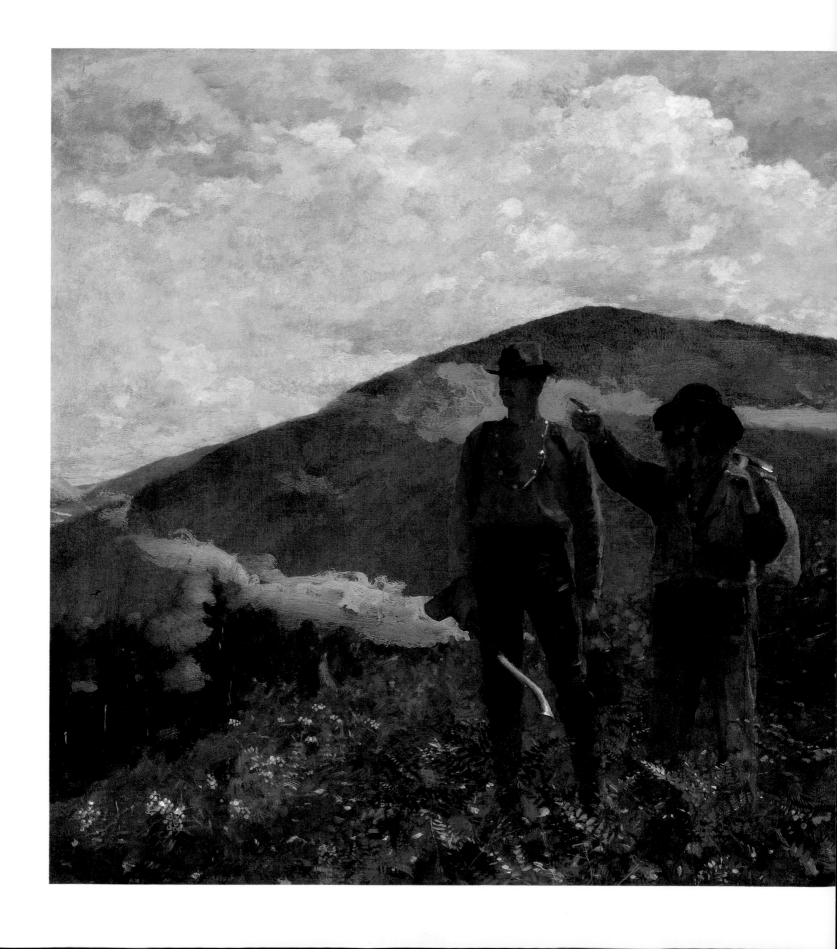

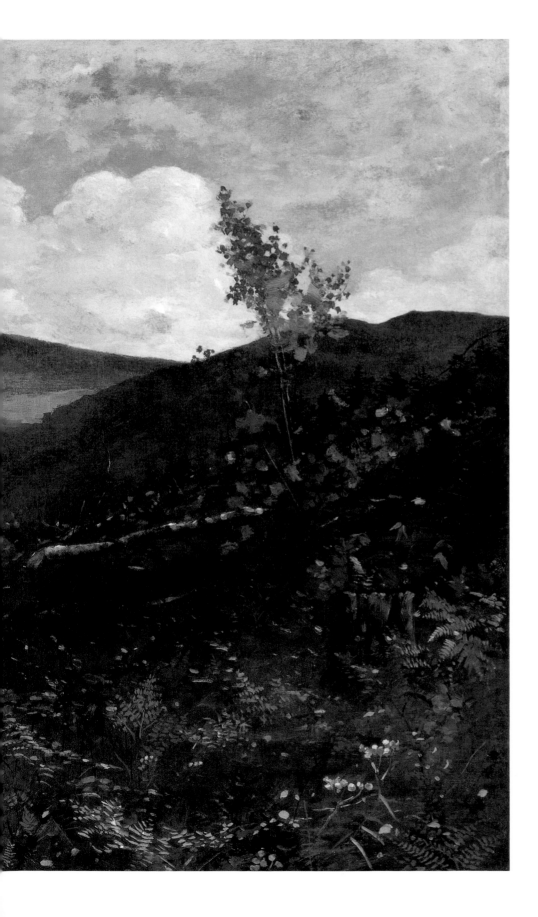

Two Guides, c. 1875
Oil on canvas, 24 1/4 x 38 1/4 inches
Sterling and Francine Clark Art Institute,
Williamstown, Massachusetts

52

Hudson River, 1892
Watercolor over pencil on paper, 14 x 20 inches
Courtesy Museum of Fine Arts, Boston
Bequest of William Sturgis Bigelow

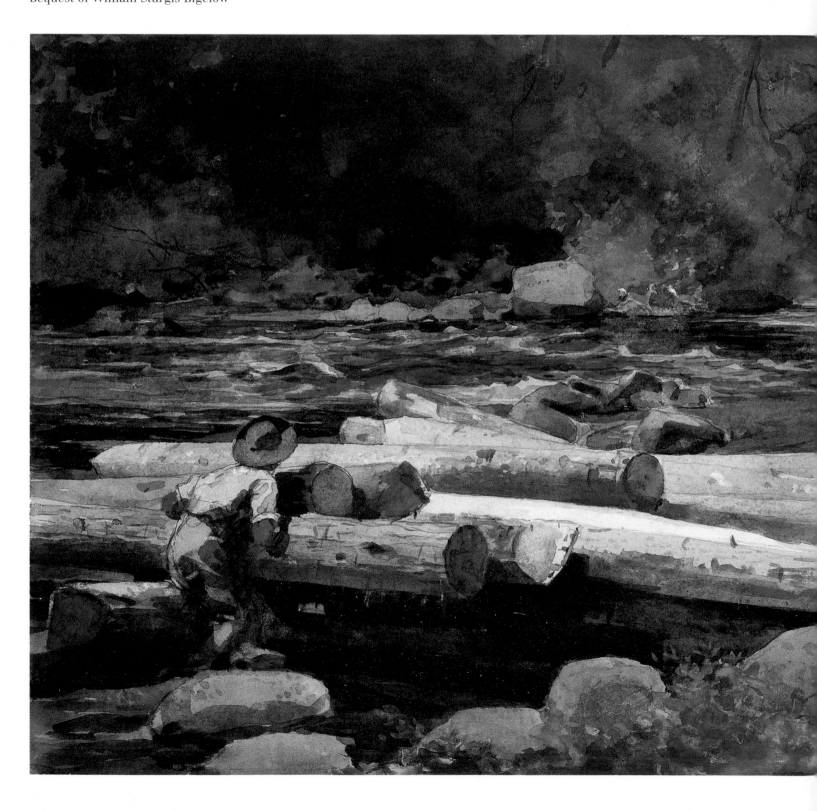

Old Friends, 1894
Watercolor over graphite on off-white wove paper,
21 3/8 x 15 1/8 inches
Worcester Art Museum, Worcester, Massachusetts

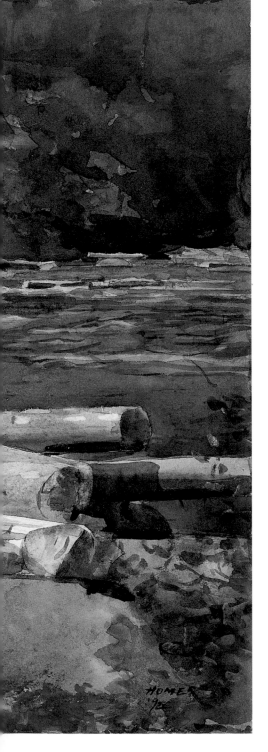

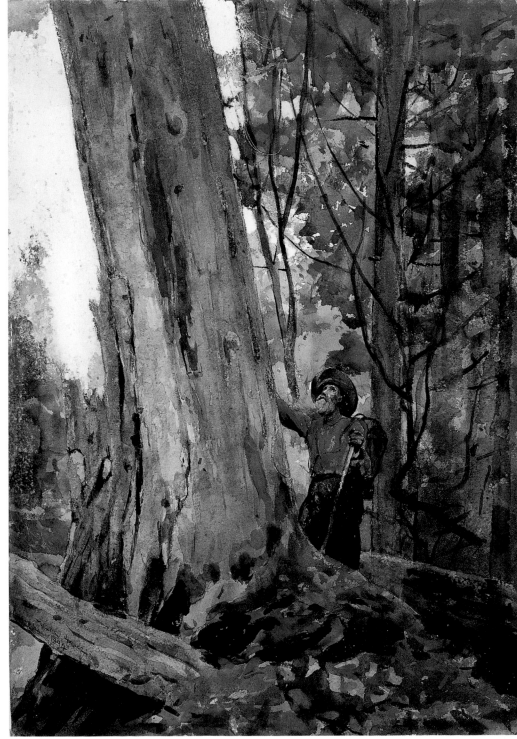

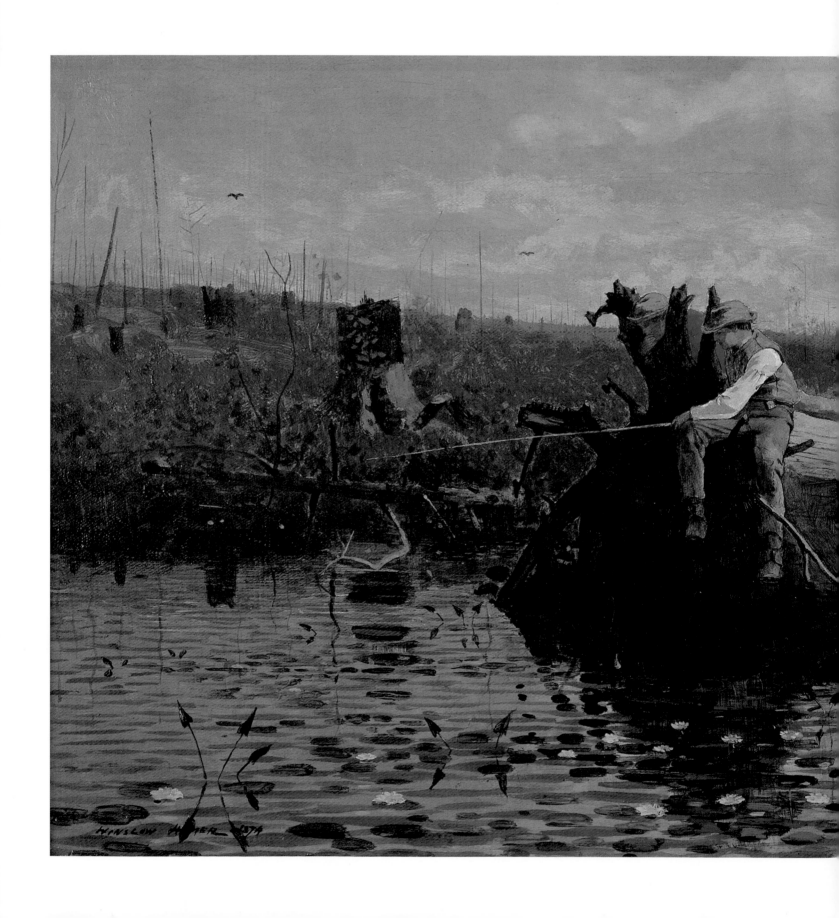

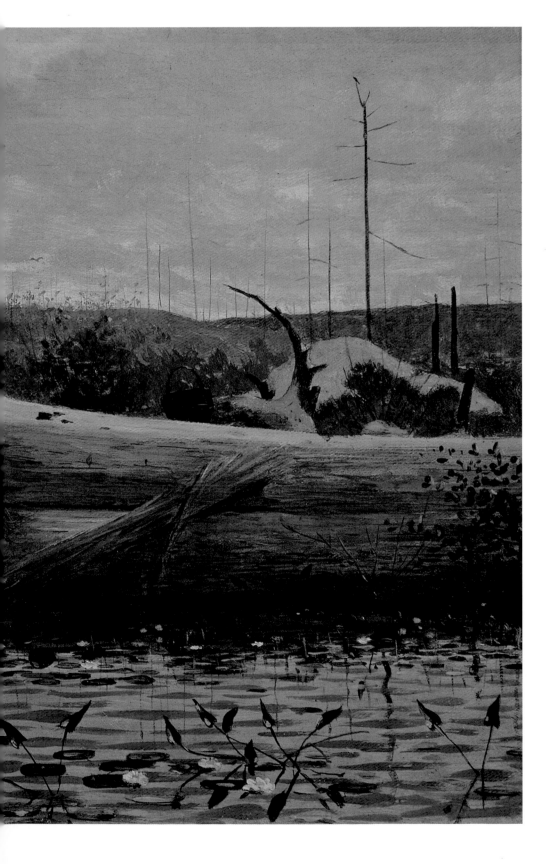

Waiting for a Bite, 1874
Oil on canvas, 12 x 20 inches
Courtesy of The Cummer Museum
Of Art & Gardens
Bequest of Ninah M.H. Cummer; C.119.1

(overleaf)

An Adirondack Lake, 1870
Oil on canvas, 24 1/2 x 38 1/4 inches
Henry Art Gallery,
University of Washington
Horace C. Henry Collection; 26.71

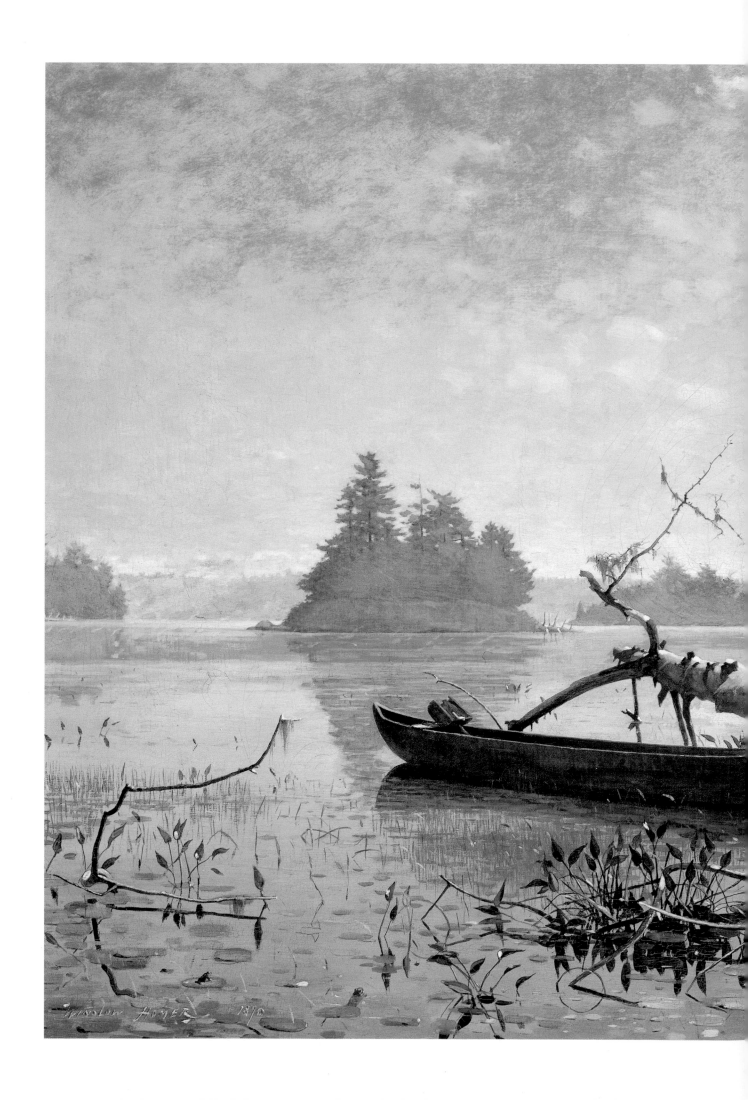

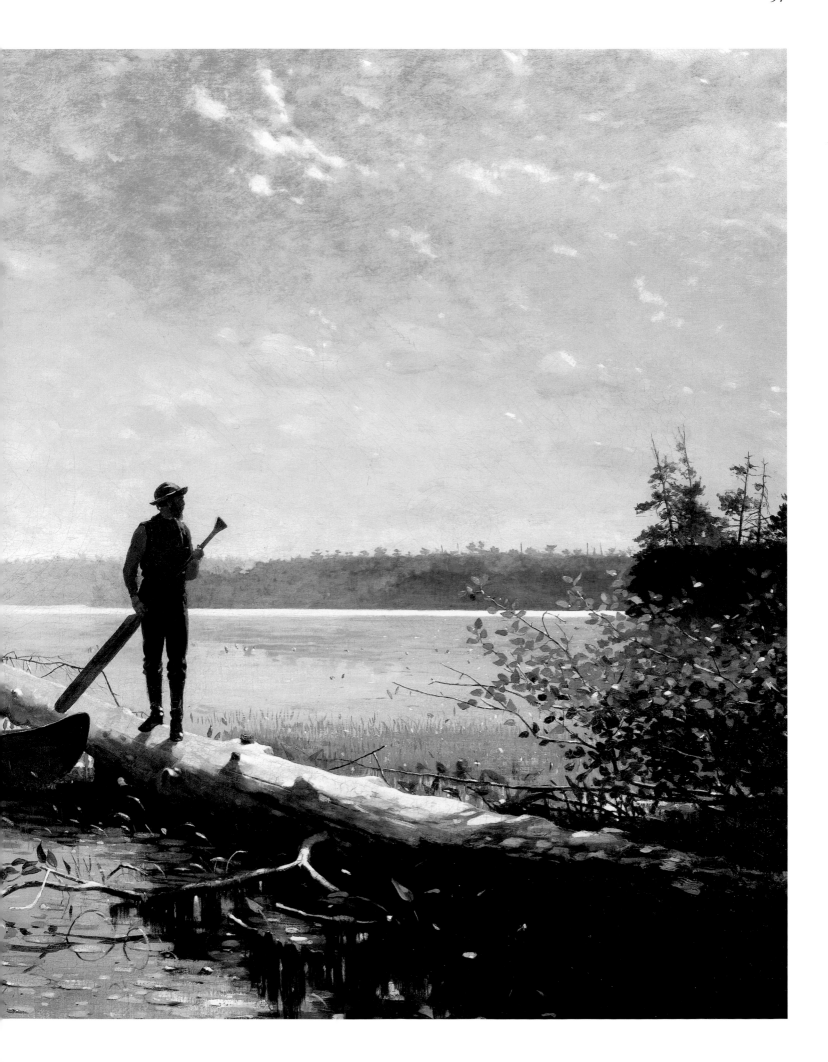

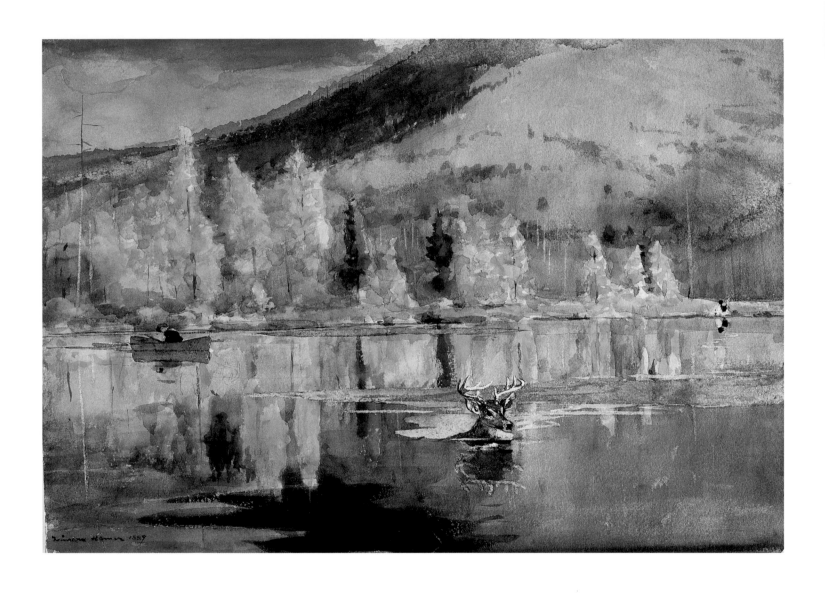

October Day, 1887
Watercolor on paper, 13 7/8 x 19 3/4 inches
Sterling and Francine Clark Art Institute,
Williamstown, Massachusetts

End of the Hunt, 1892
Watercolor and graphite, 15 1/8 x 21 3/8 inches
Bowdoin College Museum of Art, Brunswick, Maine
Gift of the Misses Harriet and Mary Sophia Walker; 1894.11

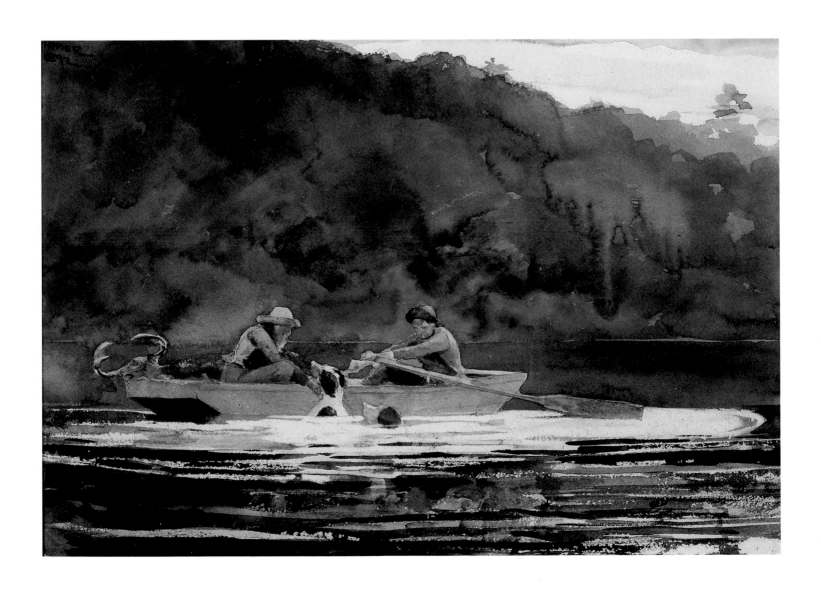

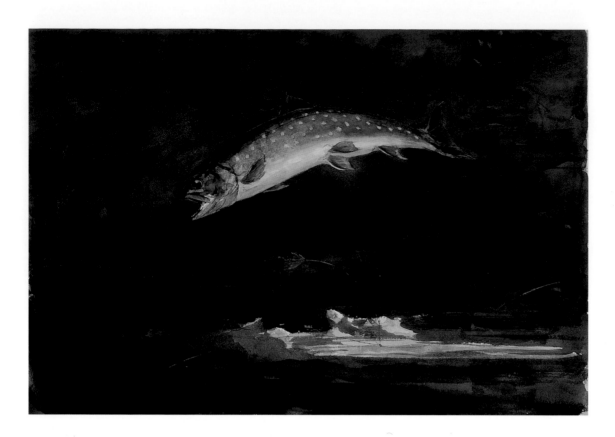

Jumping Trout, 1889
Watercolor, 13 15/16 x 20 inches
The Brooklyn Museum of Art
In memory of Dick S. Ramsay
41.220

An Unexpected Catch, 1890
Watercolor on paper, 11 1/2 x 19 3/4 inches
Portland Museum of Art, Maine
Bequest of Charles Shipman Payson; 1988.55.9
Photography by Benjamin Magro

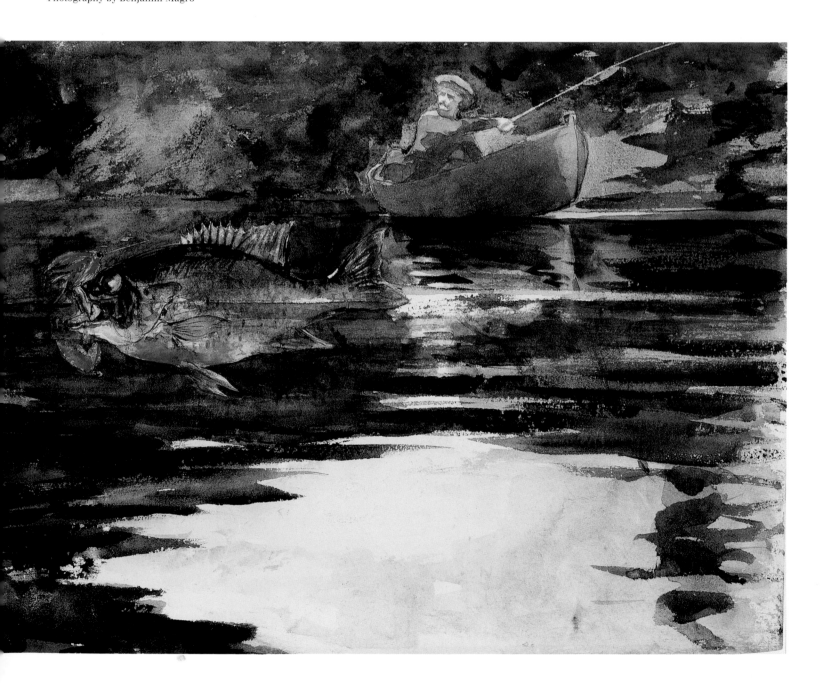

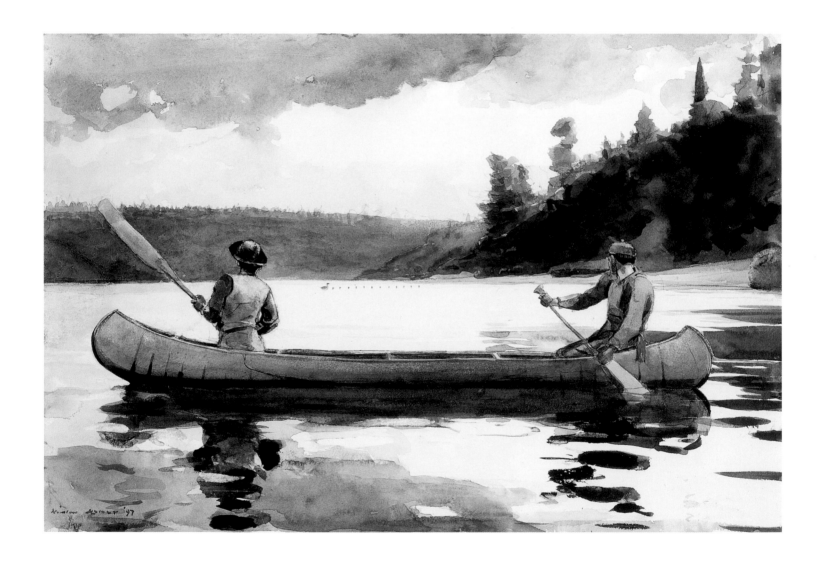

Young Ducks, 1897
Watercolor on wove paper, 14 x 21 inches
Portland Museum of Art, Maine
Bequest of Charles Shipman Payson; 1988.55.13

The Boatman, 1891
Watercolor over pencil, 13 15/16 x 20 inches
The Brooklyn Museum of Art
Bequest of Mrs. Charles S. Homer; 38.68

(Overleaf)

Two Men in a Canoe, 1895
Watercolor, 13 15/16 x 20 1/16 inches
Portland Museum of Art, Maine
Bequest of Charles Shipman Payson; 1988.15.12
Photography by Melville McLean

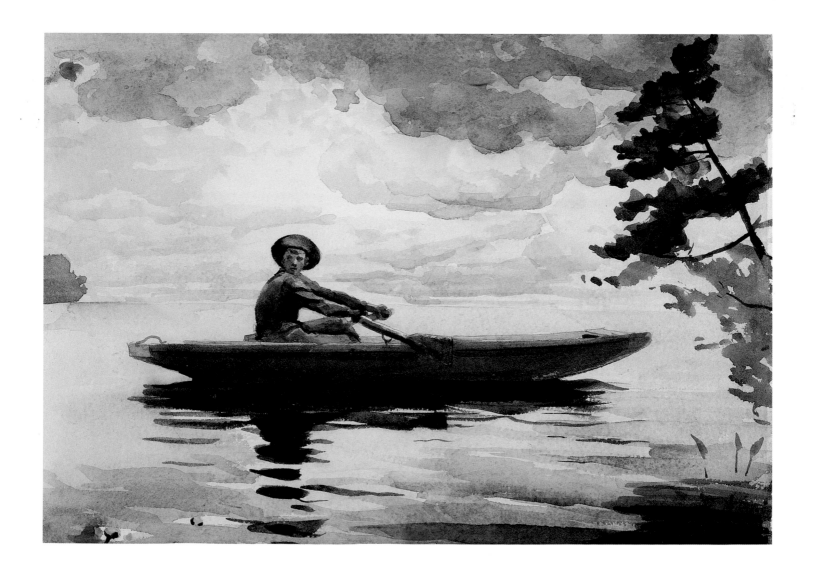

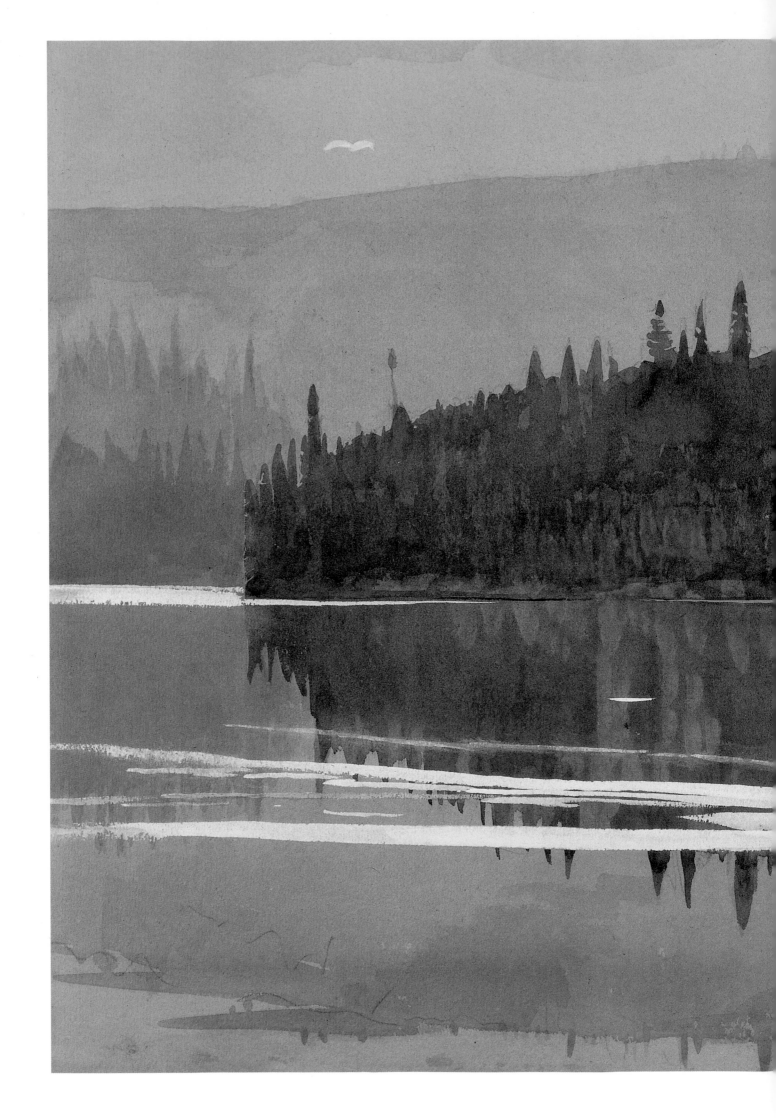

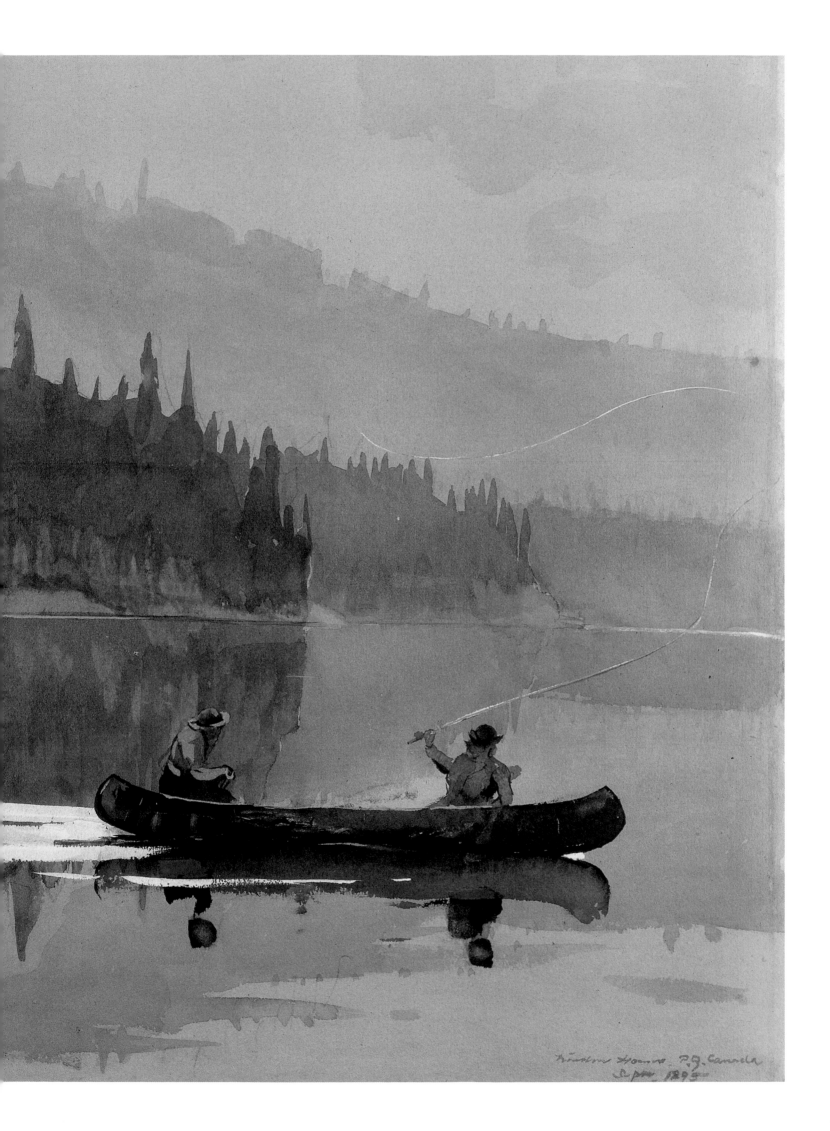

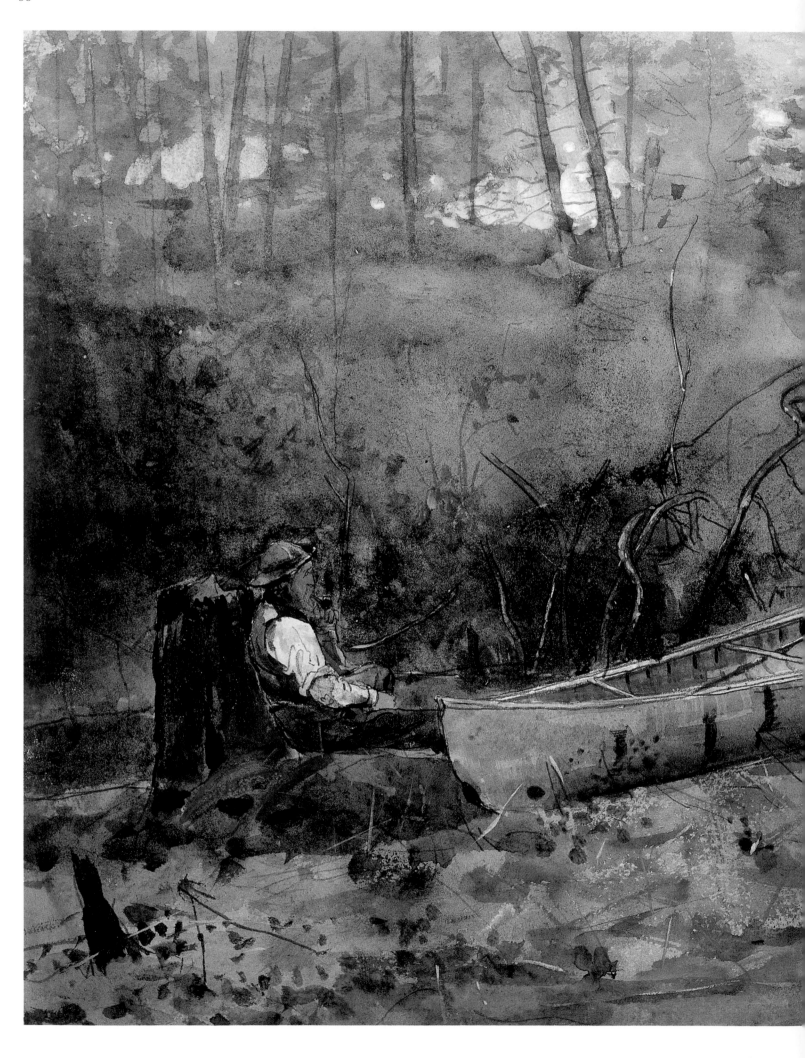

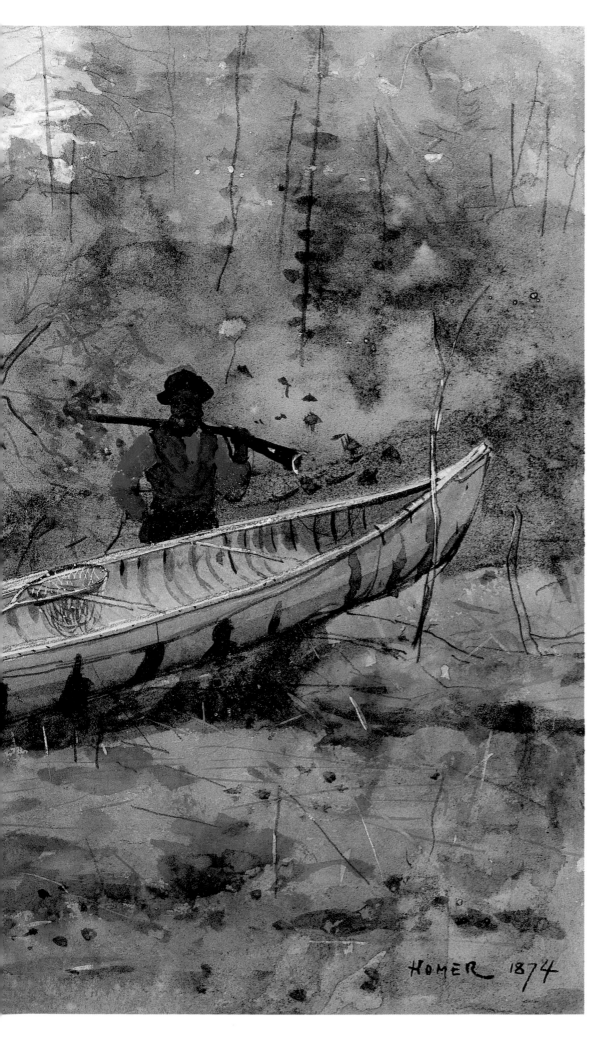

HOMER 1874

Trappers Resting, 1874
Watercolor on paper,
9 5/8 x 13 3/4 inches
Portland Museum of Art, Maine
Bequest of Charles Shipman
Payson; 1988.

Houghton Farm and Rural New York State

In the 1870s Homer made several trips to the Catskills in upstate New York. The focus of much of the work were women and children, involved in country activities: picking berries or pumpkins, tending sheep, teaching school.

A number of paintings from this period, such as *Snap the Whip,* 1872 have become emblems of American rural life in all its unabashed innocence. The barefoot boys linked hand to hand play in the sun, on recess from the simple one-room schoolhouse that stands in the background.

In the later 1870s, Homer stayed at Houghton Farm in Mountainville, New York. This experimental farm was owned by Lawson Valentine, a patron of the artist. There, the painter discovered an idyllic country setting, where shepherd-esses tended their flocks of sheep, lazing in pools of shade or standing in the full sun.

In Homer's day, the newspapers reported on a regular basis the where-abouts of artists; they were celebrities, as it were, and the public followed their activities with great interest. Thus, in the "Art Notes" from the November 11, 1878, edition of the *New York Evening Post,* it was noted that "Mr. Winslow Homer has returned from the country with a large collection of sketches and studies in water-colors."

Historians have tied these shepherdess pictures to the work of the great Barbizon painter Jean François Millet, yet the mood and demeanor of Homer's girls seem utterly different from the somewhat morose figures of his French counterpart. A journalist of the day, reviewing Homer's work, made this point in a very patriotic manner: "Here are the American shepherdesses which only Mr. Homer paints—self-possessed, serious, independent; not French peasants who till the soil, but free-born American women on free-soil farms."

Although Homer worked in a studio, he recognized that indoor light was not the best for his purposes. "This making studies and then taking them home is only half right." he said. "You get composition, but you lose freshness; you miss the subtle and, to the artist, the finer characteristics of the scene itself."

A watercolor like *Fresh Air,* 1878, embodies this belief. Through Homer's great artistic graces, the viewer experiences the light, the breeze, the very warmth and pleasure of this girl on a hillside, looking out over the countryside as her flock grazes around her.

Also in a rural mode was a series of paintings of blacks during recon-struction. Where the Houghton Farm "bo-peeps" and their young friends and suitors have a carefree quality about them, the two women in *The Cotton Pickers,* 1876, appear pensive and ill at ease, as if their slavery had not ended with the Emancipation Proclamation.

Wherever Homer went, north or south, he cast a sympathetic eye upon the people. "Always," wrote Philip Beam, "Homer found people worthy of studying wherever he went." His brushes brought them alive.

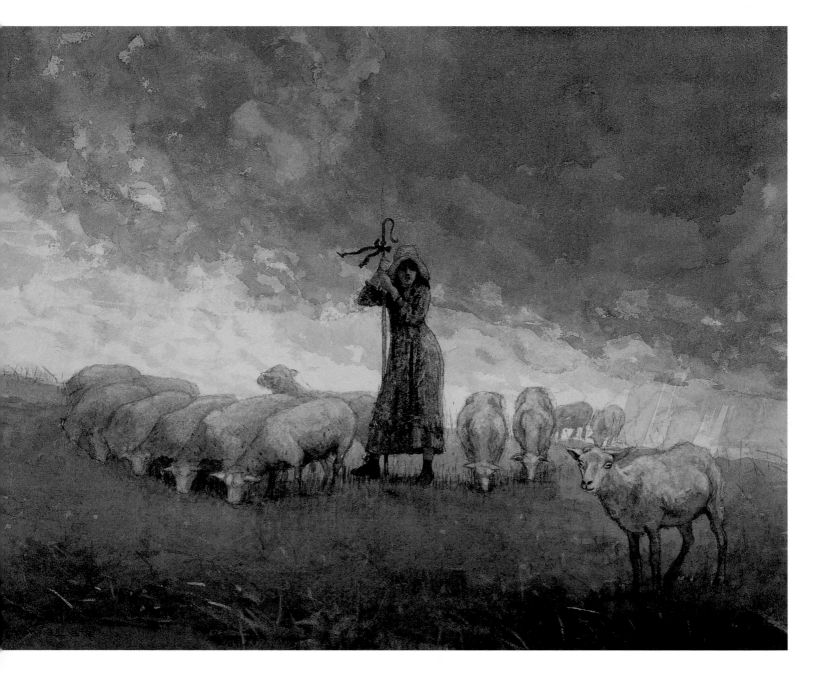

Shepherdess Tending Sheep, 1878
Watercolor, 11 9/16 x 19 3/4 inches
The Brooklyn Museum of Art
Dick S. Ramsay Fund; 41.1088

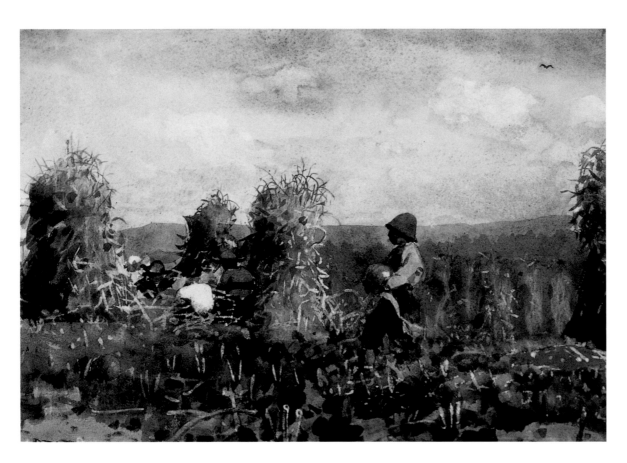

The Pumpkin Patch, 1878
Watercolor, 14 x 20 inches
Courtesy of the Canajoharie
Library and Art Gallery

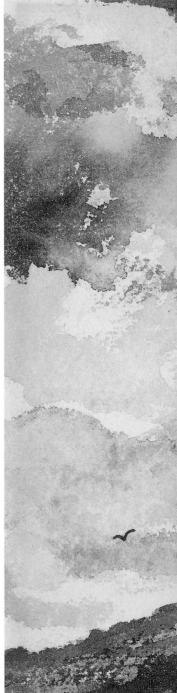

Boy and Horse Ploughing, 1880
Watercolor, 9 3/8 x 13 7/16 inches
Museum of Art,
Rhode Island School of Design
Photography by Del Bogart

(overleaf left)

Fresh Air, 1878
Watercolor over charcoal,
20 1/16 x 14 1/16 inches
The Brooklyn Museum of Art
Dick S. Ramsay Fund; 41.1087

(overleaf right)

The Reaper, 1878
Watercolor on paper,
19 1/2 x 13 3/4 inches
Private collection

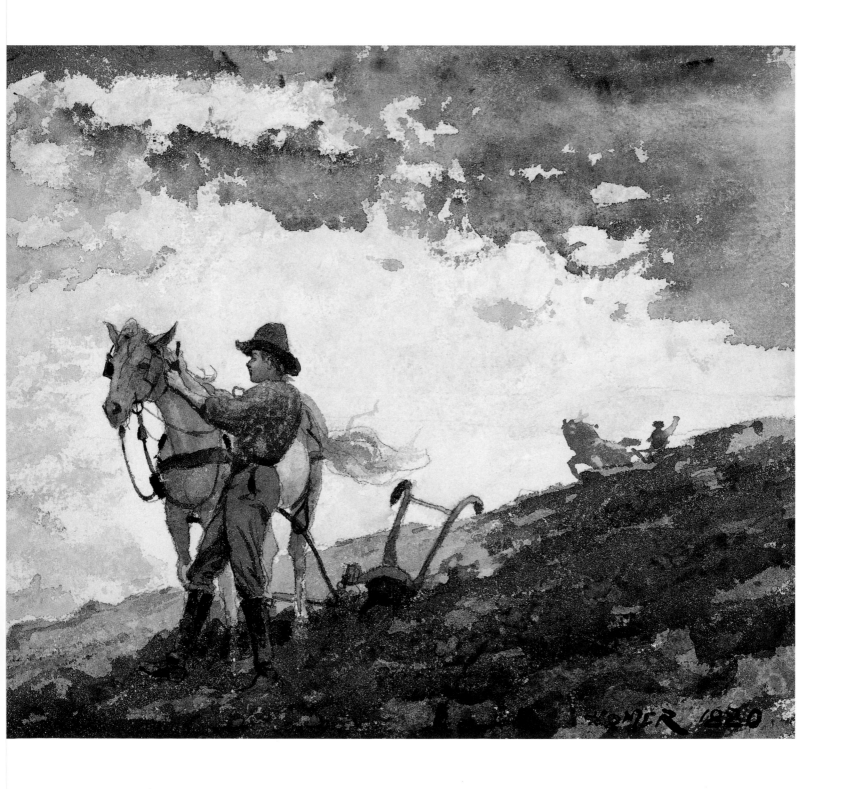

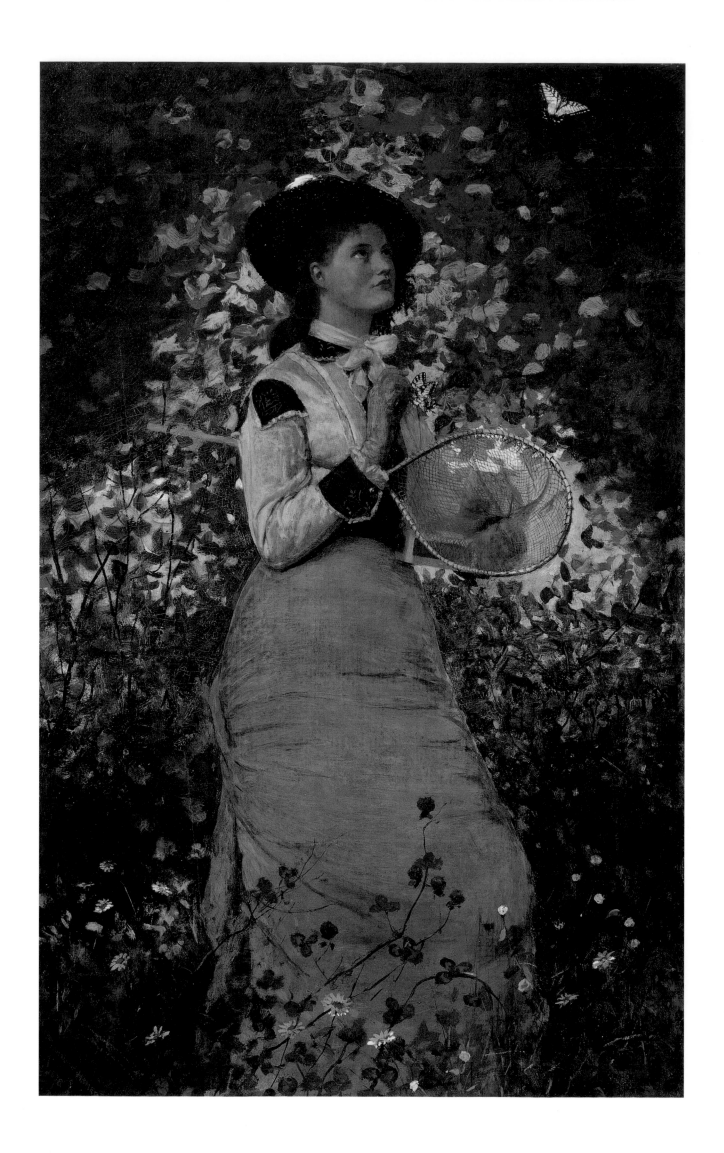

The Butterfly Girl, 1878
Oil on canvas, 37 1/2 x 23 1/2 inches
Collection of the New Britain Museum of
American Art, Connecticut
Friends of William F. Brooks
Photography by E. Irving Blomstrann

Girl and Daisies, 1878
Watercolor, 5 3/4 x 6 3/4 inches
Museum of Art, Rhode Island School of Design
Bequest of Isaac C. Bates
Photography by Del Bogart

(overleaf)

The Morning Bell, c. 1866
Oil on canvas, 24 x 38 1/4 inches
Yale University Art Gallery
Bequest of Stephen Carlton Clark; BA1903

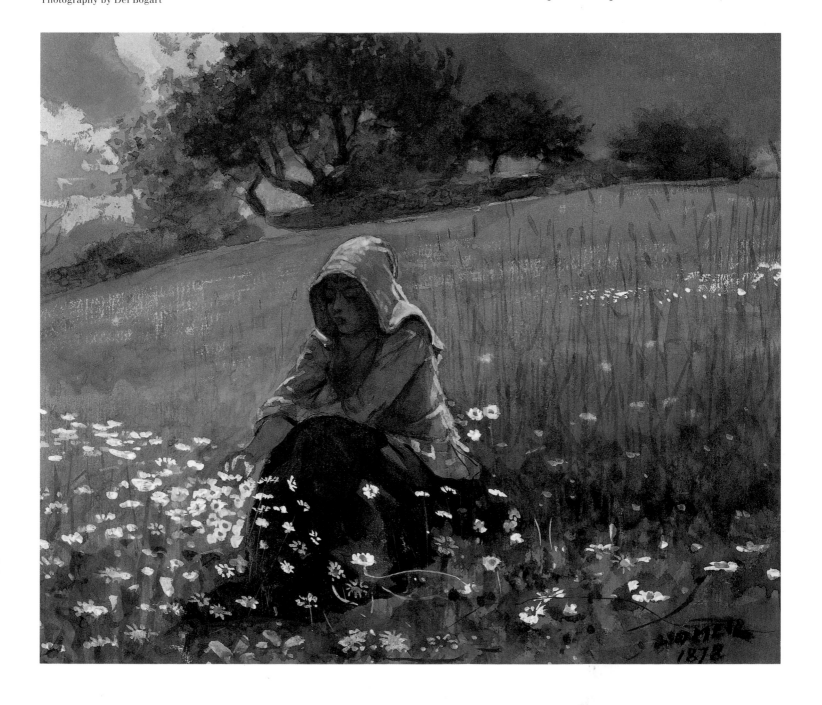

Milking Time, 1875
Oil on canvas, 24 x 38 1/4 inches
Delaware Art Museum
Gift of the Friends of Art and other donors

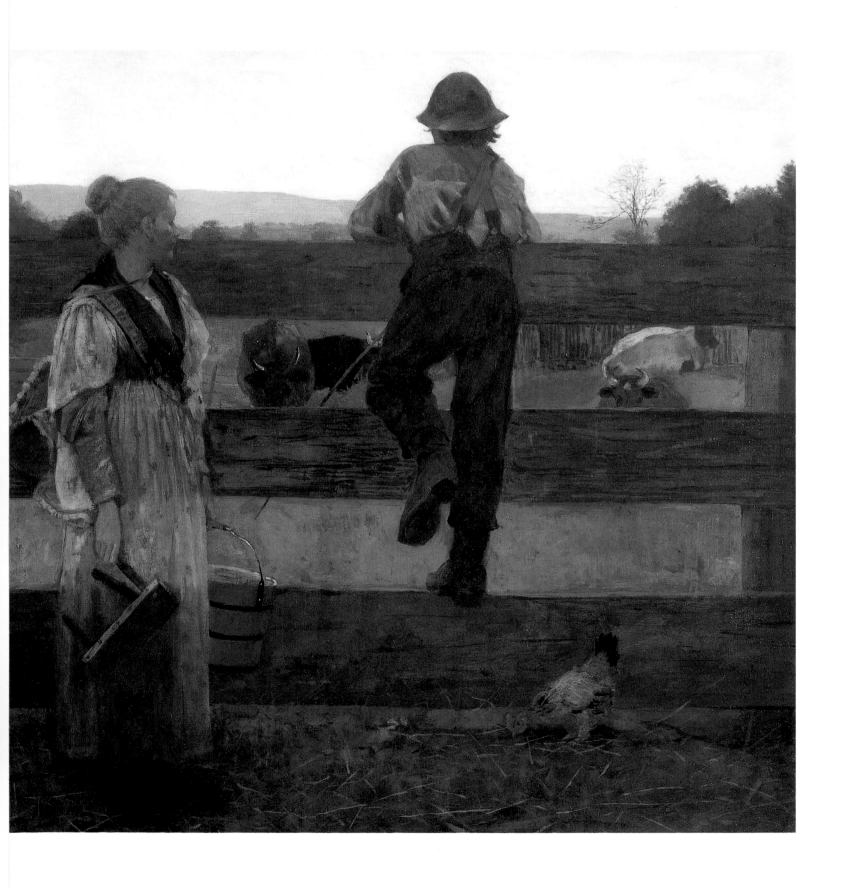

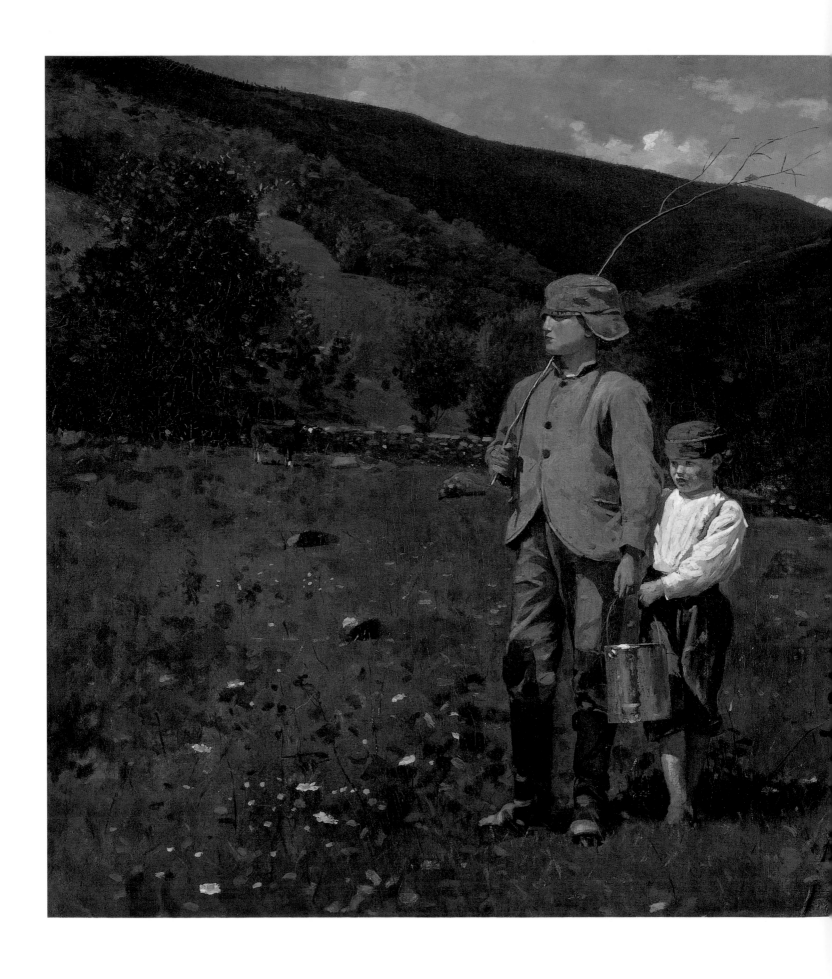

Crossing the Pasture, c. 1872
Oil on canvas, 26 1/4 x 38 1/8 inches
Amon Carter Museum, Fort Worth, Texas; 1976.37

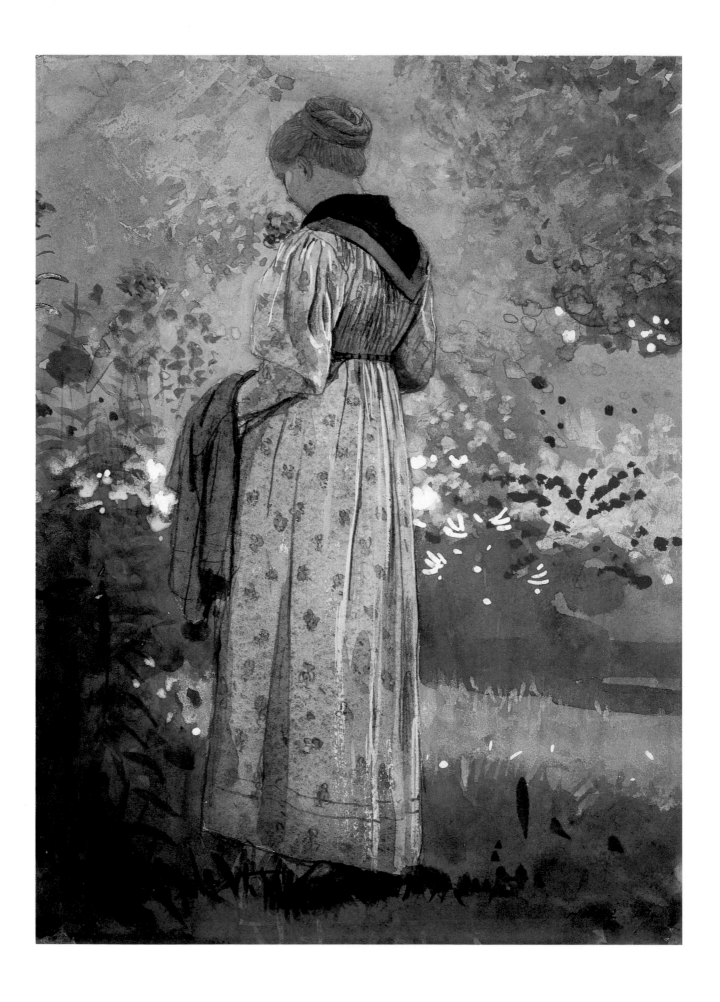

In the Garden, 1874
Watercolor on paper, 23 x 17 inches
Private collection

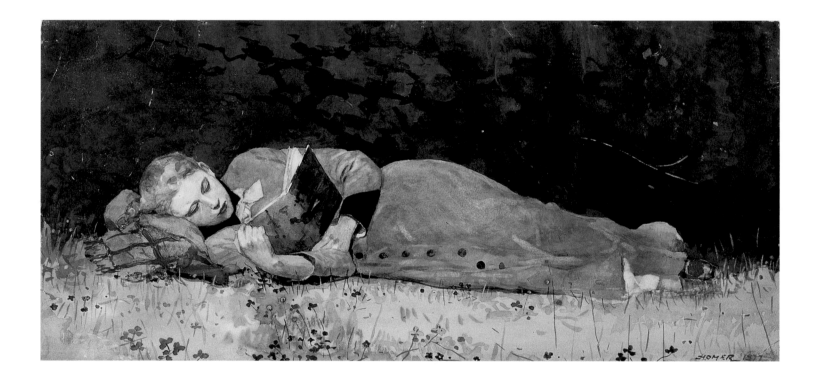

The New Novel, 1877
Watercolor and gouache on paper,
9 1/2 x 20 1/2 inches
Museum of Fine Arts, Springfield
Horace P. Wright Fund

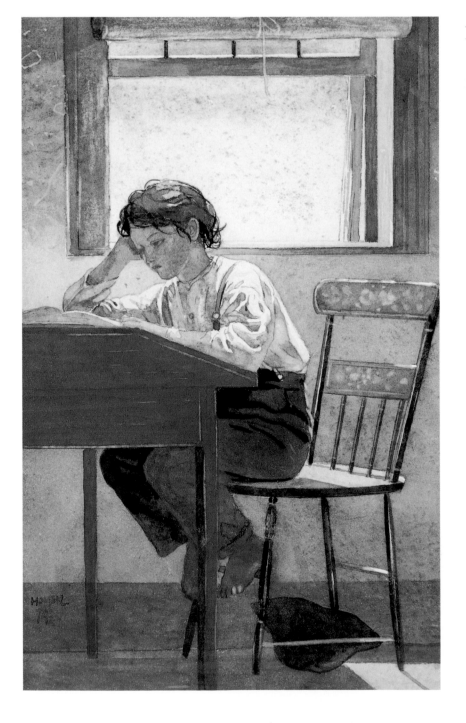

Homework, 1874
Watercolor, 8 x 5 inches
Courtesy of the Canajoharie
Library and Art Gallery

Blackboard, 1877
Watercolor on wove paper, 19 3/4 x 12 3/4 inches
National Gallery of Art, Washington, D.C.
Gift (partial and promised) of Jo Ann and Julian
Ganz, Jr., in honor of the 50th Anniversary of
The National Gallery of Art

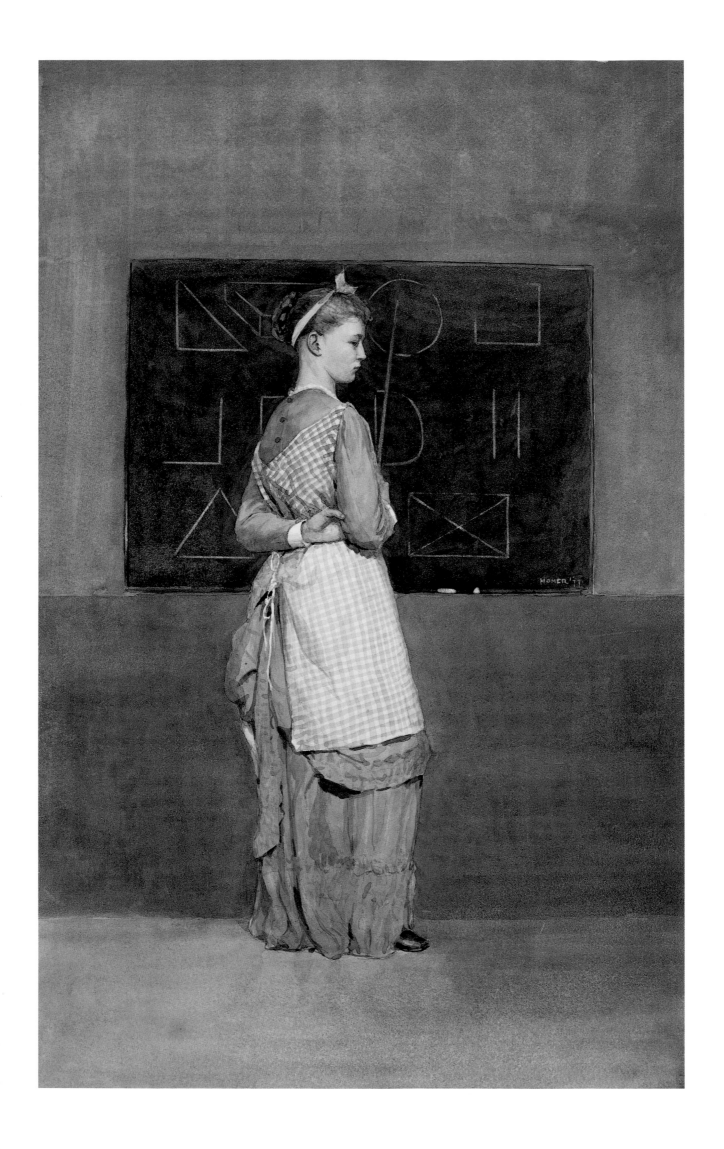

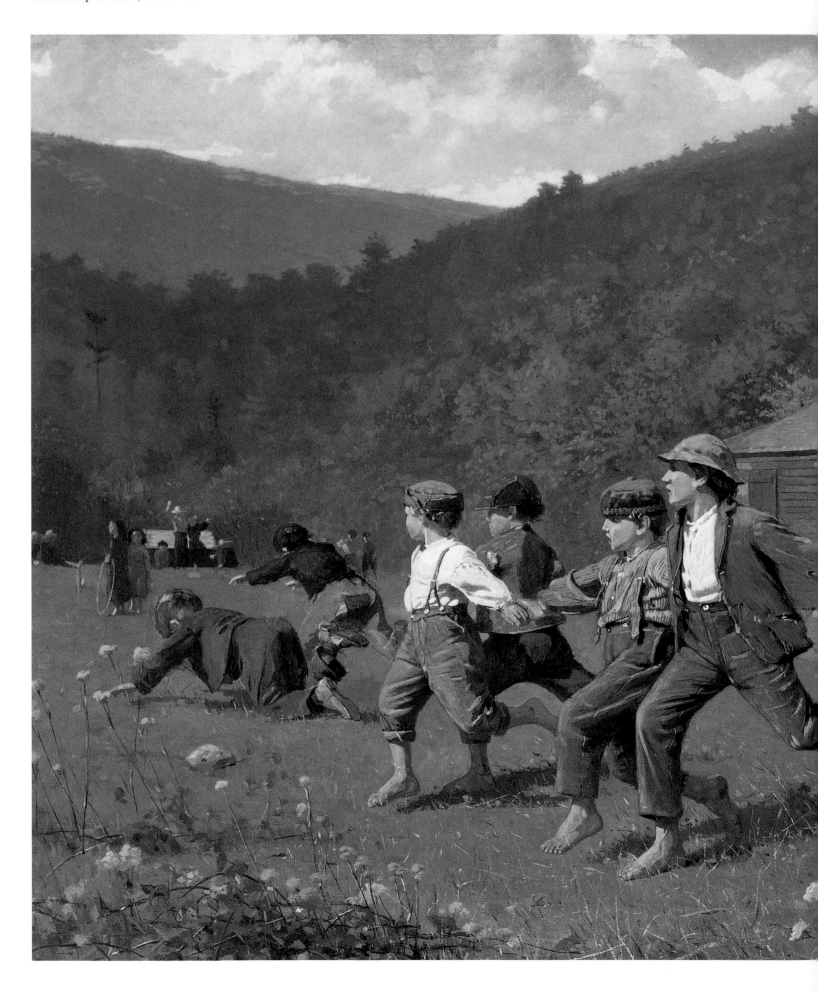

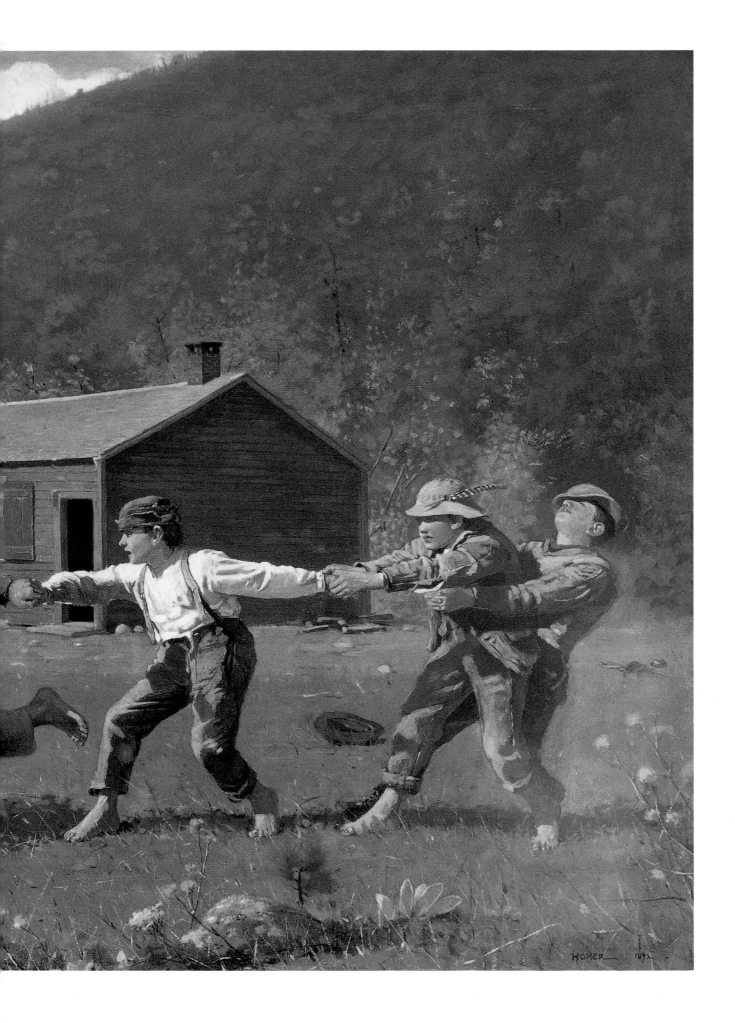

Contraband, 1875
Watercolor, 8 x 5 inches
Courtesy of the Canajoharie
Library and Art Gallery

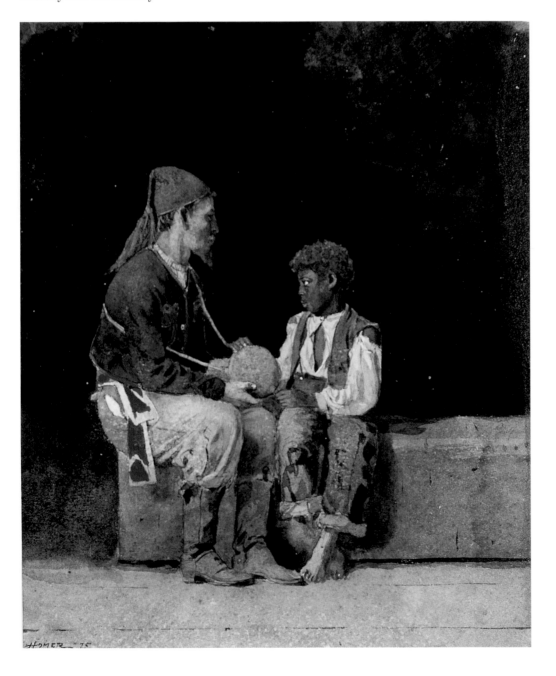

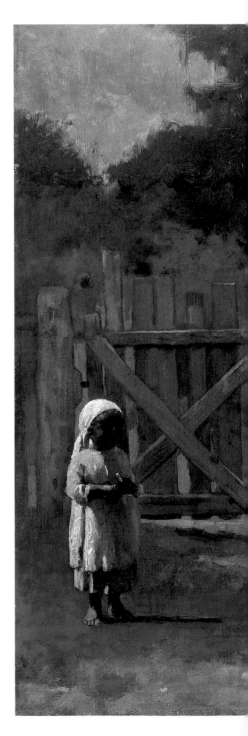

(overleaf)

The Cotton Pickers, 1876
Oil on canvas, 24 x 38 inches
Los Angeles County Museum of Art
Acquisition made possible through museum trustees: Robert O. Anderson, R. Stanton Avery, B. Gerald Cantor, Justin Dart, Charles E. Ducommun, Mrs. F. Daniel Frost, Julian Ganz, Jr., Dr. Armand Hammer, Harry Lenart, Dr. Franklin D. Murphy, Mrs. Joan Palevsky, Richard Sherwood, Maynard J. Toll, and Hal B. Wallis.

The Carnival (Dressing for the Carnival), 1877
Oil on canvas, 20 x 30 inches
The Metropolitan Museum of Art
Amelia B. Lazarus Fund; 1922

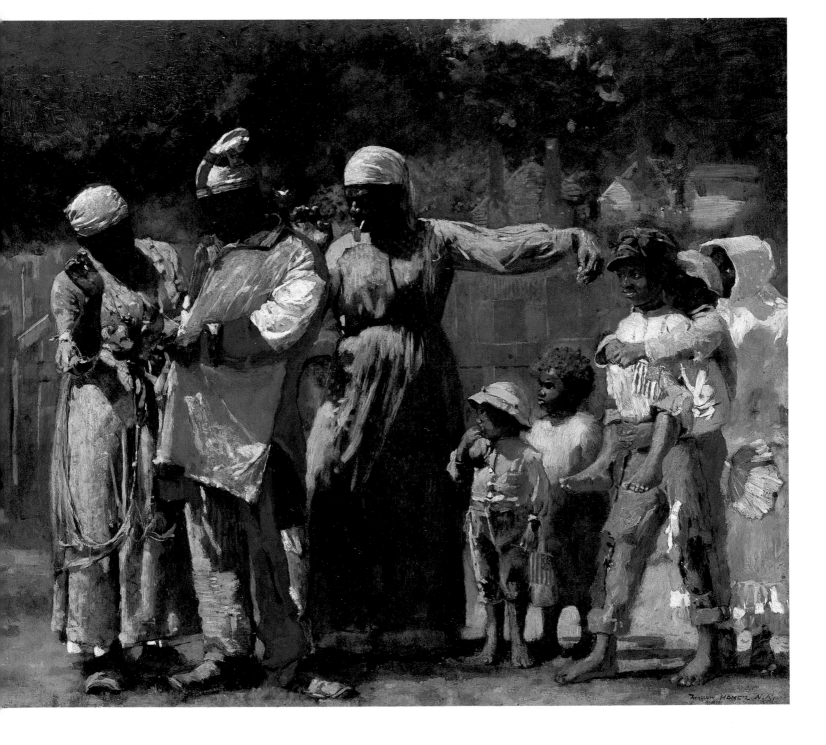

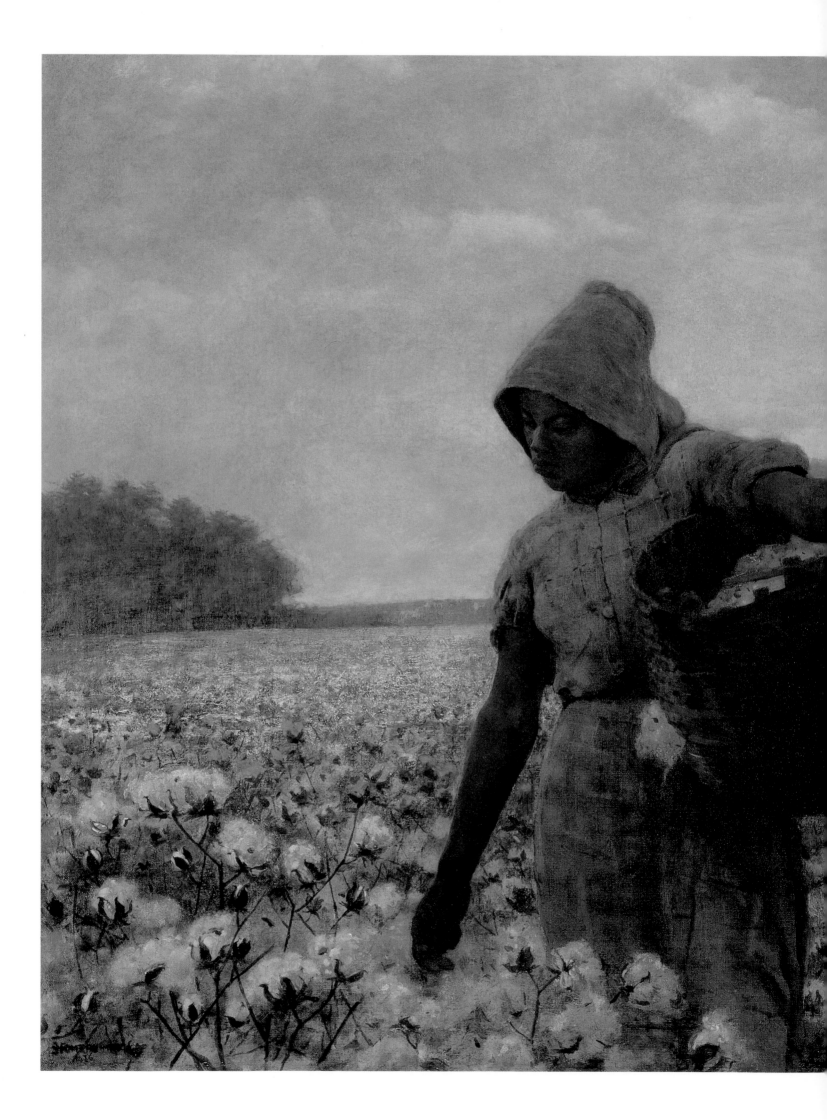

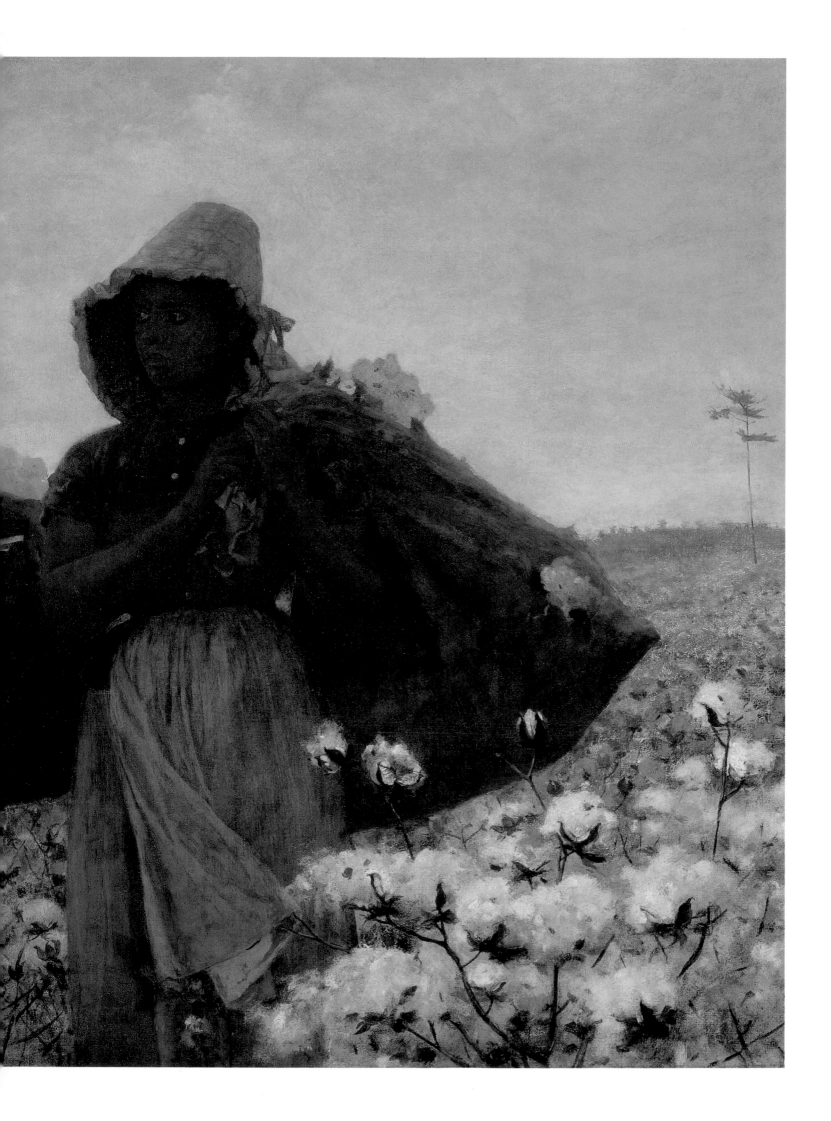

Canada

There is no man in the world capable of profitable thought who does not know that the real worth and genuineness of the human heart are measured by its readiness to submit to the influences of Nature, and to appreciate the goodness of the Supreme Power who has made and beautified Nature's abiding-place. —GROVER CLEVELAND, *Fishing and Shooting Sketches, 1906*

Homer first visited the Province of Quebec in 1893, staying in a camp in the region of Lake St. John and the Saguenay River. Accessible by train from New York City, these distant regions drew plenty of dedicated sportsmen and an occasional extraordinary artist.

Homer painted some of the landmarks of the region—the tumbledown settlement of Wolfe's Cove, for example, and the stern profile of Cape Trinity—but his greatest interest lay in the rush of river waters. Whereas the lakes and ponds of the Adirondacks provided a relatively placid setting for his art, in Canada the water seethed and roiled.

Fascinated, Homer captured the rapids and the turbulent comminglings of rivers in a series of expressive watercolors. Like the seasoned canoeists he painted, Homer mastered the currents and rapids. Writing about *Shooting the Rapids*, 1902, art historian Donelson Hoopes noted how Homer "conveys with the utmost economy of means a sense of movement and energy in the water: no line or color is included that does not contribute to the impression of the profound truth of his observation."

And there was also great fishing, and once again Homer turned his attention to fish leaping through the air and the arc of a fly-fisherman's line over the water. In *A Good Pool, Saguenay River*, 1895, he depicts a ouananiche, or land-locked salmon, in midair, a fly caught in its lip. We witness the scene seemingly from water level, a vantage point that heightens the drama of the moment. Homer's library included a book about the ouananiche, but one suspects he trusted more in his own observations when depicting this dashing sport fish.

The critical reception for these watercolors often consisted of simple wonderment at the artist's matchless skill at rendering the Canadian wilds. "The thorough healthfullness, the virile directness of Mr. Homer's great swashes of transparent colour," wrote one observer, "is well-nigh unique in the annals of aquarelle art."

More than a hundred years later, novelist Joyce Carol Oates drew the same conclusion. "Homer's genius was to paint the exceptional as if it were somehow ordinary," she wrote, "to so convincingly capture the fluidity of motion of the present moment...that other paintings, by other highly regarded artists, appear static by contrast."

Homer recognized his special kinship to this wild region; in one letter he wrote, "The place suits me as if made for me by a kind of providence." Once more, he found artistic inspiration—and salvation—far from civilization.

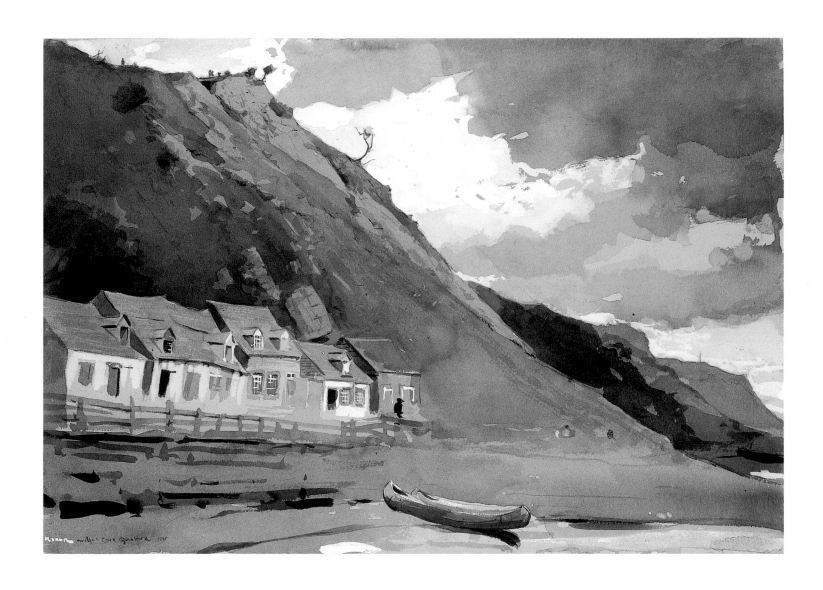

Wolfe's Cove, 1895

Watercolor with opaque white on gray paper, 13 3/4 x 20 1/8 inches

Bowdoin College Museum of Art, Brunswick, Maine

Purchase with Museum funds and with donations from
Neal W. Allen '07, John F. Dana 1898, John H. Halford '07,
William Lawrence 1898, and Benjamin R. Shute '31, 1955.2

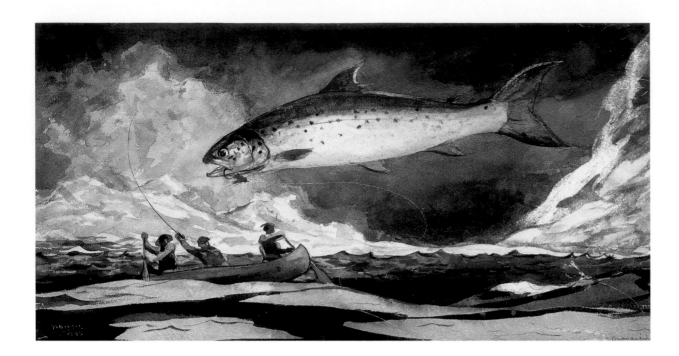

A Good Pool, Saguenay River, 1895
Watercolor over pencil on paper, 9 3/4 x 18 7/8 inches
Sterling and Francine Clark Art Institute,
Williamstown, Massachusetts

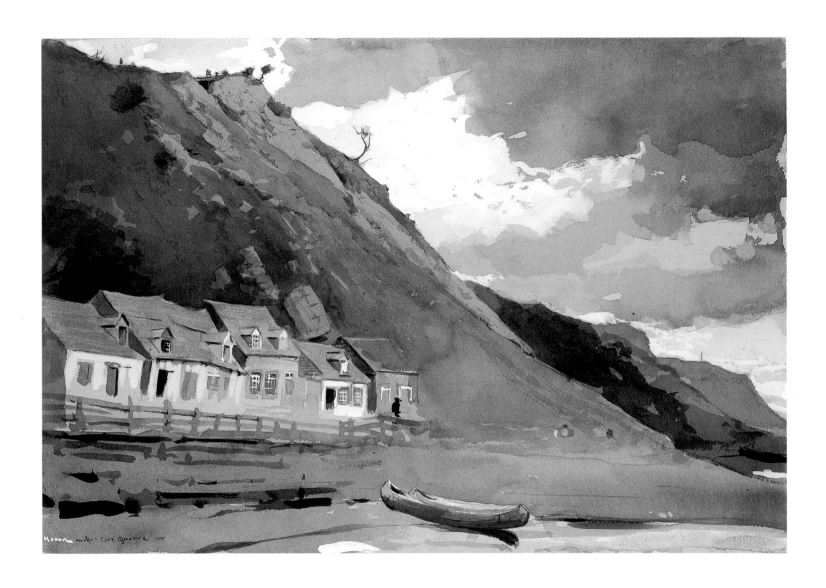

Wolfe's Cove, 1895

Watercolor with opaque white on gray paper, 13 3/4 x 20 1/8 inches

Bowdoin College Museum of Art, Brunswick, Maine

Purchase with Museum funds and with donations from
Neal W. Allen '07, John F. Dana 1898, John H. Halford '07,
William Lawrence 1898, and Benjamin R. Shute '31, 1955.2

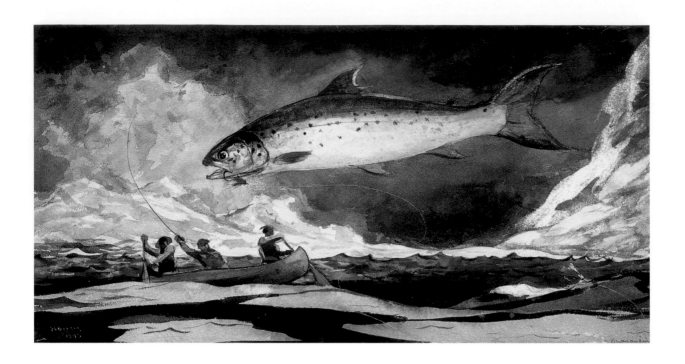

A Good Pool, Saguenay River, 1895
Watercolor over pencil on paper, 9 3/4 x 18 7/8 inches
Sterling and Francine Clark Art Institute,
Williamstown, Massachusetts

Grand Discharge, Lake St. John, c . 1897
Watercolor over graphite on moderately thick, smooth
Off-white wove paper, 13 7/8 x 21 3/4 inches
Worcester Art Museum, Worcester, Massachusetts

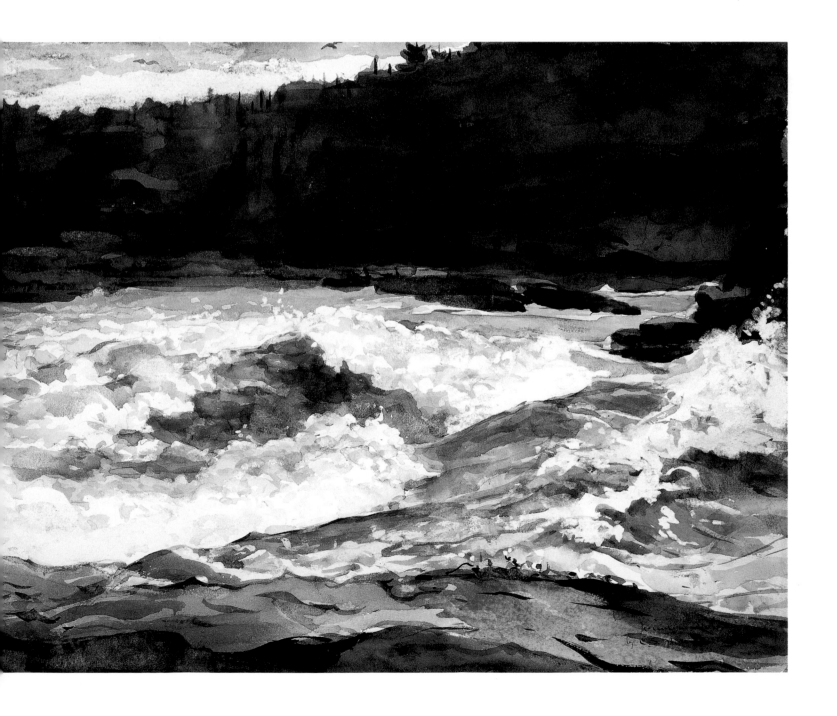

Saguenay River, Lower Rapids, 1897
Watercolor over graphite on moderately
Thick, smooth off-white wove paper,
14 x 20 15/16 inches
Worcester Art Museum,
Worcester, Massachusetts

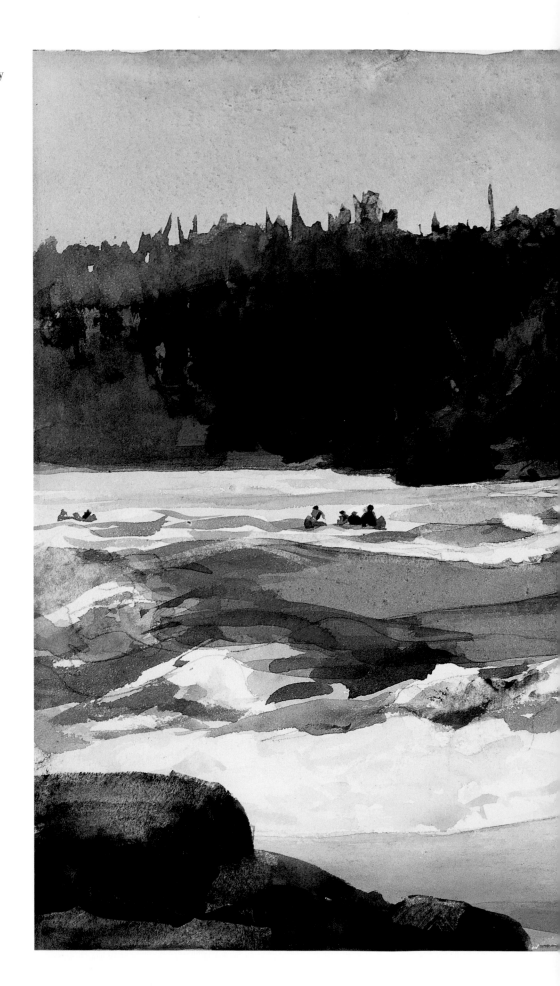

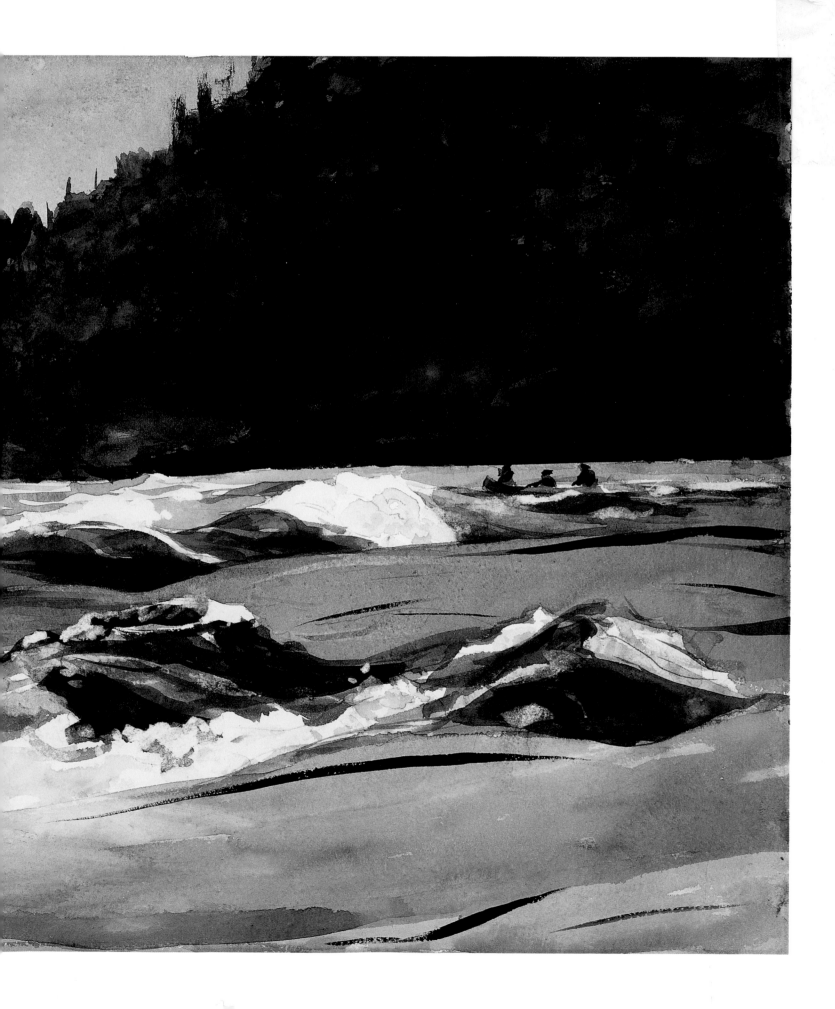

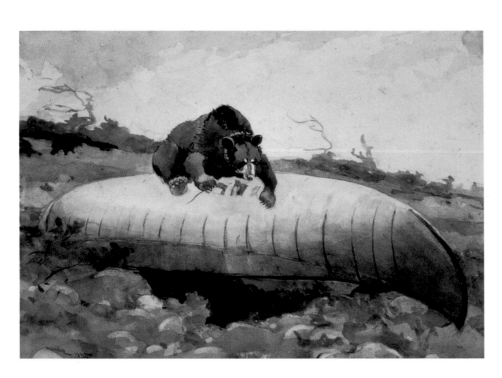

Bear and Canoe, 1895
Watercolor over charcoal, 14 x 20 inches
The Brooklyn Museum of Art
Museum Collection Fund and
Special Subscription; 11.541

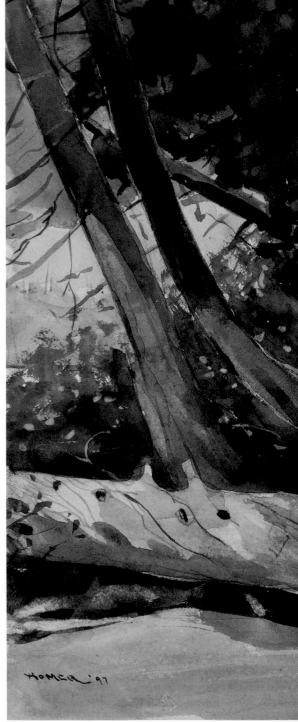

End of the Portage, 1897
Watercolor over pencil, 14 x 21 inches
The Brooklyn Museum of Art
Bequest of Helen Babbott Sanders; 78.151.1

(Overleaf)

Shooting the Rapids, 1902
Watercolor over pencil,
14 x 21 13/16 inches
The Brooklyn Museum of Art
Museum Collection Fund and
Special Subscription; 11.537

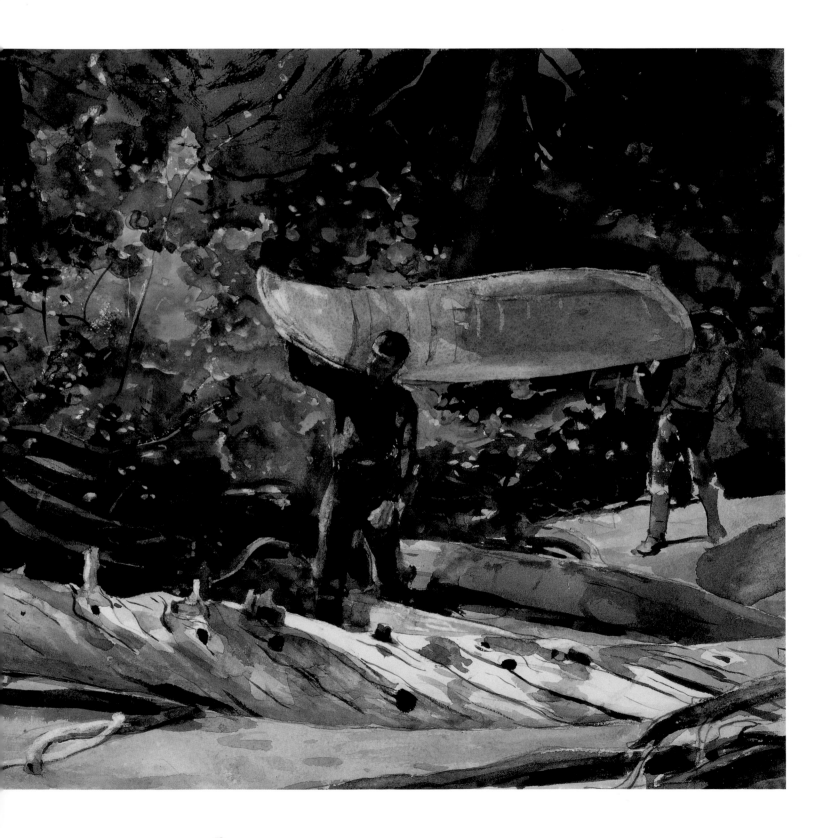

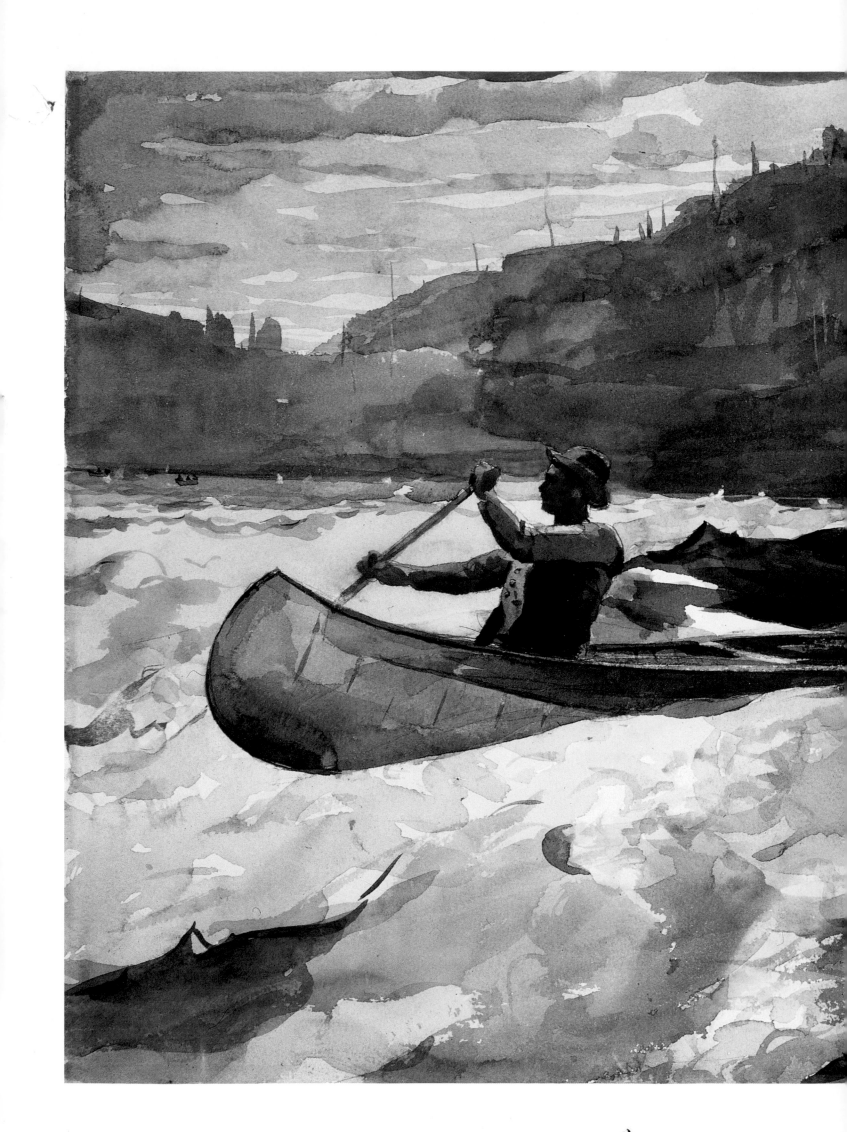

Grand Discharge, Lake St. John, c . 1897
Watercolor over graphite on moderately thick, smooth
Off-white wove paper, 13 7/8 x 21 3/4 inches
Worcester Art Museum, Worcester, Massachusetts

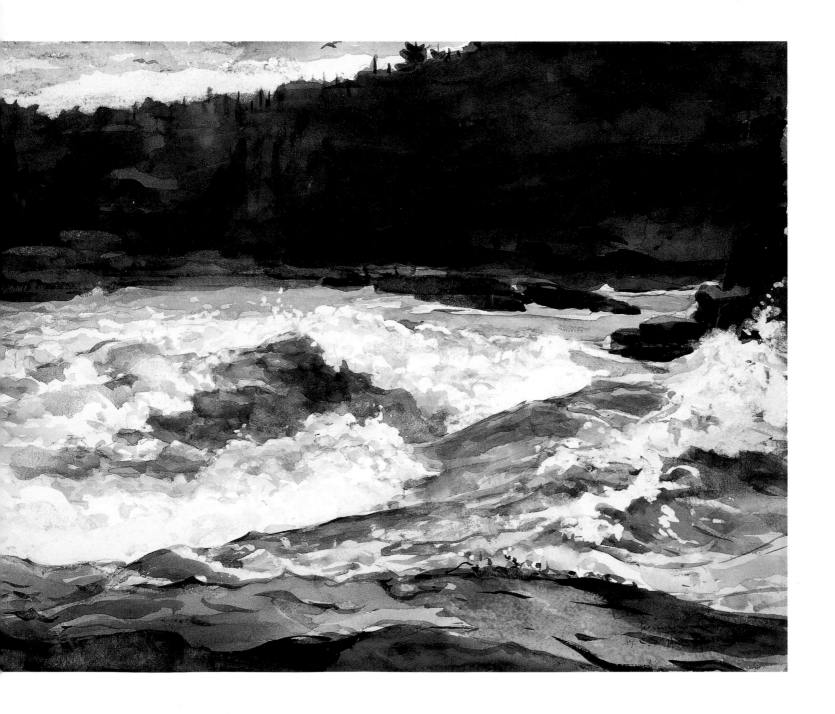

Saguenay River, Lower Rapids, 1897
Watercolor over graphite on moderately
Thick, smooth off-white wove paper,
14 x 20 15/16 inches
Worcester Art Museum,
Worcester, Massachusetts

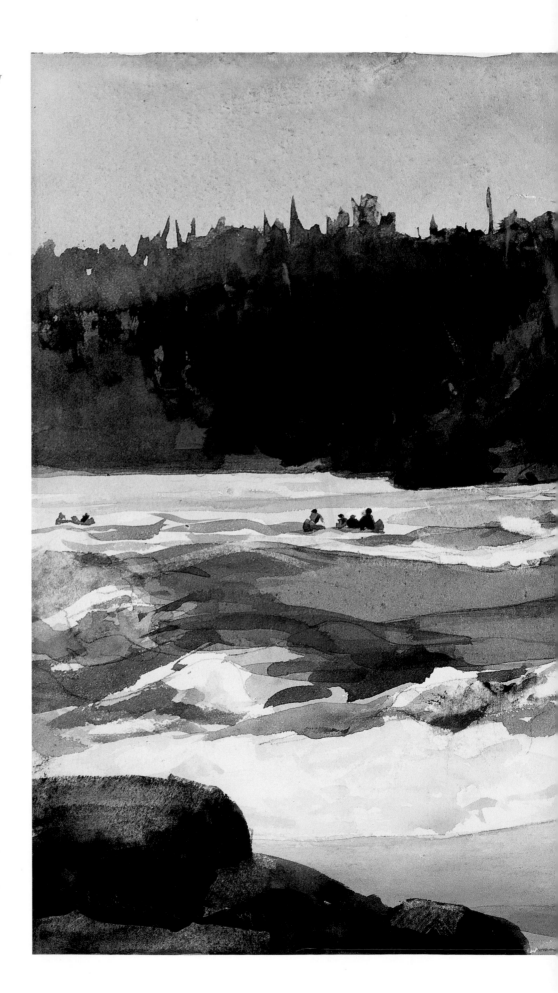

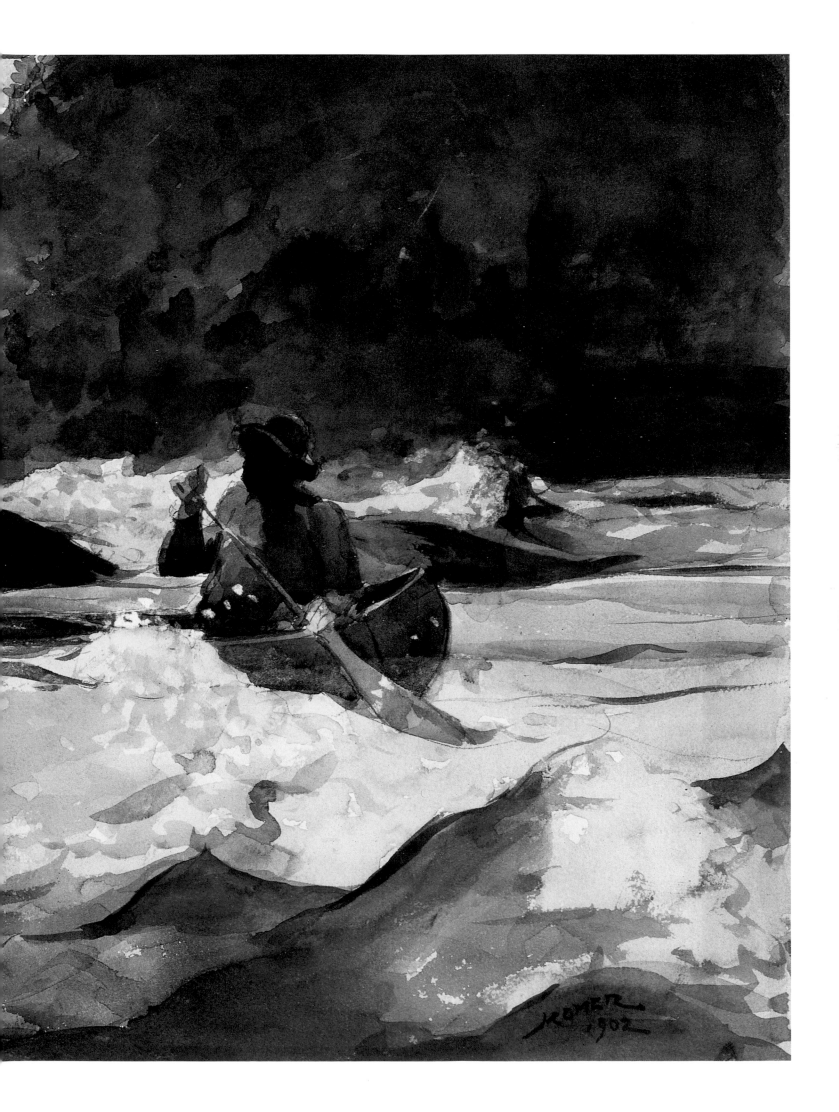

Cape Trinity, Saguenay River, 1904-1906/7
Oil on canvas, 28 1/2 x 48 inches
Curtis Galleries, Minneapolis, Minnesota

England

It [the sea] is like what we imagine knowledge to be:
dark, salt, clear, moving, utterly free,
drawn from the cold hard mouth
of the world, derived from the rocky breasts
forever, flowing and drawn, and since
our knowledge is historical, flowing, and flown.
—ELIZABETH BISHOP, *At the Fishhouses*

In 1881, Homer became an expatriate, moving to England. He had been abroad before, visiting Paris briefly, but this trip that lasted twenty months represented a full-fledged immersion—a baptism, if you will—into another culture and environment.

After a short visit to London, Homer settled in the seaside fishing village of Cullercoats, near Tynemouth, on the North Sea. Although he made forays along the coast from time to time, he remained situated in Cullercoats for the duration of his English sojourn.

As Jean Gould has written, Homer "wanted to study the contour of the coast-line, the turbulent waters of the North Sea, and the stoicism of the men who braved them to bring in the catch, the women who waited patiently for the day's end, when their labor began. The people, in few words, told him what he wished to learn."

Whereas his Gloucester marines rarely referred to the perils that are associated with the lives of fishermen, in Cullercoats Homer could not avoid the subject. Living among the fisherfolk he learned firsthand the consequences of this often dangerous livelihood, where a storm at sea could swamp a fishing boat, the waves sweeping men to a watery demise. One is reminded of some lines from Melville:

Implacable I, the old implacable Sea
Implacable most when most I smile serene—
Pleased, not appeased, by myriad wrecks in me.

Cullercoats had a lifesaving station and crew, and Homer came to know the drills and the actual rescues, as this storm-racked coastline bred disaster. The artist's admiration for the courage and daring of the surfmen was renewed later on, when he returned stateside, and led to the painting of several masterworks, including *Undertow*, 1886.

Homer portrays the fisherfolk—especially the mothers, wives, and daughters—in a noble light. Strong and sturdy, they play an active role in the fishing industry. Yet even as they mend the nets or haul the baskets, they cast their eyes seaward, expectant and fearful.

Living in this small village hard by the sea demanded that Homer make certain aesthetic adjustments. Accordingly, his watercolor style shifted to suit his new surroundings. As Goodrich wrote, "[Homer's] vision [grew] more atmospheric, his color deeper and subtler." The palette resonates, as it were, with the moods of the place and its people.

"In a big picture," wrote painter Thomas Eakins, "you can see what o'clock it is, afternoon or morning, if it's hot or cold, winter or summer, and what kind of people are there, and what they are doing and why they are doing it." Homer made many "big pictures" in his lifetime, many of them inspired by the lives of Northumbrian fisherfolk.

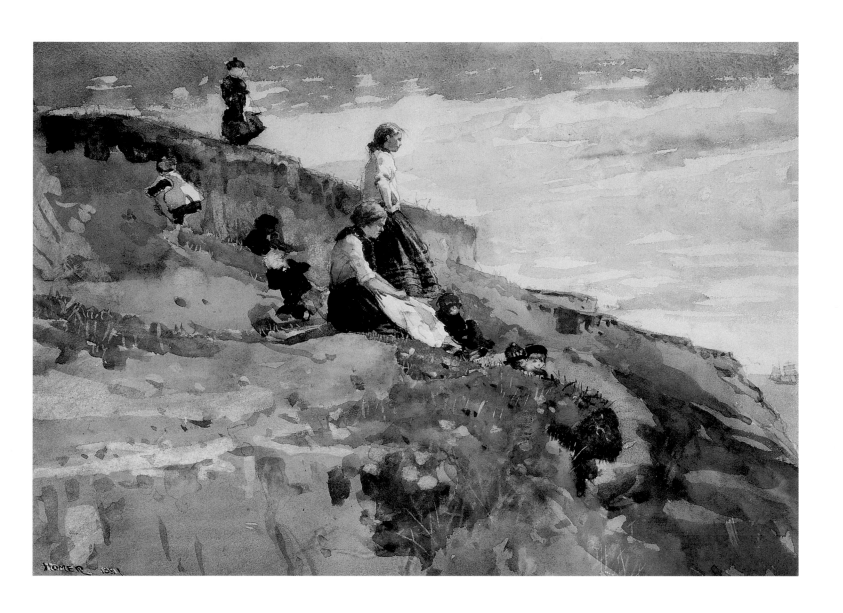

On the Cliff, 1881
Watercolor, 14 x 20 inches
Courtesy of the Canajoharie
Library and Art Gallery

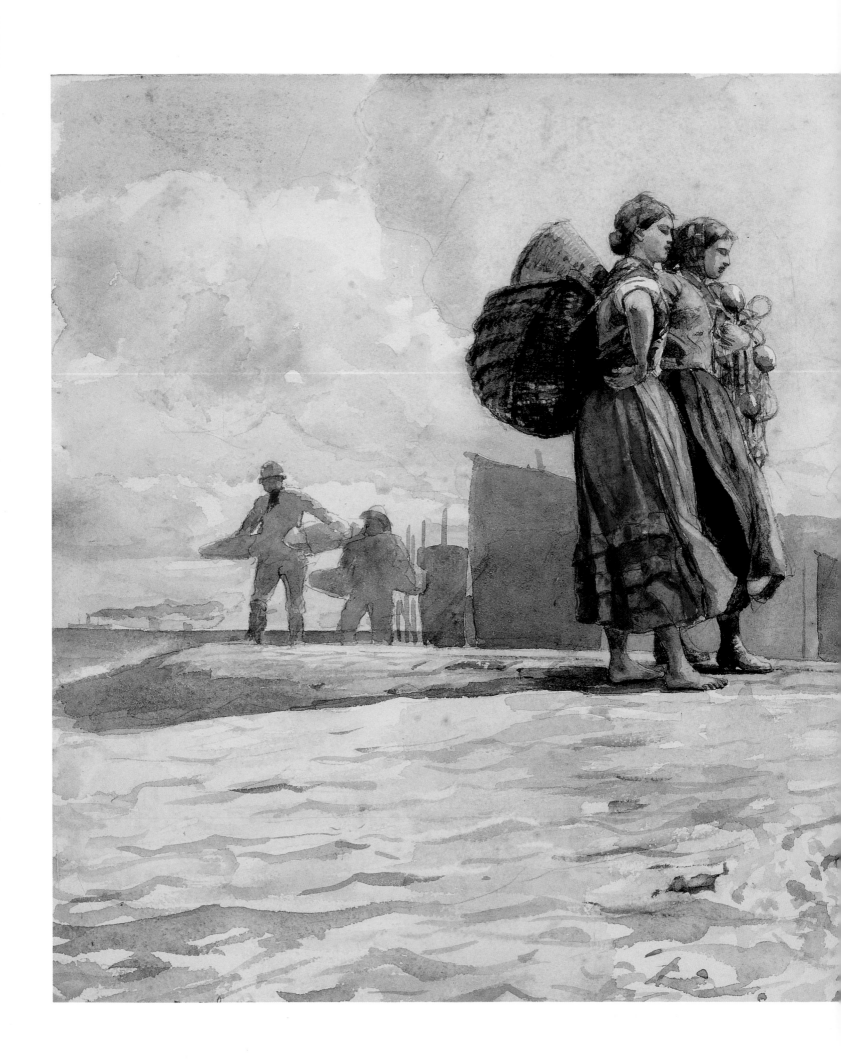

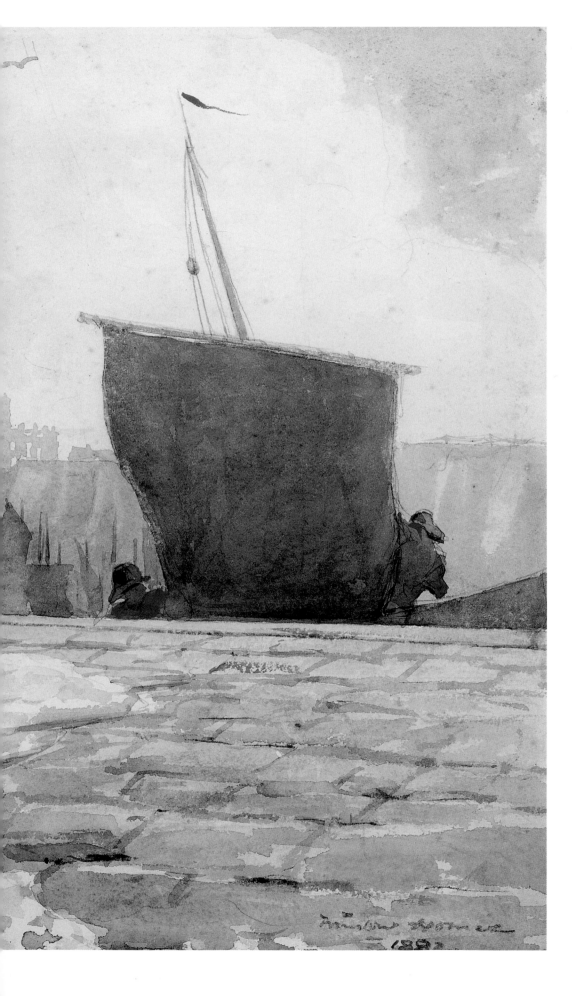

The Breakwater, Cullercoats, 1882
Watercolor on paper,
13 1/4 x 19 3/4 inches
Portland Museum of Art, Maine
Bequest of Charles Shipman
Payson; 1988.55.16

Photography by Benjamin Magro

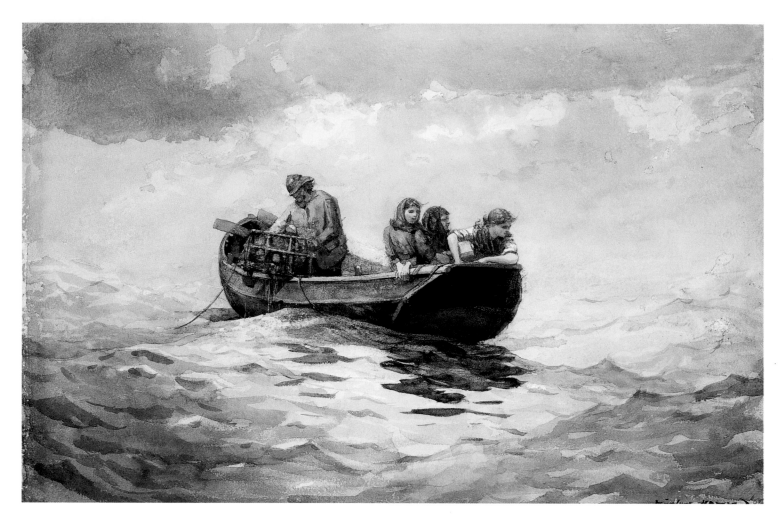

Crab Fishing, 1883
Watercolor over graphite on medium, smooth off-white
Wove paper, 14 9/16 x 21 3/4 inches
Worcester Art Museum, Worcester, Massachusetts
Bequest of Grenville H. Norcross

Homecoming, 1883
Watercolor, 14 x 21 inches
Courtesy of the Canajoharie
Library and Art Gallery

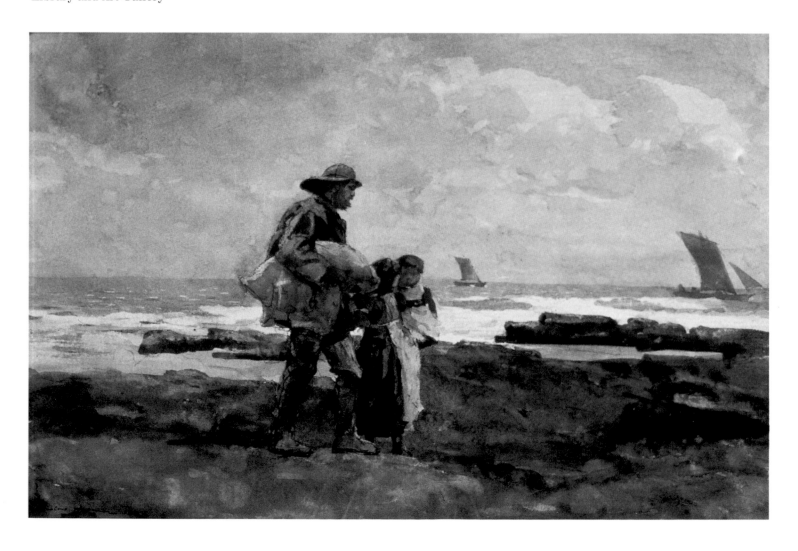

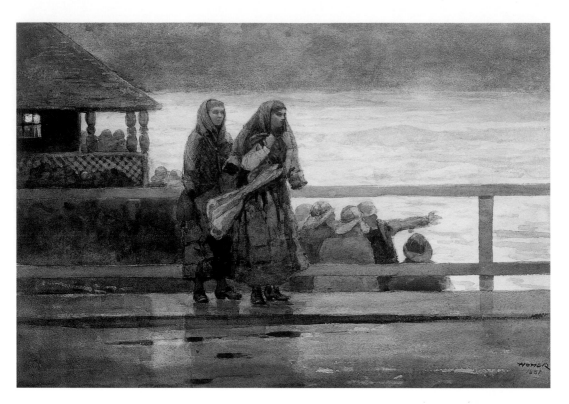

Perils of the Sea, 1881
Watercolor over black chalk on paper,
14 5/8 x 21 inches
Sterling and Francine Clark Art Institute,
Williamstown, Massachusetts

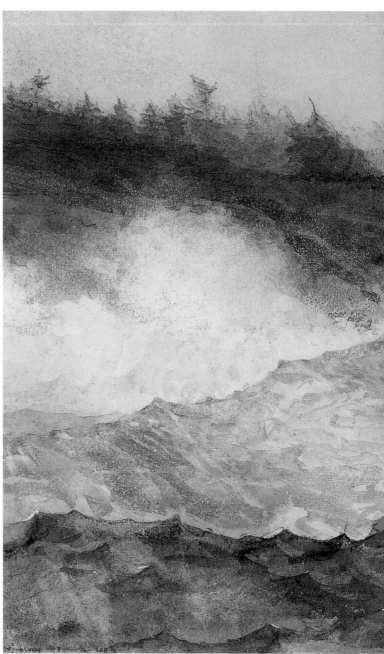

The Ship's Boat, 1883
Watercolor, 16 x 29 inches
Collection of the New Britain Museum of
American Art, Connecticut
Charles F. Smith Fund

Photography by Michael Agee

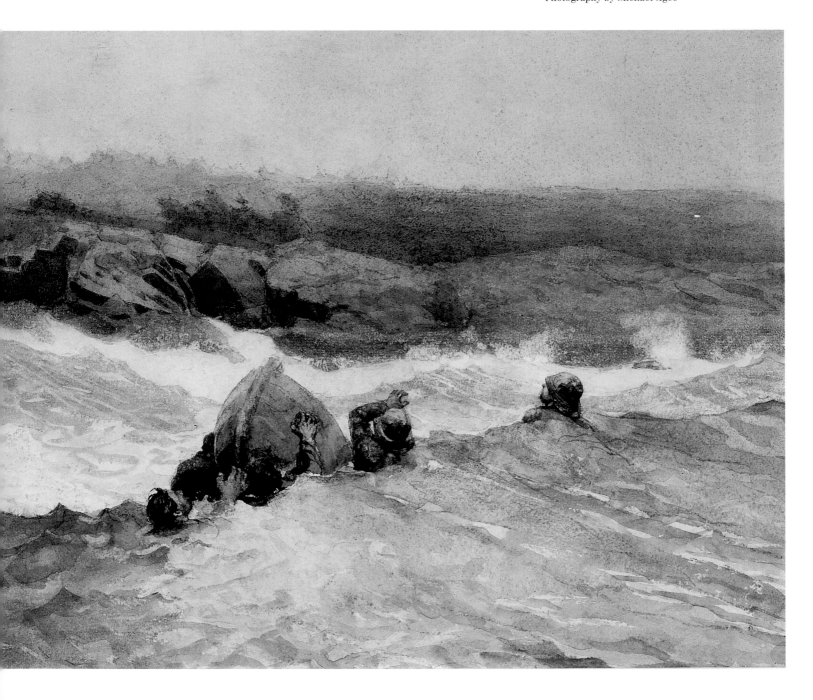

Returning Fishing Boats, 1883
Watercolor and white gouache over graphite
On white paper, 15 7/8 x 24 3/4 inches
Courtesy of the Fogg Art Museum
Harvard University Art Museums
Anonymous gift

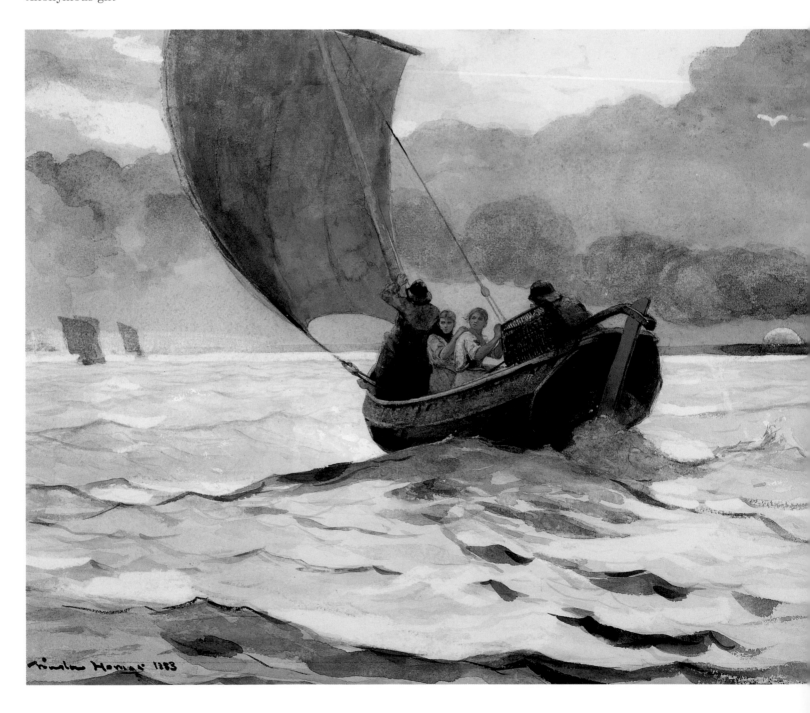

Marine, 1881
Watercolor over graphite on paper,
9 3/4 x 13 1/2 inches
Bowdoin College Museum of Art,
Brunswick, Maine
Bequest of Augustus F. Moulton,
Class of 1871; 1933.1

(overleaf)

An Afterglow, 1883
Watercolor over pencil on paper,
15 x 21 1/2 inches
Courtesy Museum of Fine Arts, Boston
Bequest of William P. Blake in memory
Of his mother, Mary M.J. Dehon Blake

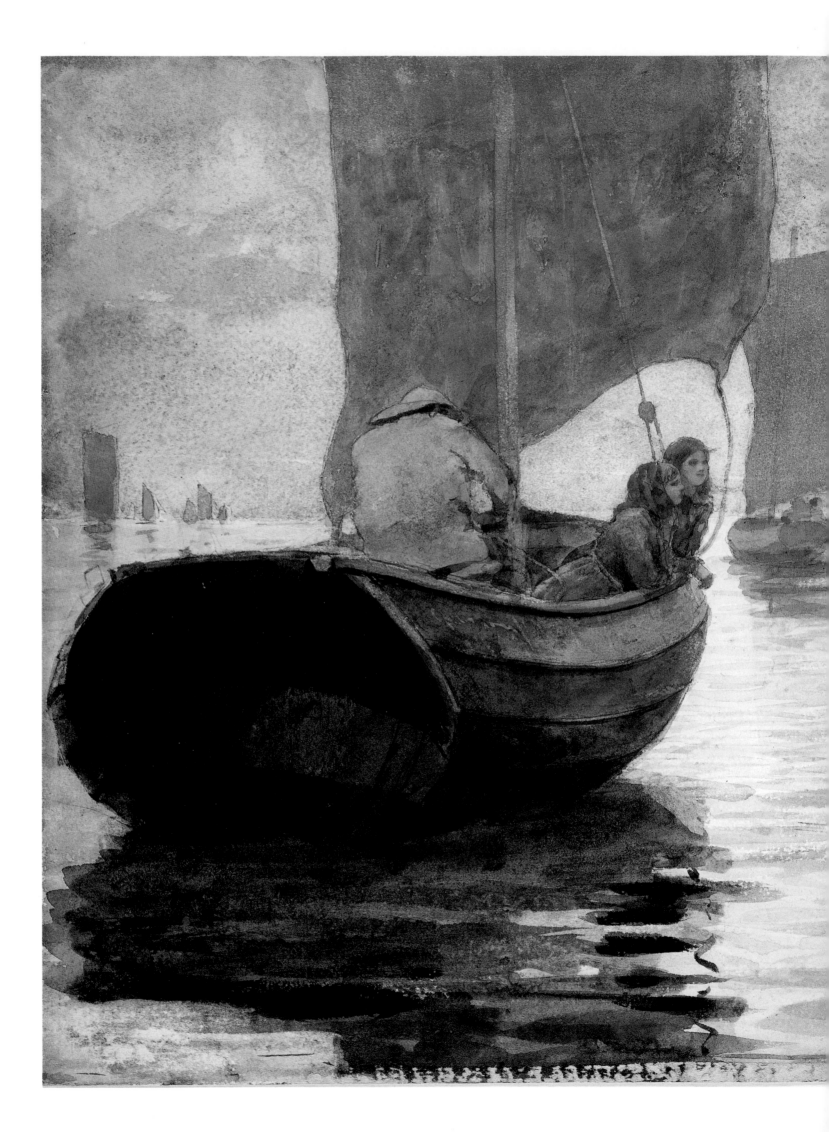

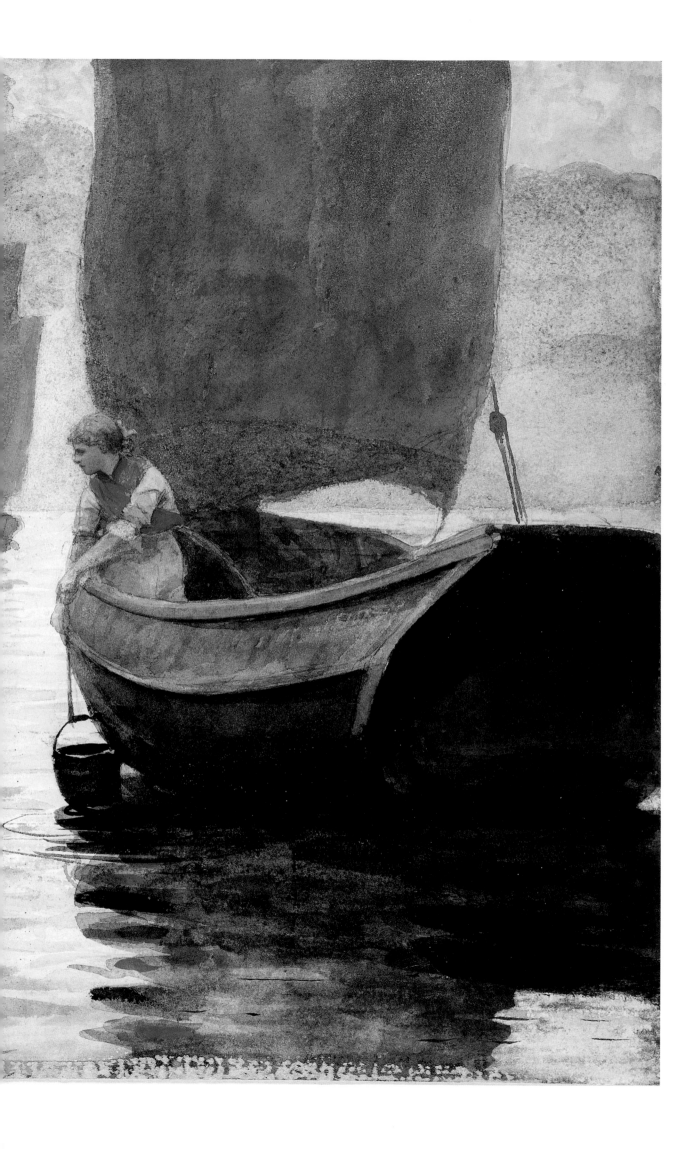

The Tropics: Florida, Bermuda, the Bahamas

> To paint good watercolors is a full time job, not a relaxation from other
> kinds of artistic expression. —ELIOT O'HARA, *Making Watercolor Behave, 1932*

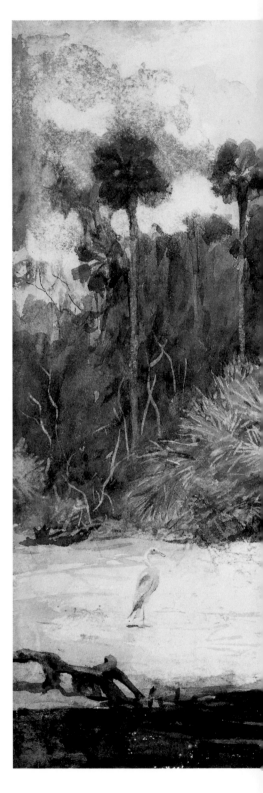

We often think of Winslow Homer as a New Englander and, taking into account his many visits to upper New York State and Canada, a northeasterner. Even his images of coastal England fit this image: after all, the landscape of Cullercoats did not differ greatly from the artist's surroundings at Prout's Neck, Maine.

We also associate Homer with the Tropics, thanks to the marvelous watercolors he created from the 1880s till his final trips south in the first decade of the twentieth century. Whereas his northern work captures the particular atmosphere of stormy coasts, winter days, and deep woods, his southern pieces are imbued with the warmth of tropical sunlight, which makes white walls whiter and turns the water into sparkling glass.

Homer painted numerous studies of the rich variety of wildlife, adding numerous warm climate species to his repertoire, from the wild pigs in Bermuda to the Florida cougar. He trained an equally fastidious eye on the flora of the islands, rendering the stately palms and bright greenery with flair.

Once again, the various fishing vessels and sailboats captured the artist's fancy and led to some of his greatest marine pictures, including *The Gulf Stream*, 1899. The activities of the natives also made a distinct impression on the artist. Many watercolors feature blacks as they make a living off the sea, gathering sponge, conch, and sea turtles.

Homer often depicted the men and women within their milieu—emerging from the water, adrift at sea, walking the roads. As Beam wrote, "None of these pictures gives the impression that the models were posed, but rather that Homer had caught them unselfconsciously at their accustomed tasks."

Art historians have uniformly praised Homer's tropical studies, trumpeting their significance in the tradition of watercolor. "During this final period," wrote Hereward Lester Cooke, "almost singlehanded[ly Homer] raised the status of watercolors in America from a secondary art which had degenerated into a poor and imitative cousin of oil painting, into a new and vital mode of expression."

According to the late Mahonri Sharp Young, "The Bahamas look exactly the way Winslow Homer painted them. The sky is bright blue; the fish are the brightest colors in the world; the palms bend and twist; the water is so blue you can't believe it; and the people are astonishingly black." Homer himself once said, "I think Bahamas the best place I have ever found." He reveled in the light, and the watercolors provide ample evidence of his love of this marvelous archipelago.

Homer's tropical studies recall a few lines of "Seamarks" by the great island poet St. John Perse. One might say that these luminous watercolors bear "the silken sound of open seas / and all the great freshness of good fortune throughout the world."

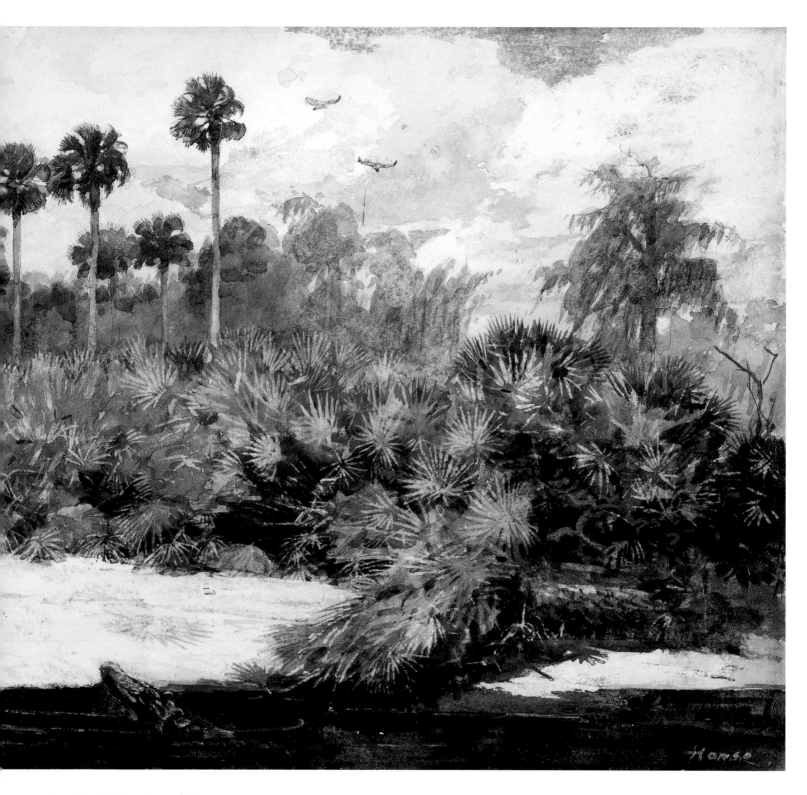

In a Florida Jungle, c. 1886
Watercolor over graphite on moderately thick,
Smooth off-white wove paper, 14 x 20 inches
Worcester Art Museum, Worcester, Massachusetts

At Tampa, 1885
Watercolor on paper, 14 x 20 inches
Courtesy of the Canajoharie
Library and Art Gallery

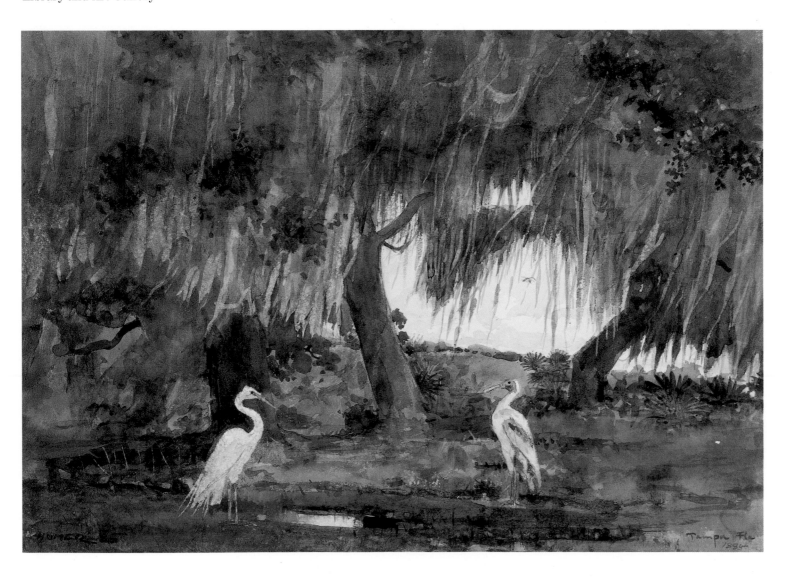

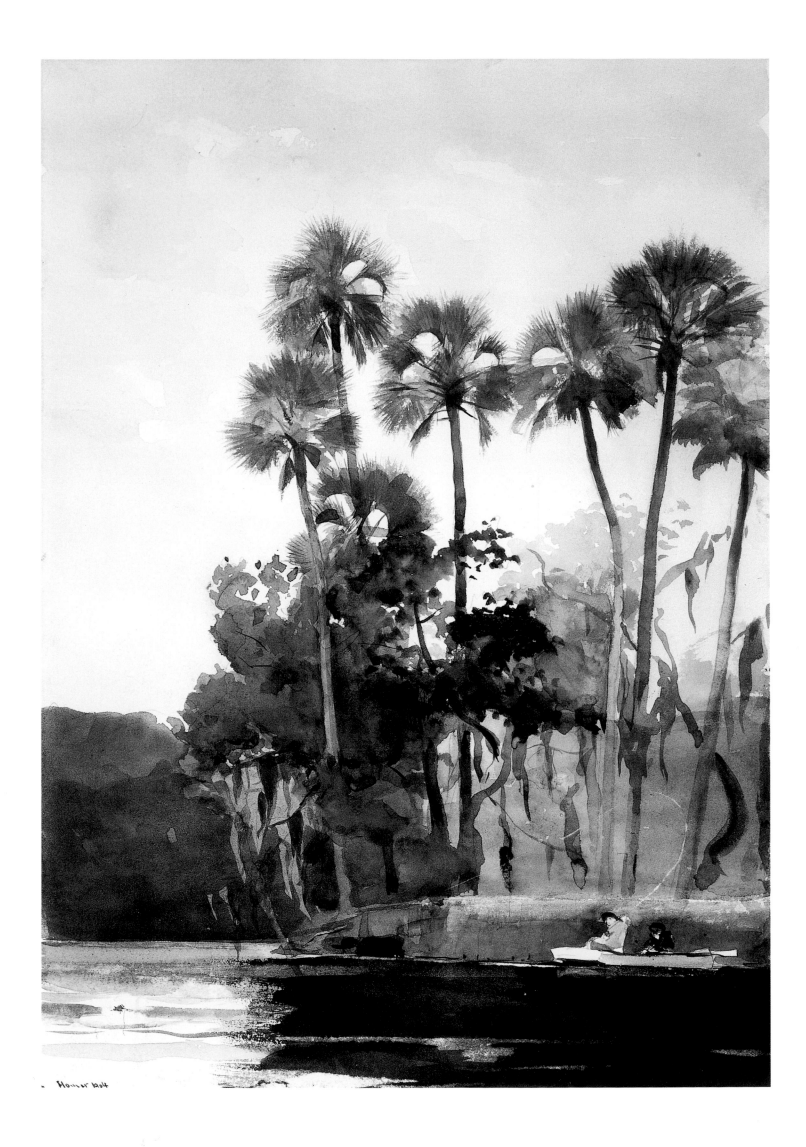

Homer 1904

In the Jungle, Florida, 1904
Watercolor over pencil,
13 7/8 x 19 11/16 inches
The Brooklyn Museum of Art
Museum Collection Fund and
Special Subscription; 11.547

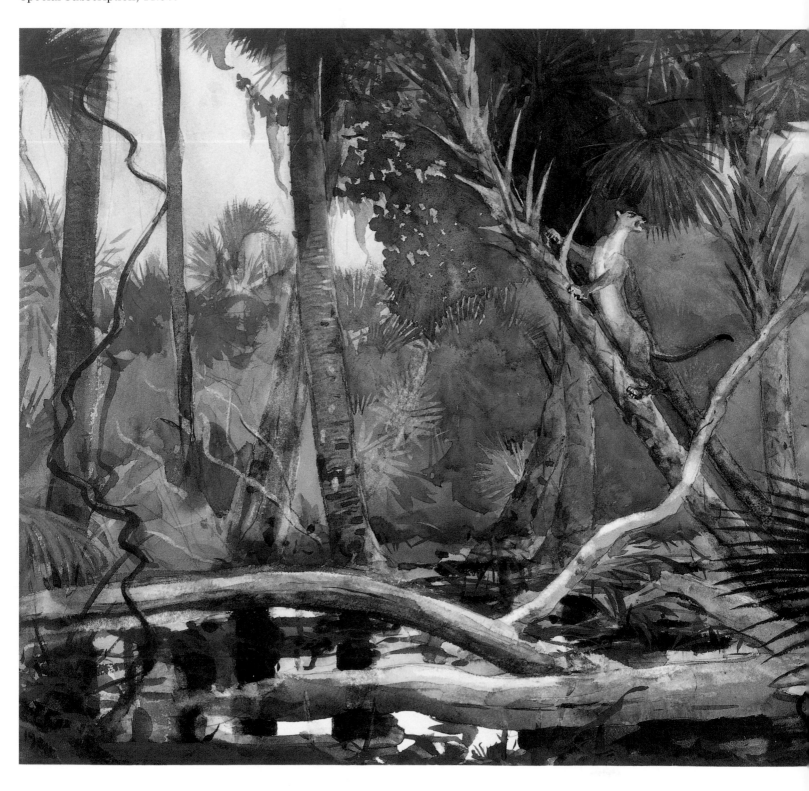

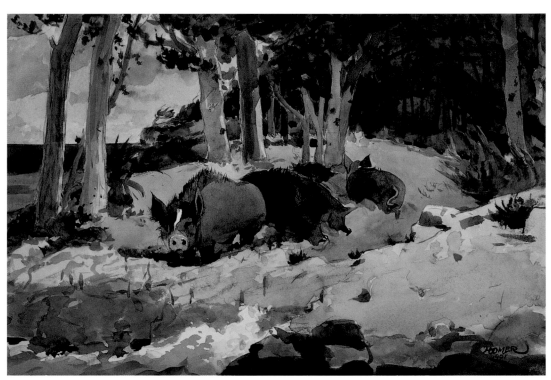

Bermuda Settlers, 1901
Watercolor over graphite on moderately thick,
Slightly textured off-white wove paper, 14 x 21 inches
Worcester Art Museum, Worcester, Massachusetts

(overleaf)

Key West, Negro Cabins and Palms, 1898
Watercolor over pencil, 14 7/16 x 21 1/16 inches
The Brooklyn Museum of Art
Museum Collection Fund and
Special Subscription; 11.538

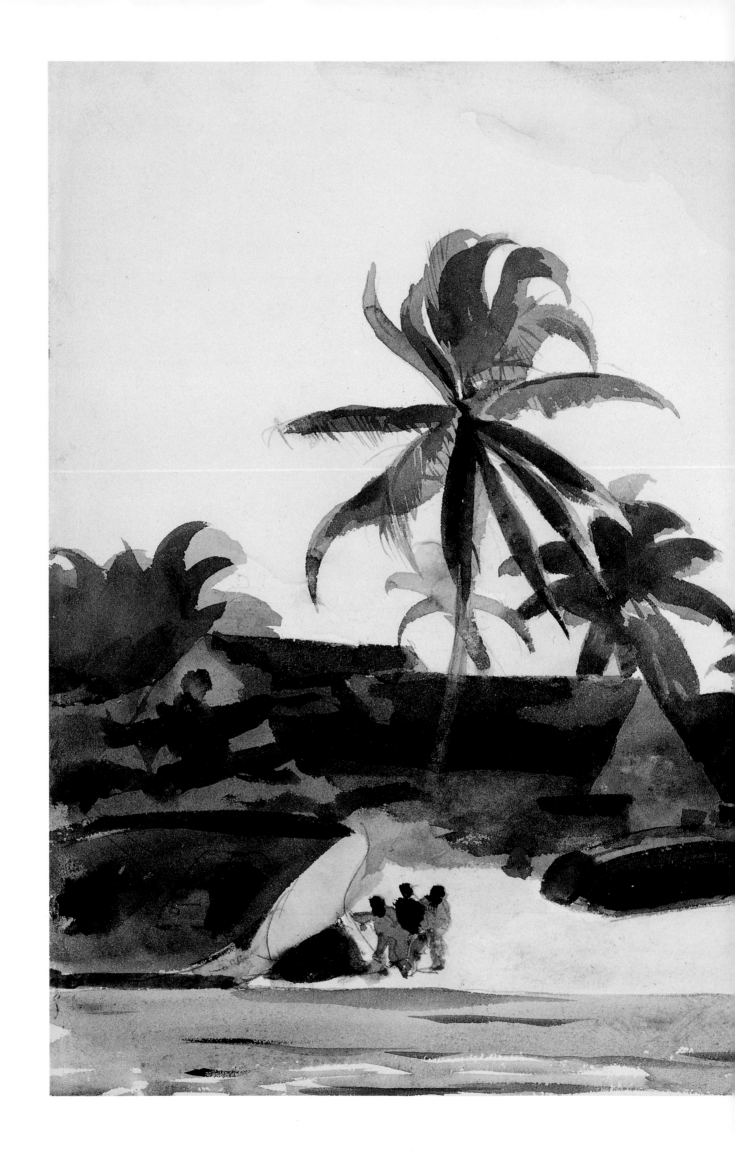

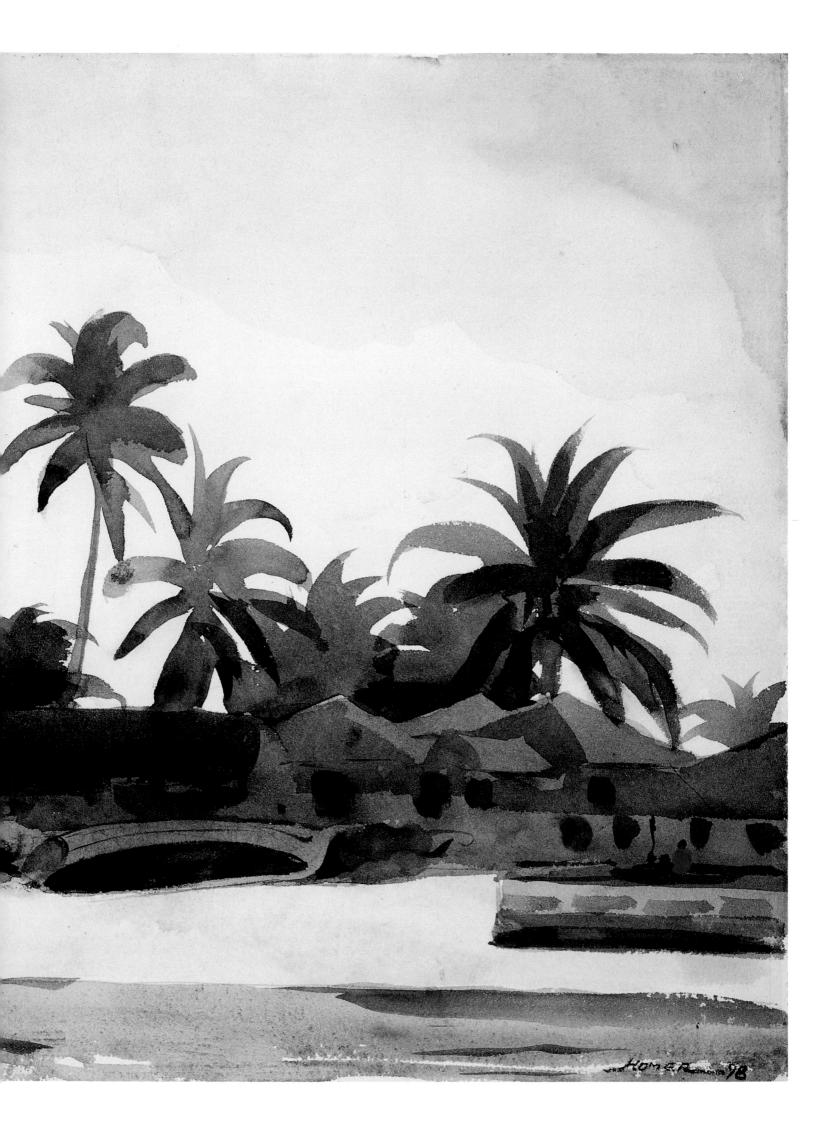

Glass Windows, Bahamas, c. 1885
Watercolor over pencil, 13 15/16 x 20 1/16 inches
The Brooklyn Museum of Art
Museum Collection Fund and Special
Subscription; 11.545

Coral Formation, 1901
Watercolor over graphite on medium, smooth,
Off-white wove paper, 14 x 21 inches
Worcester Art Museum, Worcester, Massachusetts

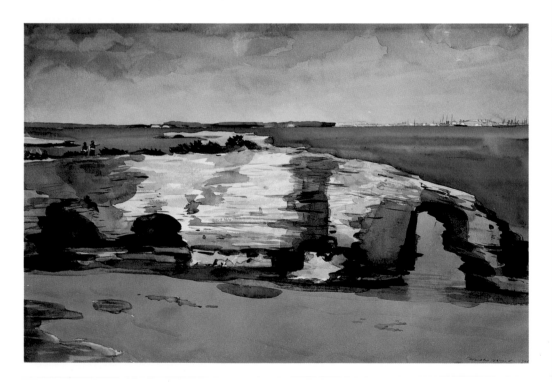

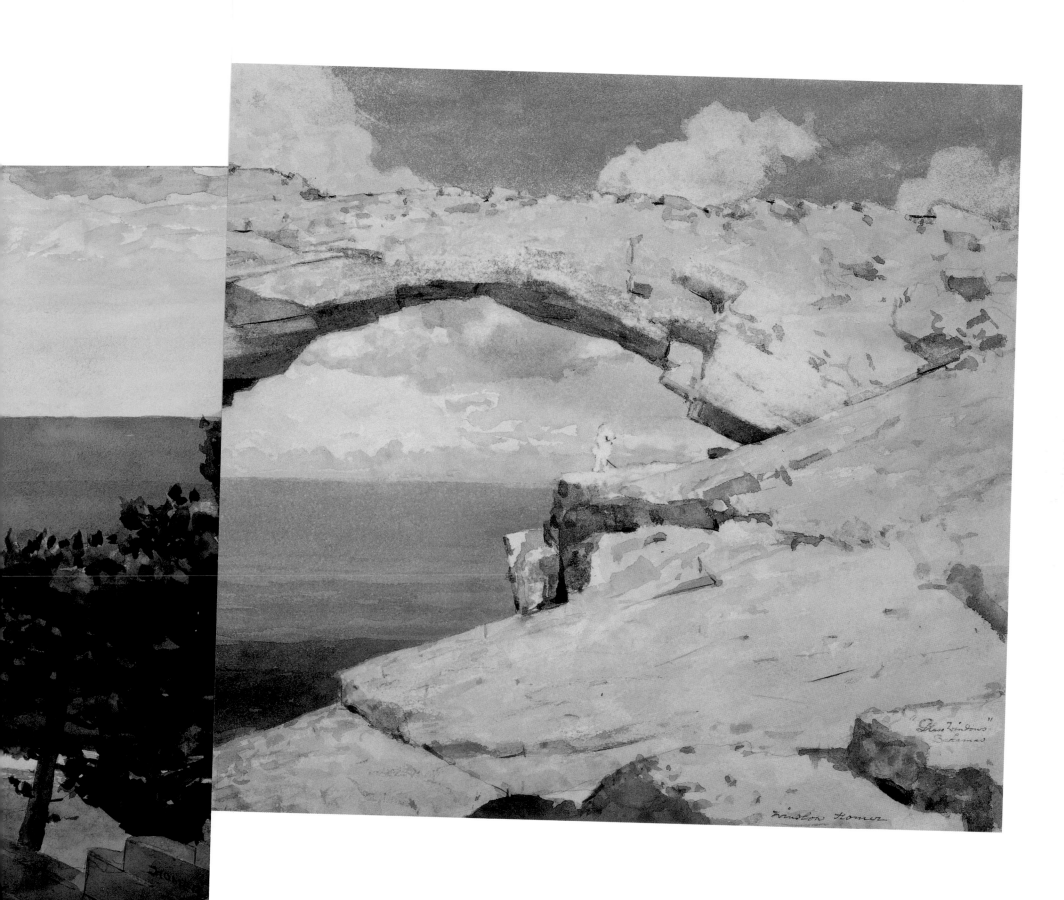

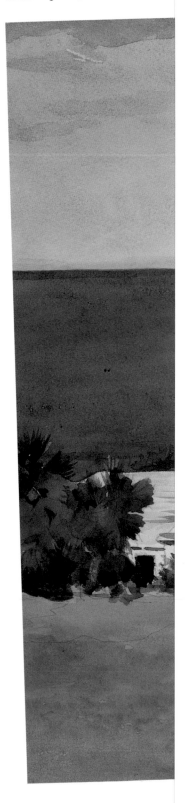

Shore at Bermuda, c. 1899
Watercolor over pencil, 14 x 2
The Brooklyn Museum of Art
Museum Collection Fund and
Subscription; 11.539

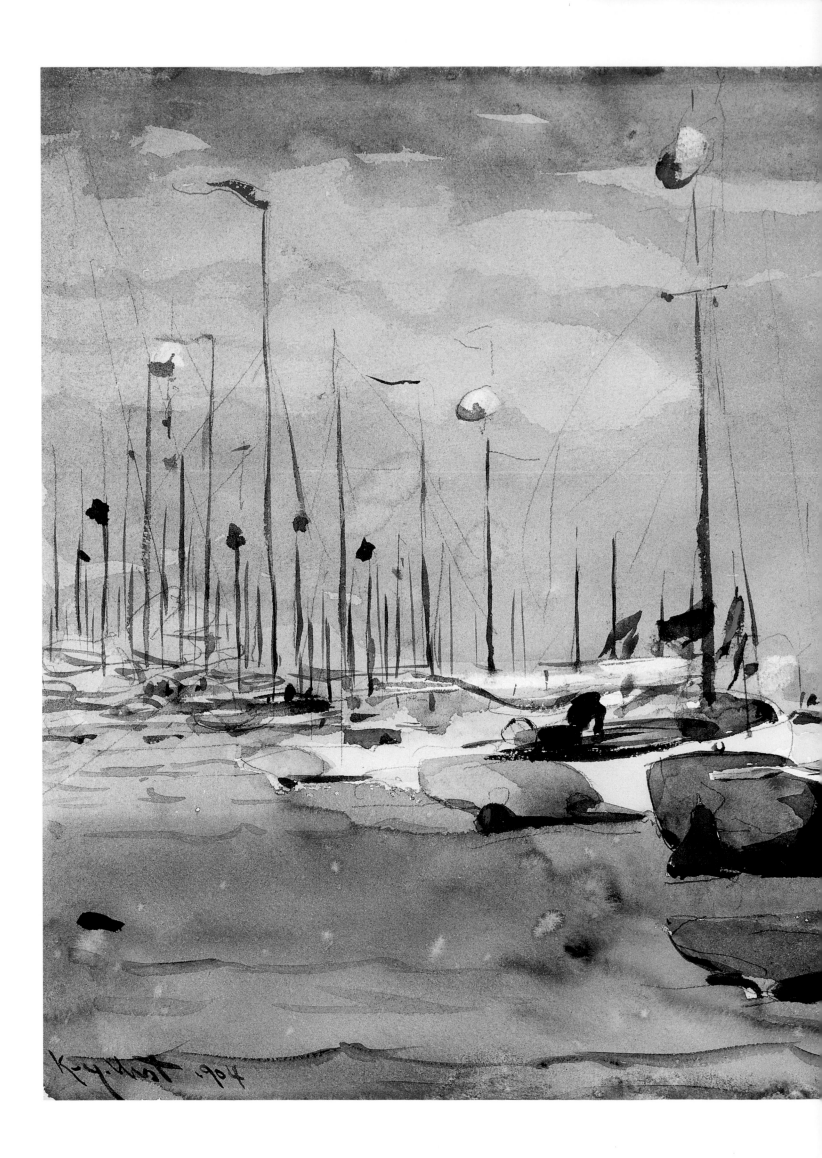

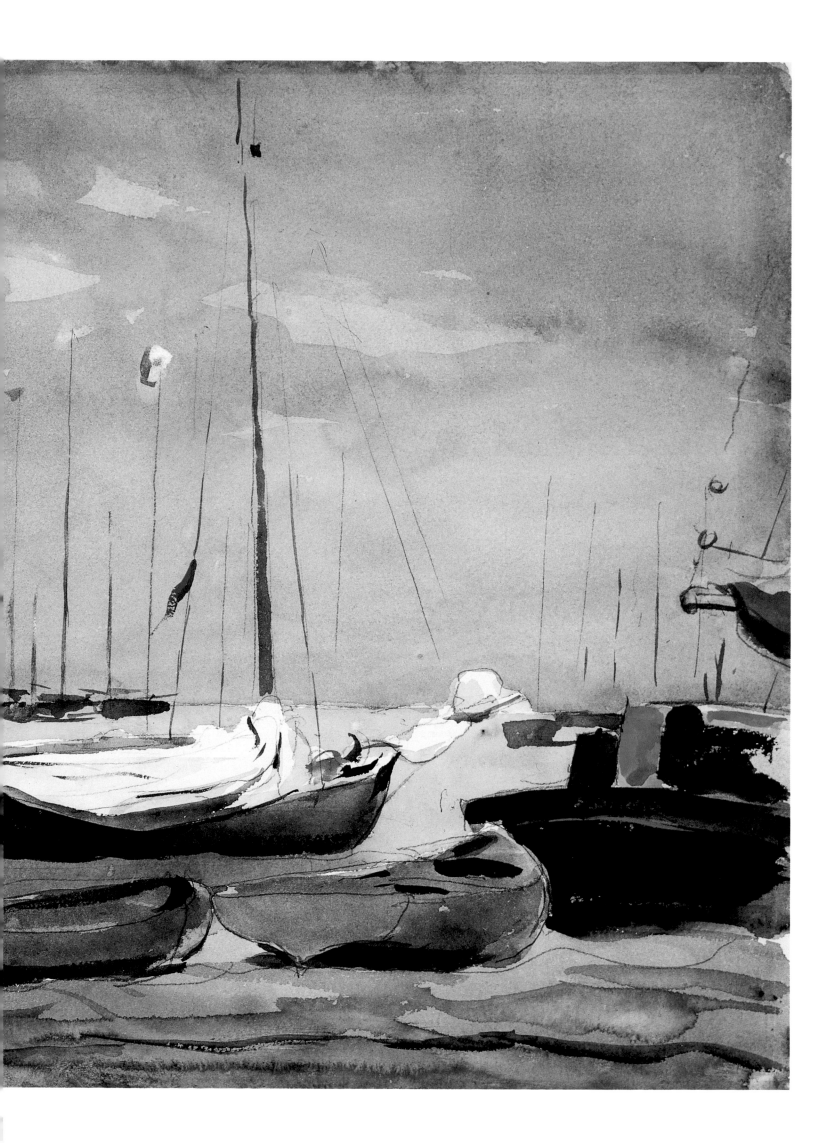

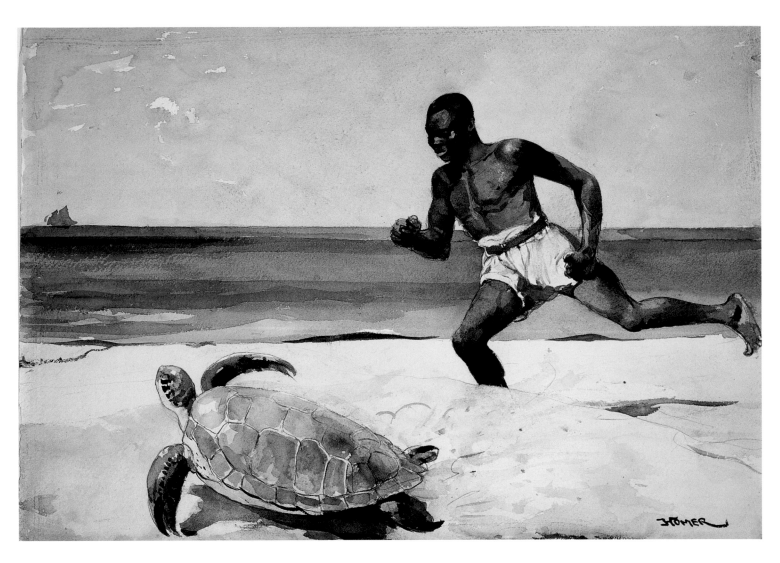

Rum Cay, 1898-99
Watercolor over graphite
On off-white wove paper
14 7/8 x 21 3/8 inches
Worcester Art Museum,
Worcester, Massachusetts

(preceding spread)

Sponge Fishing, the Bahamas, 1885
Watercolor, 14 x 20 inches
Courtesy of the Canajoharie Library and Art Gallery

The Turtle Pound, 1898
Watercolor over pencil,
14 15/16 x 21 3/8 inches
The Brooklyn Museum of Art
Sustaining Membership Fund;
A.T. White Memorial Fund;
A. Augustus Healy Fund; 23.98

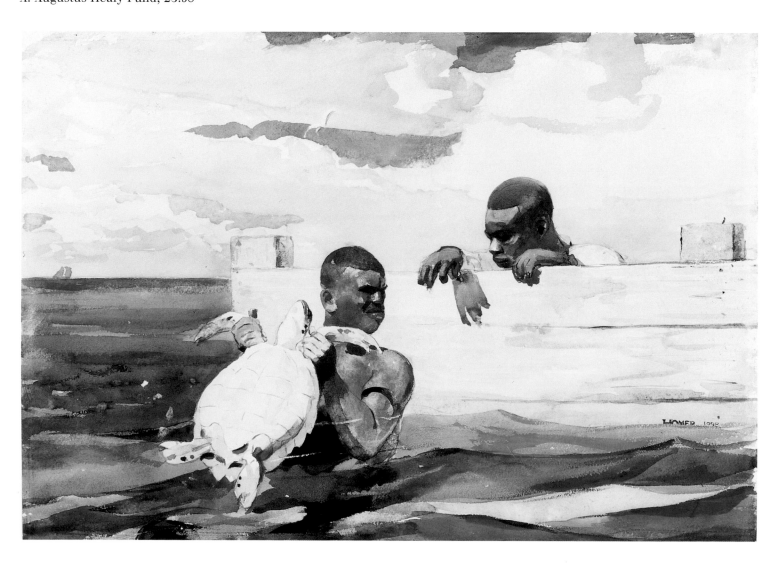

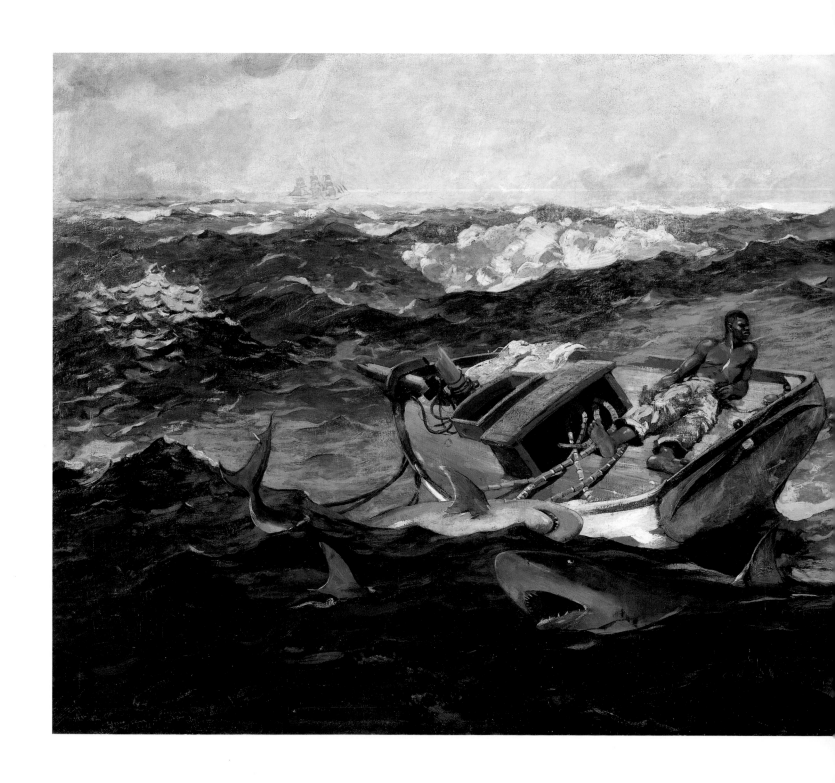

The Gulf Stream, 1899
Oil on canvas, 28 1/8 x 49 1/8 inches
The Metropolitan Museum of Art
Catherine Lorillard Wolfe Collection,
Wolfe Fund; 1906 (06.1234)

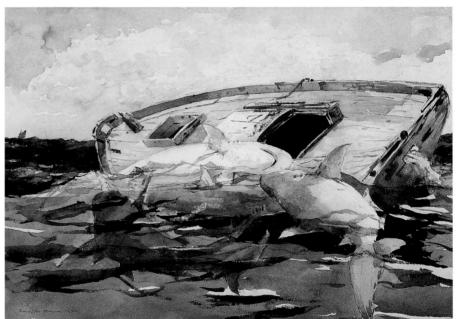

Sharks; also *The Derelict*, 1885
Watercolor over pencil, 14 1/2 x 20 15/16 inches
The Brooklyn Museum of Art
Bequest of Helen Babbott Sanders; 78.151.4

Coast in Winter, 1892
Oil on canvas, 28 3/8 x 48 3/8 inches
Worcester Art Museum, Worcester, Massachusetts
Theodore T. and Mary G. Ellis Collection

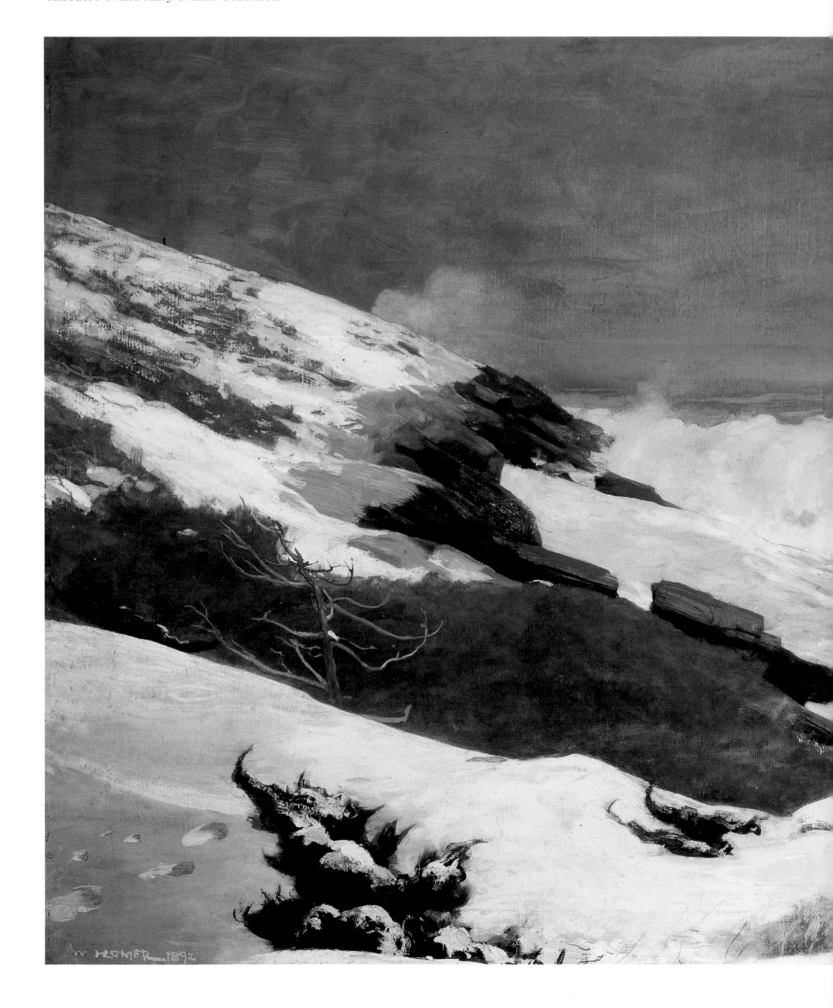

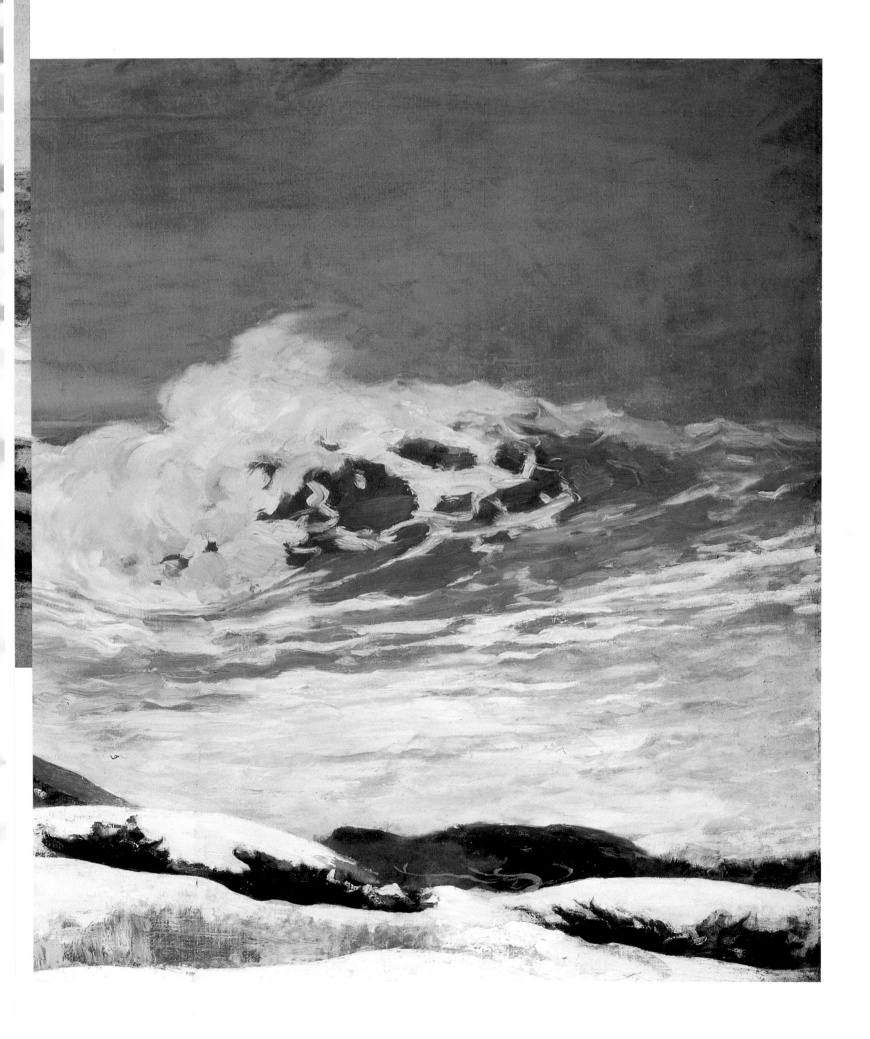

150

A Summer Night, 1890
Watercolor, 14 1/2 x 21 1/2 inches
Wadsworth Atheneum, Hartford
Gift of James J. Goodwin

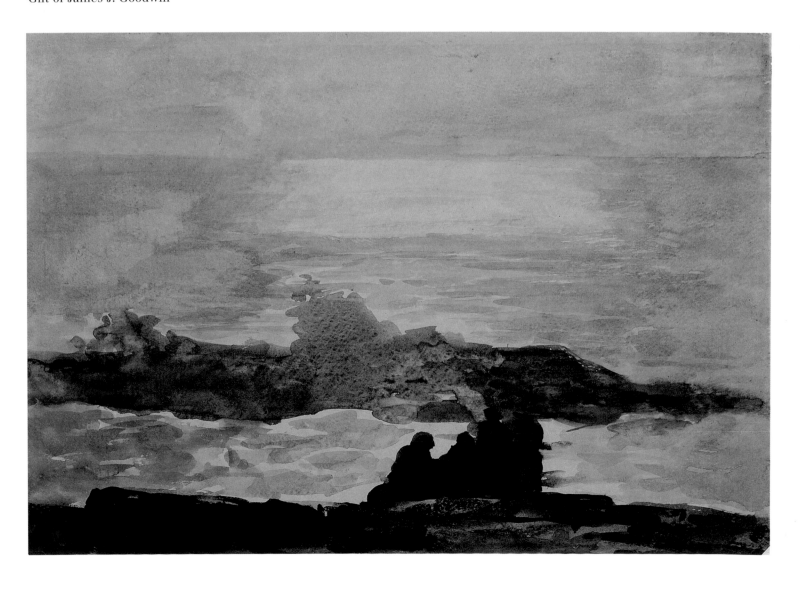

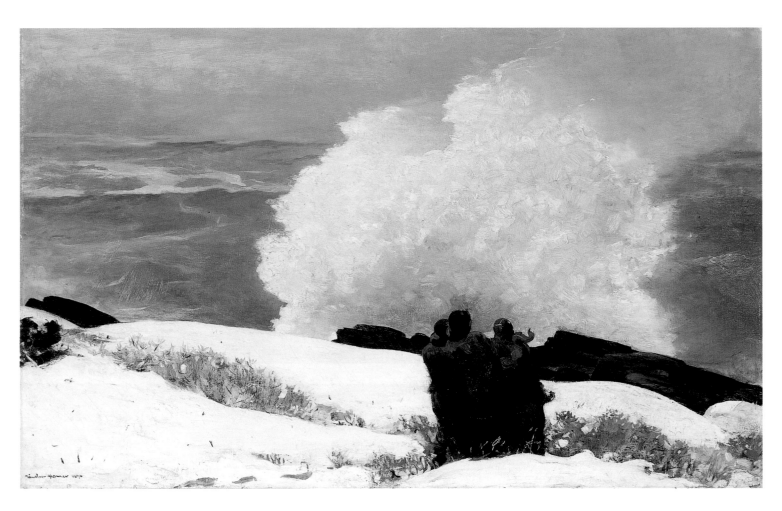

Watching the Breaker—A High Sea, 1896
Oil on canvas, 24 x 38 inches
Courtesy of the Canajoharie Library and Art Gallery

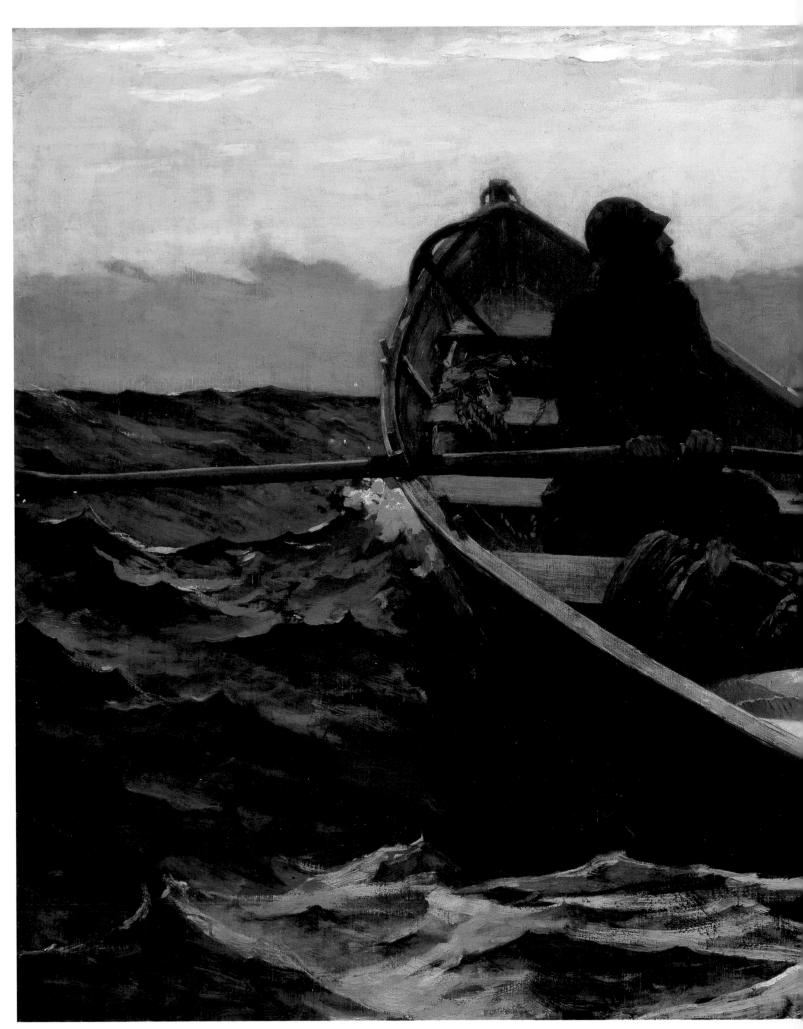

Blown
Water
10 1/8
The B
Muse
Speci

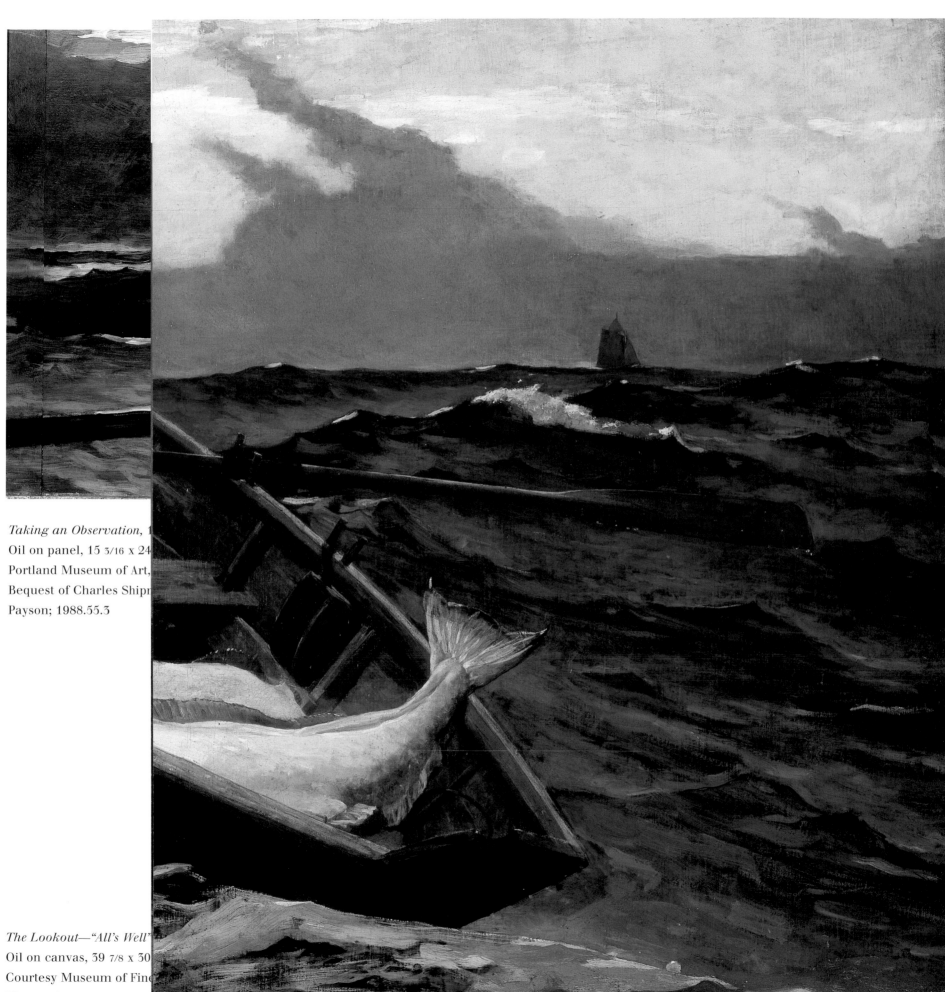

Taking an Observation,
Oil on panel, 15 3/16 x 24
Portland Museum of Art,
Bequest of Charles Shipm
Payson; 1988.55.3

The Lookout—"All's Well"
Oil on canvas, 39 7/8 x 30
Courtesy Museum of Fine
Warren Collection

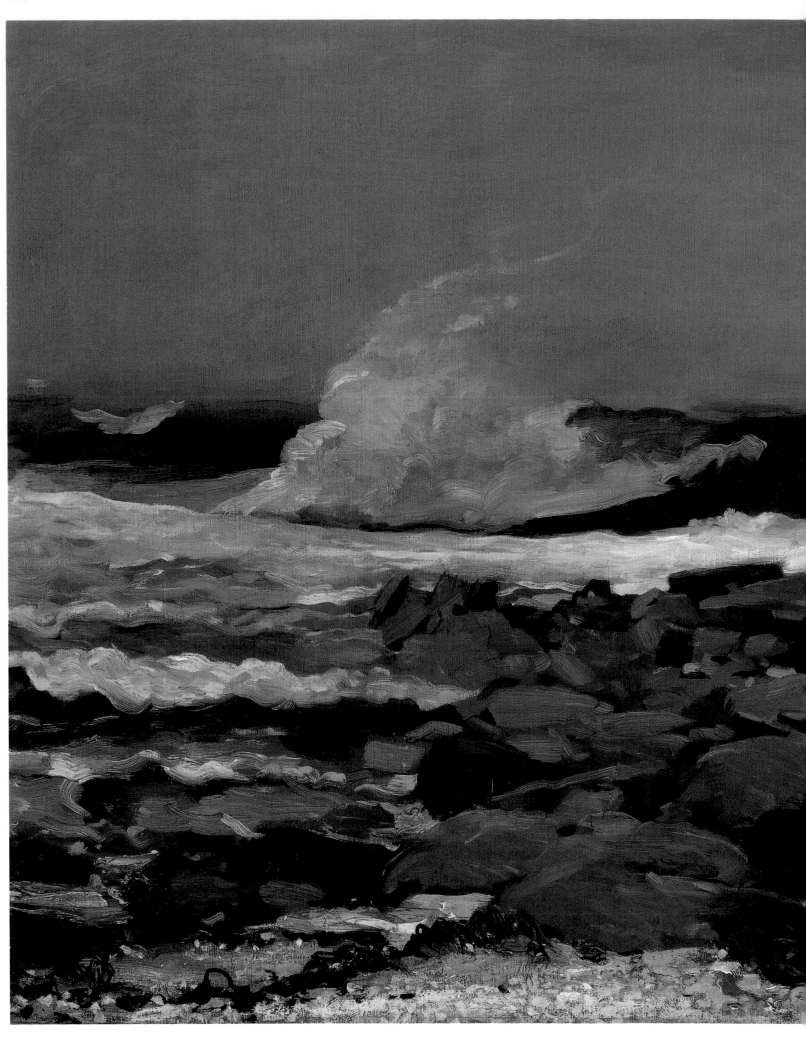

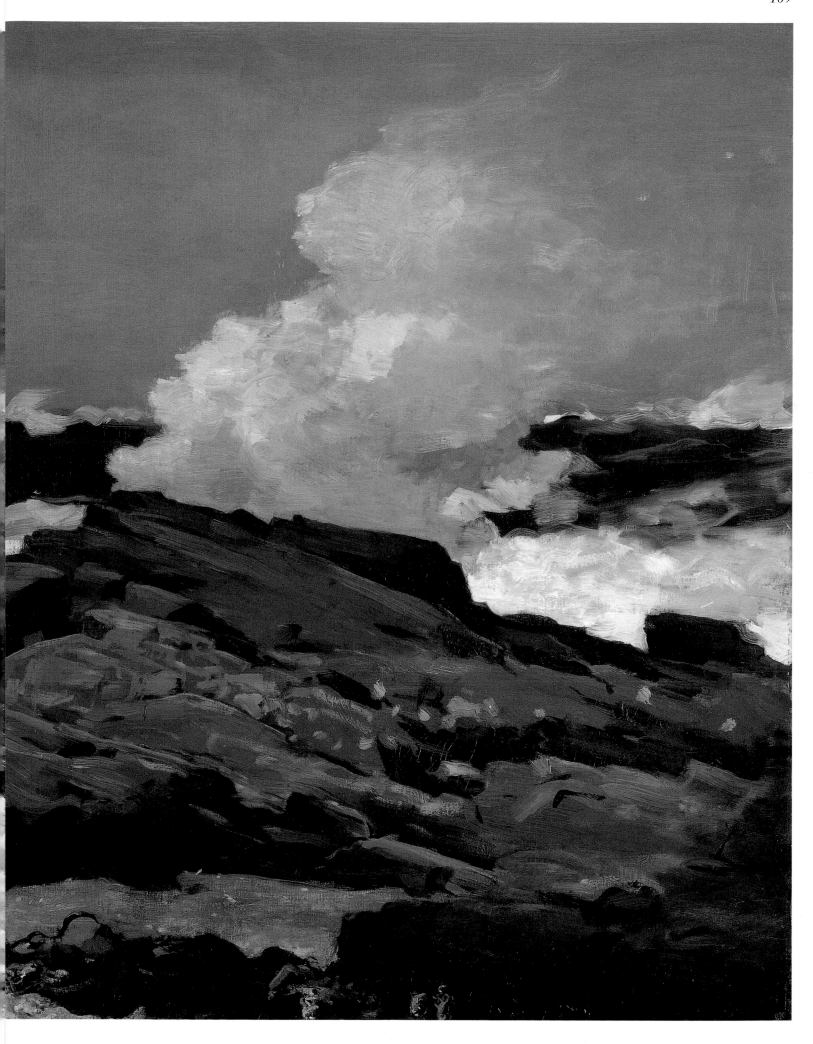

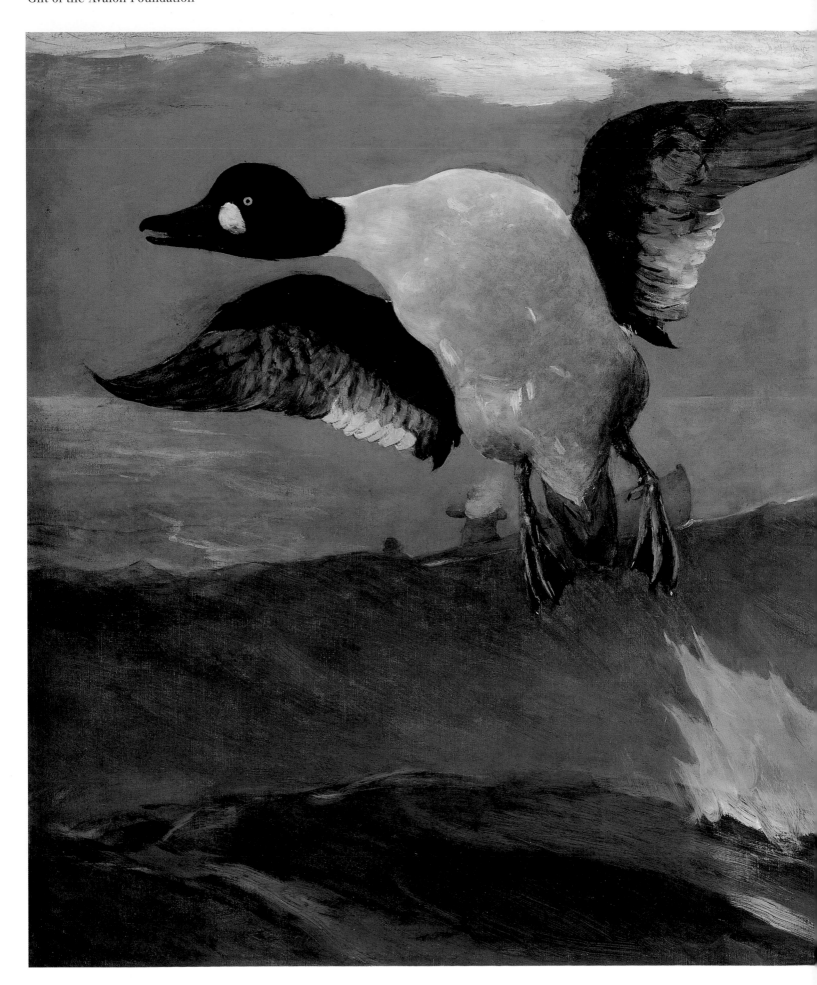

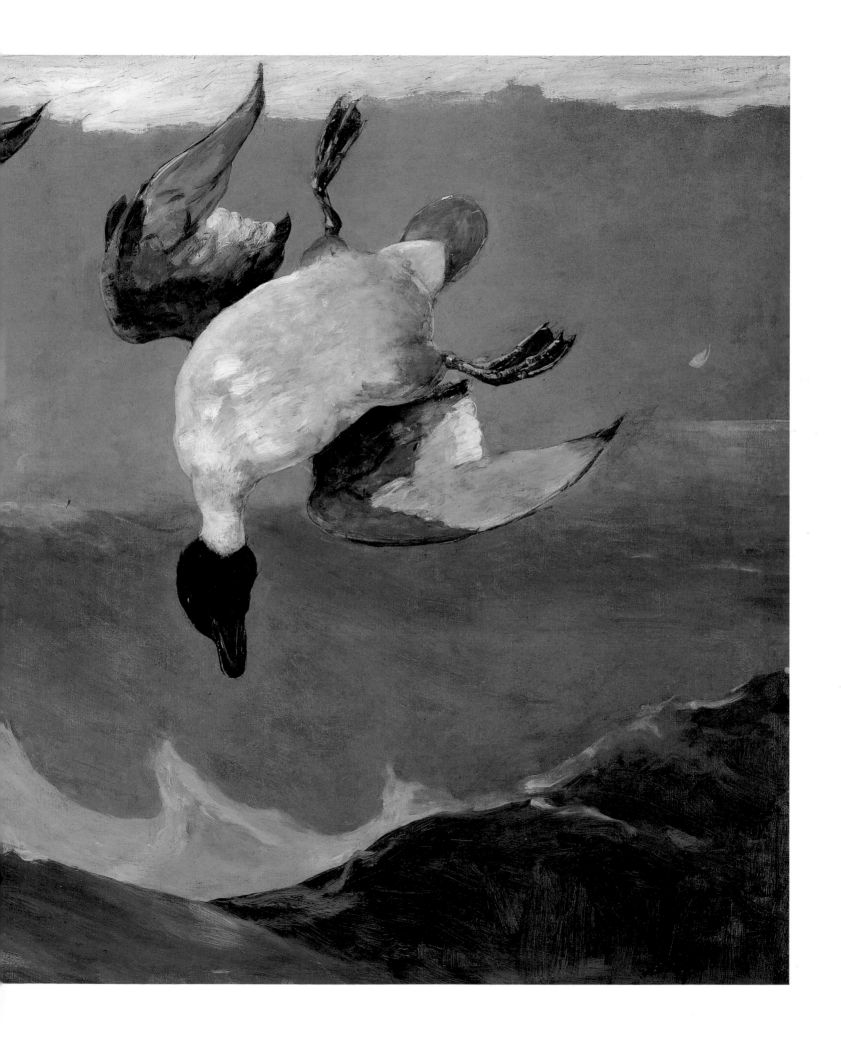

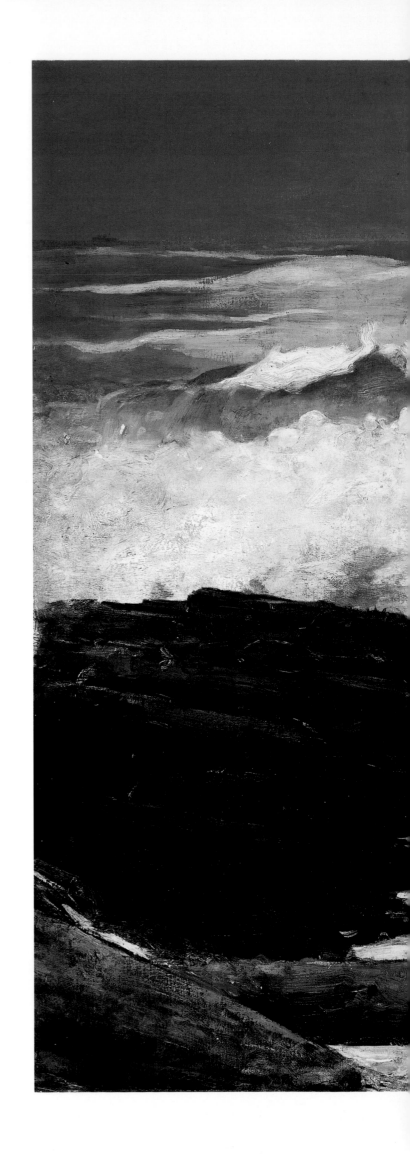

Driftwood, 1909
Oil on canvas, 24 1/2 x 28 1/2 inches
Courtesy Museum of Fine Arts, Boston
Henry H. and Zöe Oliver Sherman Fund
And other funds

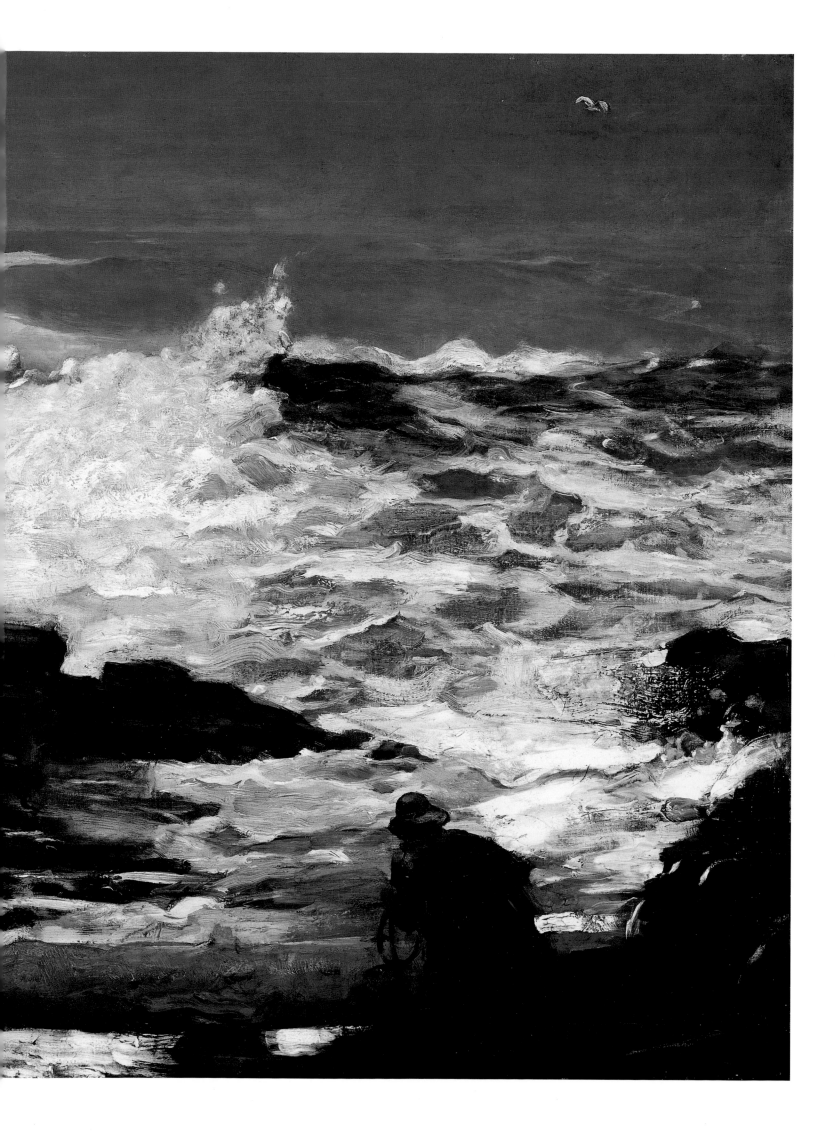

List of Paintings

An Adirondack Lake, 56-57
An Afterglow, 116-117
Artists Sketching in the White Mountains, 22
At Tampa, 120
Bear and Canoe, 100
Bermuda Settlers, 123
The Berry Pickers, 42-43
Blackboard, 87
Blown Away, 152
The Boatman, 63
Boy and Horse Ploughing, 70-71
Boy in a Boatyard, 10
Boys and Kitten, 40
Boys in a Pasture, 81
The Breakwater, Cullercoats, 108-109
Bridle Path, White Mountains, 22-23
The Butterfly Girl, 74
Cape Trinity, Saguenay River, 104-105
The Carnival [Dressing for the Carnival], 90-91
Coast in Winter, 142-143
Contraband, 90
Coral Formation, 126
The Cotton Pickers, 92-93
Crab Fishing, 110
Croquet Scene, 26-27
Crossing the Pasture, 82-83
Dad's Coming, 28-29
Deep Sea Fishing, 152-153
Defiance: Inviting a Shot Before Petersburg, 16-17
Driftwood, 174-175
Eagle Head, Manchester, Massachusetts, 30-31
Eastern Point, Prout's Neck, 168-169
The End of the Hunt, 59
End of the Portage, 100-101
The Faggot Gatherers, 160-161
Feeding Time, 80
Fisher Girls on the Beach, Tynemouth, 12
Fishing Boats, Key West, 130-131
The Flirt, 38-39
The Fog Warning, 154-155
The Fountains at Night, World's Columbian Exposition, 9
Fox Hunt, 140-141
Fresh Air, front cover, 72
The Gale, 160
The Garden Gate, Bahamas, 14
Girl and Daisies, 75
A Girl in a Punt, 41
Girl with Shell at Ear, 43
Glass Windows, Bahamas, 126-127
A Good Pool, Saguenay River, 96
Grand Discharge, 96-97
The Gulf Stream, 138-139
The Herring Net, 156-157
Homecoming, 111
Homework, 86
Homosassa River, 121
Hudson River, 52-53
In a Florida Jungle, 118-119
In the Garden, 84
In the Hayfield, 9
In the Jungle, Florida, 122-123

In the Mountains, 48-49
Jumping Trout, 60
Key West, Negro Cabins and Palms, 124-125
Kissing the Moon, 164-165
The Light House, Nassau, 136-137
Long Branch, New Jersey, 24-25
The Lookout—"All's Well," 158
Maine Cliffs, 146
Marine, 115
Milking Time, 78-79
Moonlight, 34-35
The Morning Bell, 76-77
The New Novel, 85
The Northeaster, 144-145
October Day, 58
Old Friends, 53
On the Beach, 46-47
On the Beach at Marshfield, 44-45
On the Bluff at Long Branch, at the Bathing House, 8
On the Cliff, 107
Oranges on a Branch, 129
Perils of the Sea, 112
Pitching Quoits, 18-19
Promenade on the Beach, 32-33
The Pumpkin Patch, 70
The Reaper, 73
Returning Fishing Boats, 114-115
Right and Left, 172-173
Road in Bermuda, half-title
Rum Cay, 134
Saguenay River, Lower Rapids, 98-99, (also back cover)
The See Saw, 39
Sharks; also The Derelict, 139
Sharpshooter, 18
Shepherdess Tending Sheep, 68-69
Shipbuilding at Gloucester, 36-37
The Ship's Boat, 112-113
Shooting the Rapids, 102-103
Shore at Bermuda, 128-129
Skirmish in the Wilderness, 20-21
Snap the Whip, 88-89
Sponge Fishing, the Bahamas, 132-133
A Summer Night, 150
Sunlight on the Coast, 170-171
Sunset Fires, title page
Sunset, Prout's Neck, 147
The Swing, 11
Taking an Observation, 159
Through the Rocks, 145
Trappers Resting, 66-67
The Turtle Pound, 135
Two Guides, 50-51
Two Men in a Canoe, 64-65
Undertow, 162-163
An Unexpected Catch, 60-61
Waiting for a Bite, 54-55
Watching the Breaker—A High Sea, 151
West Point, Prout's Neck, 166-167
The West Wind, 148-149
Winter at Sea—Taking in Sail off the Coast, 7
Wolfe's Cove, 95
Young Ducks, 62
Young Girl at Window, 10

Selected Bibliography

Atkinson, D. Scott, and Jochen Wierich. *Winslow Homer in Gloucester*. Chicago: Terra Museum of American Art, 1990.

Beam, Philip C. *Winslow Homer at Prout's Neck*. Boston: Little Brown and Company, 1966.

Cikovsky, Nicolai, Jr. *Winslow Homer*. New York: Harry N. Abrams/National Museum of American Art, 1990.

———, ed. *Winslow Homer: A Symposium*. Hanover: University Press of New England for the National Gallery of Art, 1990.

Cikovsky, Nicolai, Jr., and Franklin Kelly. With contributions by Judith Walsh and Charles Brock. *Winslow Homer*. New Haven: Yale University Press for the National Gallery of Art, 1995.

Cooper, Helen. *Winslow Homer Watercolors*. New Haven: Yale University Press for the National Gallery of Art, 1986.

Cox, Kenyon. *Winslow Homer*. New York: Frederic Fairchild Sherman, 1914.

Day, Alexandra. *Winslow Homer in the Clark Collection*. Williamstown: Clark Art Institute, 1986.

Downes, William Howe. *The Life and Works of Winslow Homer*. Boston: Houghton Mifflin, 1911.

Eliot, Alexander. *Three Hundred Years of American Painting*. New York: Time, 1957.

Flexner, James. *The World of Winslow Homer*. New York: Time, 1966.

Gardner, Albert Ten Eyck. *Winslow Homer, American Artist: His World and His Work*. New York: Clarkson N. Potter, 1961.

Goodrich, Lloyd. *Winslow Homer*. New York: Macmillan for the Whitney Museum of American Art, 1944.

———. *Winslow Homer*. New York: George Braziller, Inc., 1959.

——— . *The Graphic Art of Winslow Homer*. New York: Museum of Graphic Art, 1968.

Hartley, Marsden. *Adventures in the Arts*. New York: Hacker, 1972.

Hendricks, Gordon. *The Life and Work of Winslow Homer*. New York: Henry N. Abrams, 1979.

Hoopes, Donelson. *Winslow Homer Watercolors*. New York: Watson-Guptill, 1969.

Knipe, Tony, et al. *Winslow Homer: All the Cullercoats Pictures*. Sunderland, England: Northern Centre for Contemporary Art, 1988.

Little, Carl. *Winslow Homer and the Sea*. Rohnert Park, Calif.: Pomegranate Artbooks, 1995.

Reed, Sue W., and Carol Troyen. *Awash in Color*. Boston: Museum of Fine Arts, 1993.

Robertson, Bruce. *Reckoning with Winslow Homer: His Late Paintings and Their Influence*. Cleveland: Indiana University Press for the Cleveland Museum of Art, 1990.

Spassky, Natalie. *Winslow Homer at the Metropolitan Museum of Art*. New York: Metropolitan Museum of Art, 1982.

Strickler, Susan, ed. *American Traditions in Watercolor*. New York: Abbeville Press for the Worcester Art Museum, 1987.

Tatham, David. *Winslow Homer and the Illustrated Book*. Syracuse: SyracuseUniversity Press, 1991.

Wilmerding, John. *Winslow Homer*. New York: Praeger, 1972.

Beam, Philip C., Lois Homer Graham, Patricia Junker, David Tatham, and John Wilmerding. *Winslow Homer in the 1890s: Prout's Neck Observed*. New York: Hudson Hills Press for the Memorial Art Gallery of the University of Rochester, 1990.

Young, Mahonri Sharp. *American Realists: Homer to Hopper*. New York: Watson-Guptill, 1977.